D0883165

B.C. BINNING

B.C. BINNING

ABRAHAM J. ROGATNICK

IAN M. THOM

ADELE WEDER

INTRODUCTION
BY ARTHUR ERICKSON

DOUGLAS & McINTYRE

VANCOUVER / TORONTO

Douglas & McIntyre Ltd.
2323 Quebec Street, Suite 201
Vancouver, British Columbia
Canada V5T 4S7
www.douglas-mcintyre.com

Library and Archives Canada Cataloguing in Publication

Rogatnick, Abraham J.

 B.C. Binning / Abraham J. Rogatnick, Ian M.
Thom, Adele Weder.

Includes bibliographical references and index.
ISBN-13: 978-1-55365-171-0
ISBN-10: 1-55365-171-5

 1. Binning, B.C., 1909–1976. 2. Architects—British
Columbia—Vancouver—Biography. 3. Modern
movement (Architecture)—British Columbia—
Vancouver. 4. Artists—British Columbia—Biography.
5. Artists—Canada—Biography. 6. University of
British Columbia—Faculty—Biography. 7. Art
teachers—British Columbia—Vancouver—Biography.
I. Thom, Ian M. (Ian MacEwan), 1952– II. Weder, Adele,
1961– III. Title.

N6549.B545R63 2006 709'.2 C2005-906401-3

Editing by Corky McIntyre
Jacket and text design by George Vaitkunas
Printed and bound in Canada by Hemlock Printers Ltd.
Printed on acid-free paper

Frontispiece: B.C. Binning, 1966
Dedication page: Bert and Jessie Binning, circa 1973

This book is gratefully dedicated
to Jessie Wyllie Binning, whose astute
understanding, encouragement and
support of her husband Bert's
development as an artist, educator
and promulgator of the arts
contributed immeasurable strength
to all his efforts and convictions.

CONTENTS

	viii	ACKNOWLEDGEMENTS
ARTHUR ERICKSON	x	INTRODUCTION
ABRAHAM J. ROGATNICK	1	A PASSION FOR THE CONTEMPORARY
ADELE WEDER	41	THE HOUSE
SIMON SCOTT	69	BINNING HOUSE, PHOTOGRAPH PORTFOLIO
IAN M. THOM	81	BINNING AS A DRAFTSMAN
IAN M. THOM	117	BINNING AS A PAINTER
RICHARD E. PRINCE	160	AFTERWORD
	163	CHRONOLOGY
	166	NOTES
	173	SELECTED BIBLIOGRAPHY
	177	NOTES ON CONTRIBUTORS
	177	PHOTO CREDITS
	178	INDEX

ACKNOWLEDGEMENTS

Among those to whom I am endlessly indebted for their contributions to this book are Geoffrey Massey, whose initiatives impelled and sustained the planning and organization of the entire effort; Adrian Archambault, who doggedly began to gather a precious mass of biographical data on B.C. Binning more than a decade ago; June Binkert, Binning's devoted assistant and mainstay during his entire tenure as Director of the UBC Fine Arts department, whose reminiscences were invaluable, and Corky McIntyre, whose acute editing honed away many rough edges. Thanks are also due to John Koerner, H. Peter Oberlander, Shelagh Lindsey, Norah Vaillant and the personnel of the Rare Books and Special Collections division of the UBC Library.

Abraham J. Rogatnick

Greatest thanks go to Jessie Binning, for her diligence, graciousness and endless cooperation. Among the many others to whom I am indebted are Corky and Scott McIntyre, Adrian Archambault, George Vaitkunas and Simon Scott. Phyllis Lambert of the Canadian Centre for Architecture provided insightful feedback to the thesis research at the heart of this essay, as did Sherry McKay and Christopher Macdonald of the UBC School of Architecture. Additional insights came from Arni Haraldsson, Peter Oberlander, Arthur Erickson, Abe Rogatnick and Geoff Massey. Peeroj Thakre's plan renderings and spirited friendship have proven indispensable. Erica Warrington Ladner and family generously provided Graham Warrington's vintage photography. Much appreciation extends to Brigitte Desrochers and the Canada Council for the Arts, which provided financial assistance. Lifelong thanks to Julia, Natalie and Jamie Chrones, for their unwavering support.

Adele Weder

My principal thanks in this project are to Mrs. Jessie Binning, a woman of unfailing grace and kindness, who has allowed me privileged access to Binning's work over a period of many years. Adrian Archambault kindly assisted me in a number of ways, and the Binning interviews conducted by Doreen Walker in the seventies are invaluable. Both of my essays would not have been possible without the assistance of the Vancouver Art Gallery. I am grateful to Daina Augaitis, Chief Curator and Assistant Director, who graciously agreed to the use of gallery resources and staff in the realization of this project. Trevor Mills is owed particular thanks as he provided most of the photography of the works of art in this book. The staff of Douglas & McIntyre; Scott McIntyre, publisher; Corky McIntyre, editor, and designer George Vaitkunas have all been invaluable in making this book better.

Ian M. Thom

My long association with Bert and Jessie Binning was without question one of the most rewarding and formative experiences of my early years. When I was in that indecisive period of gestation, having never as an aspiring artist had a lesson in the field, I went to the Vancouver School of Art, housed in a bulky wooden monster of a building on Richards Street at Hamilton, to take a painting course with Jack Shadbolt and a drawing course from Bert Binning. Bert's course was the most memorable, leaving an indelible mark on my drawing style, for he taught me the beauty of the less detail, the better.

The exercise was to follow as carefully as possible, without looking at the paper before you, the subtle curves of the live model before you. The drawing had to be completed without reference to your depiction of it, so that at the beginning, a line tracing the torso might cross over another outlining an arm or a leg, or you might place an eye off the head altogether, resulting in a disrespectful similarity to a very naïve Matisse, Picasso or Jean Cocteau. The lesson was how much a simple line could imply the mass and detail of the body and how the scrutiny of the focussed eye could reveal its mastery over the moving hand. From then on I had an implicit trust in the importance of the simple line and adapted it for my future architectural drawings. This lesson in simplicity also influenced my own later teaching.

Bert and Jessie's house became a museum of masterpieces of Kawai and Hamada pottery and deeply expressive calligraphy on rice paper collected on their visits to Japan. In contrast to this were Bert's whimsical drawings of the paraphernalia of their own sailboat. He delighted in the forms of the perky tugboats and nets of fishing craft at rest at the rough log wharves of the B.C.'s west coast. Reconfigured, these subjects formed the lively compositions of his west coast paintings. This work reflected his joy in the ordinary everyday coastal life, his delight in detail, and the pervasive inward chuckle at the whimsy such forms induced in him sailing up the coast.

Bert and Jessie were two individuals of such contrasting natures as to be a perfect match in the constant delight they gave each other. Bert's massive frame and expansive rough-shod humour contrasted with Jessie's immaculate elegance (and refinement) that suggested her affinity to things Japanese, which her early trips to Japan with her merchant father had instilled in her. Her petiteness, charm and perfectly tailored presence were the foil to Bert's intellectual curiosity and passionate energy. Their expeditions at sea, and her willing adaptation to a confined galley, contrasted with the delectable fare she served in the dining room of their remarkably appointed home, a product of Bert's art and architecture.

Richard and Dionne Neutra were occasional visitors from California whom the Binnings invited me to meet before I set out to study architecture. Richard, an admirer of their house and an intellectual match for Bert, was a graduate Fellow of Taliesin, where he must have learned his remarkably sensitive interpretation of site. But he went out on his own rather than strictly abiding with the Fellowship. In a state of indecision myself about an architectural future, I asked him if he could recommend a university that taught architecture as an art. "The best thing for you, young man," he said, "would be to go to MIT and study engineering!" It was a wise and practical bit of advice, although it made me deeply skeptical about architecture as a personal profession.

The Binnings' greatest gift to me was in 1961, when they heard of my Canada Council grant to visit Japan. They gave me a list of the Japanese "Living National Treasures," the accomplished artists and craftspeople who were carrying on the great Japanese craft traditions. And they provided me with an introduction to Bishop Sakamoto of the Takarazuka temple, at the "Lourdes" of Japan. The bishop had visited Vancouver at the Binnings' invitation in 1960. At the Vancouver Art Gallery he had given demonstrations of his exceptional calligraphy while sitting on a raised tatami platform in

his scarlet silk robes. In the late summer of 1961 I visited his temple, known for its collection of Tessai scrolls of brush painting on rice paper of exuberant mastery, and was again made aware of the bishop's close relationship to the Binnings.

I arrived for lunch in a set of tatami rooms in the bishop's house from which, while sitting at the exquisitely set table, one could view the Tessai paintings in the surrounding rooms. In typical Japanese manner, each time you looked up from the lunch, the paintings in the surrounding rooms had been changed so discreetly that you were unaware of it. All of the Tessai collection was shown to me during that lunch. Takarazuka was also known for its all-women musical theatre, which I was able to see before returning to Tokyo. Few visitors to Japan have had the introductions to the "National Treasures" that I had through the Binnings.

My visit to Japan was a decisive experience for me that would influence my work from that time on. I had learned how to look at the ground, at the iridescent mosses springing between scattered stepping stones, at the carefully raked white sand portraying ripples around green promontories, at an isolated rock—a ship buffeted by the rapids of a rushing stream—as a limited space or as a vast ocean landscape.

ABRAHAM J. ROGATNICK **A PASSION FOR THE CONTEMPORARY**

H E REVELLED in the art and architecture that burst upon the world during the early decades of the twentieth century. In his youth he quickly became aware of the artistic and architectural innovations rapidly evolving from the Arts and Crafts revolutions that had been transforming the world of art since the 1890s. Bert Binning, upon discovering this new world during the years between the two world wars, fell in love with it. A mood of bright and promising hope in the arts would inspire and excite young Binning. It was a time of exhilarating, refreshing breaths of air, when society was happy to disencumber itself from stifling social attitudes towards the arts still lingering from the Victorian era, stimulated by a sense of freedom to innovate that twentieth-century society was slowly, if painfully, beginning to tolerate and even encourage.

Most of all, it was a time that provided a clear program of action initiated by the idealist dreamers of the late nineteenth and early twentieth centuries. Dreamers such as William Morris, Louis Sullivan, Frank Lloyd Wright, Tony Garnier, Le Corbusier, and Bauhaus participants in the arts, crafts and architecture. This was also the time of the Post-Impressionists, Fauves, Cubists, Constructivists, Futurists, Dadaists and De Stijl adherents who straddled those remarkable turn-of-the-century decades.

Bert Binning was still a teenager when Bauhaus artists and architects were busily demonstrating practical applications of their philosophy—a philosophy that extolled and accommodated itself to the Industrial Revolution rather than rebelling against it. Most importantly to Binning, they emphasized the intrinsic oneness of art and everyday life.

Binning very early felt the urgency to envision art and life working in unison to enrich and invigorate society. He became dedicated to this vision, plunged into active pursuit of it, and ultimately became a proselytizer and champion of it in Canada, especially in British Columbia. It is for this inspiration and contribution to Canadian life and culture, notably the influence he had on young people, that he deserves profound remembrance.

Born in 1909 in Medicine Hat, Alberta, young Bertram Charles Binning came to Vancouver with his parents in 1913. At that time the city's culture had changed very little from the frontier town it had been less than thirty years before when the apparently unpromising site of Gastown had been chosen as the terminus for the railroad. Renamed Vancouver in 1886, the city was destined to develop from a tiny

saloon-dominated settlement, essentially a "rest stop" for loggers, fishermen and miners, to become one of Canada's most important urban centres.

In 1913 the Panama Canal opened, and just as San Francisco had profited from the U.S. transcontinental railroad by providing a convenient jumping-off point to the Far East, Vancouver was now able to proclaim itself Canada's "Gateway to the Orient." As the western end of Canada's own transcontinental railroad, Vancouver was euphoric about its potential connection via Panama to the Atlantic coast and to Europe as well. The years from 1910 to 1913 witnessed an optimistic building boom in Vancouver similar to those that had recently occurred in San Francisco and Chicago. Several buildings which rose in Vancouver during that period, while not as high as those beginning to soar in New York, were catching up with the tall steel-structured buildings pioneered in Chicago during the latter years of the nineteenth century. One of these buildings, the Dominion Building, which still stands today, was able for a short time to vaunt itself as the tallest building in the British Empire. Consciously or unconsciously these audacious structures must have made a significant impression on Bert the teenager, not only because he had arrived from a small town, but because the seeds of young Binning's fascination with architecture had already been planted by his maternal and paternal grandfathers, both of them architects.

Cecil Binning, my great-grandfather, was a British naval officer who was so taken with his first sight of Ontario that he left the navy and founded the town of Listowel. He had three wives and 36 children and used to ride around town in a cutter drawn by racehorses, white beard flying in the wind, yelling "Go ye devils! Go!" My [paternal] grandfather was the first architect in that part of Ontario, and my maternal grandfather was an architect in Alberta. I would have been an architect too had it not been for an illness early in my life which kept me in bed for two years. Today I am not a bit sorry that I became a painter and teacher instead.[1]

There were other architectural wonders to be seen as well, less spectacular but nevertheless profoundly attractive to an architecturally aware youth. These were the mansions of the captains of B.C.'s primary industries, often built on spectacular sites of high ground looking north to the mountains and across the wide inlet that separated the city from the north shore. Beginning in the optimistic year of 1910, the new wealthy elite, many of whom were the executives of the railroad, developed a

precinct for a cluster of mansions laid out on winding streets on a hill overlooking the growing city. The area, now known as Shaughnessy, was designed by Frederick Todd, a Montreal landscape architect and member of the studio of Frederick Law Olmsted, the admired designer of Central Park in New York as well as other parks and residential areas in Canada and the United States, and L.E. Davick, a Danish engineer.

Much of the building activity of the early 1900s, which continued until the Great Depression of 1929, occurred in the middle- and working-class residential townships laid out in orthogonal grids around the periphery of Vancouver city, spurred in their development by a network of streetcar lines that facilitated easy commuting from home to work in the city. These gridded townships were soon incorporated as neighbourhoods within the municipality of Vancouver. They were remarkable in their adherence to a philosophy of city development that was healthier and more attractive than that of the industrially oriented cities that had been built and deplored in the nineteenth century.

The turn of the twentieth century saw the rise and popularity of city planning reformers concerned for the well-being of the working-class families born into the roiling, stressful world of the Industrial Revolution. The Garden City movement was born, which advocated segregation of city functions into separate zones of commercial, industrial and residential development interspersed with a careful distribution of parks for recreation and the enjoyment of nature within urban precincts. In addition, the idea of the Garden City came with the belief that the majority of its inhabitants should have the opportunity to live in a detached house with front and rear gardens. This utopian vision was enforced as a requirement in the Vancouver area, turning every residential street into a continuous series of gardens, further augmented by municipally provided *allées* of trees planted along wide strips of lawn in boulevard fashion at the edge of the relatively narrow roadways. With the advent of the automobile, these roadways no longer had to accommodate unwieldy, difficult to manoeuvre carriages pulled by one or more horses. Horseless streets could now be paved and easily washed clean.

This was indeed a new world, the world in which Binning was to grow into adulthood and begin a career. The architectural and urban examples that surrounded him developed and reinforced his early education in architecture, a study which circumstances prevented him from pursuing in a formal manner. His wish to study

Bert Binning, circa 1927

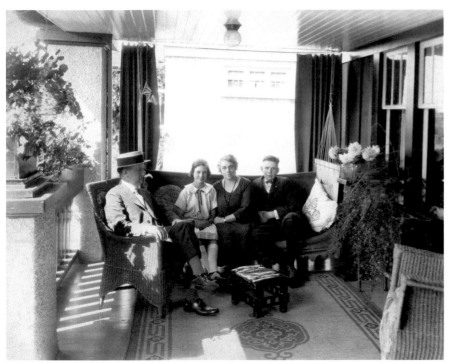

The Binning family in their Vancouver
home, circa 1920

architecture had to be abandoned when at the age of sixteen he fell ill and was hospi-
talized for over two years. To occupy his time with what was considered minimum
strain, the young patient began to draw. Binning, however, never abandoned his love
of architecture. Throughout his entire career as an artist he always maintained that
the discipline of architecture, its dependence on a strong sense of organization and
structure, informed his approach to drawing, painting and mural design.

Fortunately for the young artist, the Vancouver School of Decorative and Applied
Arts (later known simply as the Vancouver School of Art and today as the Emily
Carr Institute of Art and Design) had just been established in 1925. In 1927 he enrolled
as a student and began his life in art. Hardly out of art school (he graduated in 1932)
he was recognized as a teacher, and in 1933 was appointed to the art school's staff.
He soon shared a studio in downtown Vancouver with a colleague, Fred Amess, who
would later become the director of the school. Binning listed himself as a "commercial
artist." By coincidence, the site of their early studio was later rebuilt and the new
structure was inaugurated in 1958 as the Imperial Bank of Canada Building (now the
Canadian Imperial Bank of Commerce) together with the unveiling of one of Binning's
most celebrated mosaic murals in the banking hall on the street level of the building.
The would-be architect was beginning to enjoy a life-long career as an admired artist
and teacher.

In 1936, Binning took another fortuitous step when he married Jessie Wyllie. The
daughter of a Vancouver businessman, Jessie was a quiet but acute appreciator of art.
In 1938, Binning made the decision to take a year away from teaching and travel to
Europe to further his studies in art. The Binnings arrived in London in August 1938
and Bert began classes at the Ozenfant Academy of Art, studying under Amédée
Ozenfant, Henry Moore and others.[2] During their time in London they visited galleries
and exhibitions, absorbing much of the culture of Europe, both old and new.

Binning's European experience awakened him to the profound experience of art,
architecture and life joining in a sublime totality. In 1950 he wrote of how his time
in Europe influenced his thinking: "When I say that a new approach must be found …
what I have in mind has [already] happened in the past … in the Gothic era and
in the first half of the Renaissance … when both arts [art and architecture] seemed to
intermingle easily … in dynamic unity; when sculpture fused with architecture …
when painting and decoration seemed the [flowering] of the building from which it

Wedding of Jessie Wyllie and Bert Binning at the Wyllie home, Gleneagles, West Vancouver, 1936; Jessie, Bert and Mrs. A.F. Binning (Bert's mother) at centre front.

Letter of introduction (May 27, 1938) from Charles H. Scott, Director, Vancouver School of Art, for Bert Binning's upcoming trip to London and Europe

grew; when, indeed, the Artist was very often the Architect—or ... the Architect was also the Artist."[3]

These experiences continued to direct his thinking, and in a speech he gave to the Ontario Association of Architects, he spoke of his memories.

I remember [when] I became aware ... that architecture is not only for the eyes ... It was one sunny morning [in] Notre Dame Cathedral. From the sunlit square the west front sparkling in contrasts of light and shade through the portal into the mysterious darkness of the huge interior—the long space of the nave, rich in structure and sculpture—the amazing light of the clerestory glass, cool and green, mingling with the warmer light of the lower aisles, combining [dramatically]. This light filtered through into the crowd of worshippers lighting candles, making great bonfires of the candelabras—the smell of wax and incense complemented by the sound of the organ and choir [weaving] in and out of the space in unison with the crowd—the procession of the clerics in multi-coloured vestments in a taut line from the entrance to altar cut rigidly into the whole medley, [giving] it order.

For the first time I really experienced architecture as I had never experienced it before. All my senses came into play. It was hard to say where one left off and another took its place, just as it was hard to say where one art form left off and another began. Architecture had demanded my total awareness.[4]

Binning records his "acute awareness of space" in Venice with its tight alleys, a slit of sky above them, breaking into a square flooded with sunshine—the coolness of the shadow contrasted with the warmth of the sun—details, such as the mouldings, carvings, peeling paint, smells; meals being cooked, the perfume of a passing girl, the aroma of coffee from a restaurant, the smell of fish—changing textures "even under your hand on handrails—I [could] look at people as individuals going about the details of their work, examining their faces, their characters and movements, the patterns they made as they moved, singly or in groups—architecture given animation. Most of all I was aware of scale, the measuring stick with which to relate yourself to the world. All these things [that] remind us of our human existence."[5]

With the growing unrest in Europe, the Binnings left London in the late spring of 1939, travelling home to Vancouver via New York. While in New York, they visited the World's Fair with its daring examples of Modernist architecture and "futuristic"

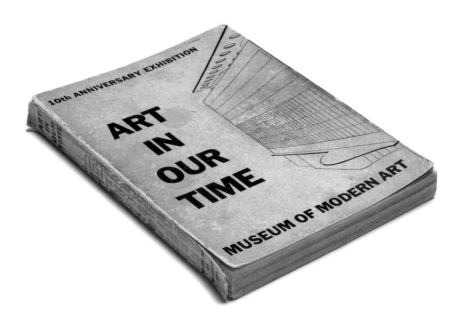

urban and regional design. They also visited the newly opened Museum of Modern Art, taking in a show of modern architecture and design that profoundly influenced Binning's view of art and architecture.

At the time of their return Vancouver was still a relatively small town. As late as 1937 there was no bridge across the Burrard Inlet. The north and south shores were connected by small ferries, used intermittently by Vancouver families who had built modest summer cottages on the north side, either along the shore or higher up on the wooded mountain foothills. In the early thirties a group of astute entrepreneurs, including the Guinness family of Ireland, acquired vast tracts of land there (a portion of which they bought from Jessie's father) and surprised Ottawa with their proposal to build a bridge to connect the city with that ripe-for-development shore. The bridge opened in 1938 with three lanes, a troublesome compromise resulting from Ottawa's objection to the "extravagance" of a four-lane structure leading to apparently nowhere.

Bert and Jessie had the luck and courage to acquire a hillside plot on that promising shore. Within months of the opening of the bridge they began to plan an ultra-modern, Bauhaus-influenced little house. After much negotiation and exhausting argument, Binning's conviction and tenaciousness succeeded in getting this landmark venture through the local building authorities, who were as puzzled by Bert and Jessie's house as the federal government was by the bridge. Binning's battle for the acceptance of modernism in British Columbia was already engaged. "I wanted to build this house," Binning said, "to prove to myself that there was a contemporary architecture, and it worked."[6]

Like the prominent inventors and practitioners of the modern movement in architecture from Le Corbusier to Mies van der Rohe (who considered themselves

heirs to the great classical architects of ancient times as well as the classical revivalists of the Renaissance and the late eighteenth century), Binning liked to think of himself as a classicist. He grew up at a time when gentlemen always wore a jacket and tie in public, and like the rationalists of ancient Greece and those of the influential Age of Reason, as well as the proponents of late-nineteenth and early-twentieth-century functionalism, Binning saw himself as a disciplined, carefully organized, controlled rational artist.[7] "I do like order … probably why I married my wife, because she was orderly … I don't like chaos. I like … my order though. I'm not ordered in a bookkeeper way. [I like] visual order. I think this has a great deal to do with my classical sense … architectural sense … I remember when I was quite young cleaning up my toys … My parents' house was always an orderly place. My father was an orderly man and my mother was [orderly] too."[8]

In spite of his early commitment to Modernism and the philosophy of purism in architecture—reinforced by his contact with Amédée Ozenfant in London[9]—the design of his house, while seemingly "ultra-modern," deviated from the strict tenets of modernist houses in Europe, such as perfect rectangularity and undecorated planar walls. He had the courage to paint a mural not only on an important interior wall of his house, but also a large, colourful one on an exterior wall as a welcoming gesture at the front door.[10]

To him it was reminiscent of an interpretation of classicism that allowed Renaissance architects, notably in Venice, to collaborate closely with artists who covered interior walls with monumental frescoes painted on exterior facades as well. Binning, the innovator, animated an outer wall with a painting at a time when students of Modernism eschewed any suggestion of applied decoration to their "pure" unadorned compositions. He dared to do this long before the great Mexican artists (whose early work he admired) coated entire facades of buildings at the Ciudad Universitaria with bold, colourful murals. It wasn't until nearly thirty years later that a graphics craze in architecture began to splash eye-catching designs over the simple planes of Modernist buildings.

During the 1940s Bert and Jessie developed intimate social contacts with prominent figures among Vancouver's artists and architects. Most notable was their friendship with Group of Seven artist Lawren Harris and his artist wife Bess, who had settled in Vancouver in 1940. At the art school the colleagues with whom Binning interacted

were all leading artists on the Vancouver scene, such as Gordon Smith, Orville Fisher (a noted muralist), Fred Amess, John Koerner, Jack Shadbolt, Lionel Thomas, and Bruno and Molly Boback. At the same time Binning's attraction to architecture drew him firmly into the circle of prominent Modernist-oriented architects such as Peter Thornton, Peter Cotton, Ned Pratt, John Porter, Fred Lasserre and Fred Hollingsworth. Contacts with these professionals helped him to refine and clarify his own distinct philosophy of art and architecture.[11]

He helped found the Art in Living Group, which functioned from 1944 to 1947,[12] and was an enthusiastic participant in the creation of the Design for Living exhibition sponsored by the Community Arts Council in Vancouver in 1949.[13] In his obsession to educate the public to understand good architecture and design, Binning saw himself as a veritable missionary dedicated to the conversion of the pagans.[14]

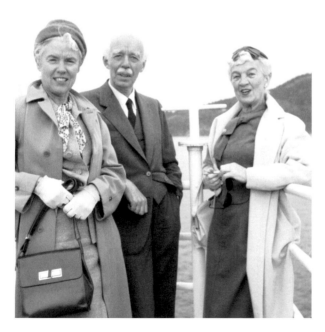

Jessie Binning, Lawren Harris
and Bess Harris on the ferry to
Victoria, circa 1948

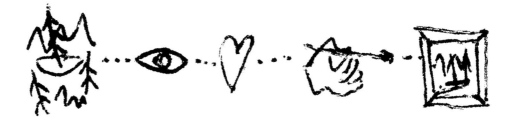

In 1949 Binning was invited by Fred Lasserre, the first director of the new School of Architecture at the University of British Columbia, to teach courses in art to the architecture students. Binning at first hesitated to leave his position at the Vancouver School of Art,[15] but the opportunity to be able to work as an artist in the education of architects was too great a fulfillment of his interests to reject. Part of his equivocation arose from his concern that academia might not be the most comfortable milieu for someone without a university degree and whose formal education had been interrupted by bouts of illness. Of course, his trepidation proved to be unfounded. In those early days at UBC a great deal of respect was given to talent, self-education and professional experience as valuable in the education and inspiration of the students.[16] The president of the university knew and trusted Binning, and in consultation with Binning was already considering plans for the establishment of a department of fine arts with Binning the likeliest candidate to direct it.

Binning flourished in the atmosphere of the university. With his tall, big-boned body and deep, avuncular voice he could have easily been mistaken for a coach of a junior hockey team. But unlike a coach with a "go-team-go" attitude, Binning possessed a quiet, confident determination. He had a talent to educate and inspire young people as forcefully as any athletic coach to go out and win for the arts.[17]

His immediate rapport with the student body soon resulted in his seriously encouraging them to set aside funds to purchase high-quality Canadian art to augment a small collection the students had started earlier, but which until Binning's arrival had not been enlarged.[18]

When Binning was assigned to teach in the School of Architecture, established only three years earlier, his educational vision for the university very soon included more than just the architecture students. He felt that the student body in general lacked an

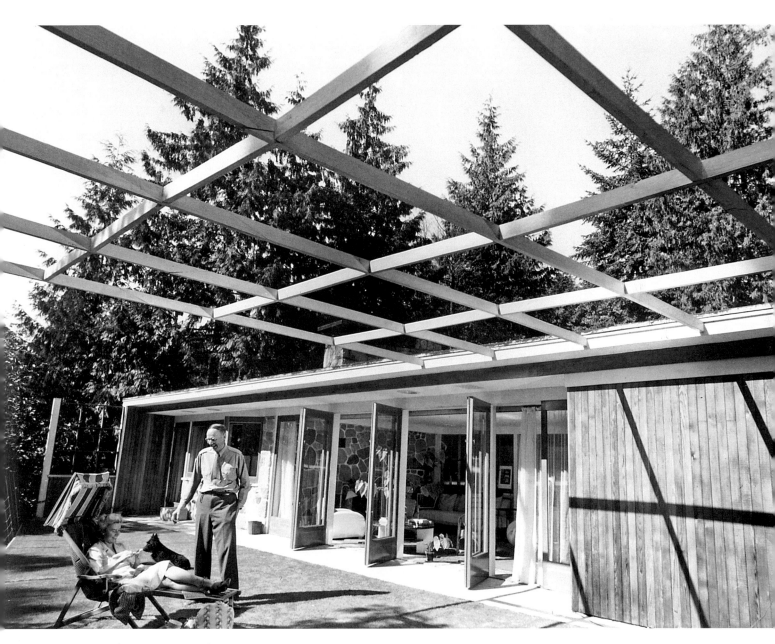

Bert and Jessie Binning on the terrace
of their home, 1945

facing page Doodle (image-eye-heart-
hand-canvas) representing Bert Binning's
approach to art, from an undated UBC
lecture sheet

acquaintance with the arts, and he believed it was his duty and responsibility to set this right. With the enthusiastic support of President N.A.M. MacKenzie he created and embarked on a variety of university programs that brought the arts to high and exciting prominence on the campus during the twenty-five years of his tenure. He ultimately helped establish thriving arts departments that attracted distinguished faculty—faculty who inspired countless students to become professionals, many to play roles in the highest echelons of their respective fields.

Binning's importance to the university was also quickly established as an advisor in the various art matters that inevitably arise in a university's affairs. Over the years his advice was sought on the handling of artworks bought by or donated to the university, the furnishing and decoration of the president's house on campus and the choosing of colours of the regalia assigned to new degrees constantly being added. His assistance was also sought in the design and colouration of other university symbols, such as its crest and flag, in the design of a mace to be carried in ceremonial processions, and, ultimately, in the planning of the MacKenzie Fine Arts Complex.[19]

Binning had always cherished the desire to interest society in art in vigorous, involving ways, whether through the support of public art, education or public exhibitions. He found the university to be fertile ground for creating direct contact between the public and arts professionals. He laboured endlessly to bring such people to Vancouver to lecture, to perform and to meet and chat with the general public as well as with promising young students, the potential artists and non-artist leaders of the future.

This was no easy task in B.C., which was referred to even into the early 1960s as "the end of the world." Vancouver and Victoria were not well known and difficult to travel to from the busier centres of art activity in the world in spite of the dependable transcontinental railroads. The promise of oceanic connections with these centres via the Panama Canal had long faded, and air travel to the Pacific coast remained tedious and relatively expensive until the 1960s. British Columbia's contact with the world of culture had been tenuous even within the rest of Canada. From its very founding B.C. had teetered in its allegiance between its connection to Canada and its ties to the Pacific coast of the United States. Well into the 1960s British Columbia's links to the arts in the rest of the world depended largely on cooperation with the universities and arts organizations along the west coast from Los Angeles to Vancouver, all of

whom sought to invite the same people to lecture and perform on the coast. It was a cooperation that was necessary, not only for economic reasons, but to make the long trip attractive and worthwhile to invitees by arranging large enough packages of appearances.

During the early years of the twentieth century, a distinct cultural identity had begun to grow in California, and it was to California that British Columbia largely turned to be informed and inspired. The architecture of California was of special interest to Canada's far west and, in spite of differences in climate and availability of building materials, California's residential architectural styles pervaded B.C.'s rapidly growing centres. The most popular styles were, on the one hand, the "bungalow" house, small, compact and usually one storey, and on the other, the grander, eclectic-styled mansion confections favoured by the rich. California architects, such as the notably creative Bernard Maybeck, whom the Binnings visited, and the Greene

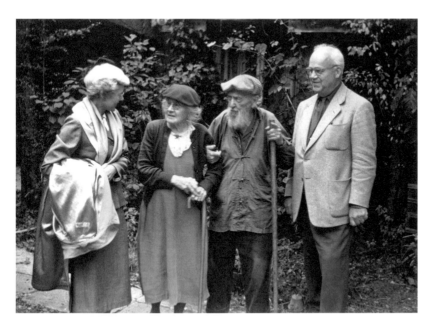

Jessie Binning, Annie Maybeck,
Bernard Maybeck and the dean of the
School of Architecture, University
of California at Berkeley, circa 1950

brothers, were designing finely crafted wood mansions influenced by both Japan and the British Arts and Crafts movement of the latter nineteenth century. This encouraged a style and method of building that inspired British Columbia architects, who shared California's Pacific coast awareness of and attraction to Japan and who could tap into the local abundance of wood.

A prominent California architect was Richard Neutra. Neutra had left his native Austria in the early 1930s imbued with the intensity of the Modernist movement epitomized in the German Bauhaus, having worked for Erich Mendelsohn, a hero of German innovation in architecture before the advent of the Nazis. In America Neutra had the rare opportunity of studying with one of the most important inspirers of Modernism: Frank Lloyd Wright.

When Neutra began to practise on his own in Los Angeles, his kinship with the more classical, non-decorative philosophy of architects involved with or sympathetic to the ideas and ideals of the Bauhaus (such as Mies van der Rohe and Le Corbusier) had educated him to join their march to the Modernist drum. Here was the kind of inspiration and kindred spirit that Binning hungered for and was determined to share with his community.

Even before Binning was appointed as a professor in the School of Architecture he had worked with the director, Fred Lasserre, who was anxious to have his students come in contact with prominent contemporary architects. In 1946 Lasserre and Binning (as members of the Art in Living Group) invited Richard Neutra to visit Vancouver in connection with an exhibition of modern architecture. In addition to

Page Ten THE VA

IN AND OUT OF TOWN

To Honor Visiting Architect And Wife

A number of affairs will be held in honor of Mrs. Richard J. Neutra of Los Angeles who is accompanying her husband, the eminent Viennese-American architect and author, to Vancouver next week. They will be the guests of Mr. and Mrs. B. C. Benning of West Vancouver.

Monday, the Ladies Auxiliary to the Art Gallery honors Mrs. Neutra and Friday, March 29, Mr. and Mrs. Neutra will be guests of honor at a reception to be given by the executive members of the Federation of Canadian Artists, sponsoring bodies and their wives at the Art Gallery.

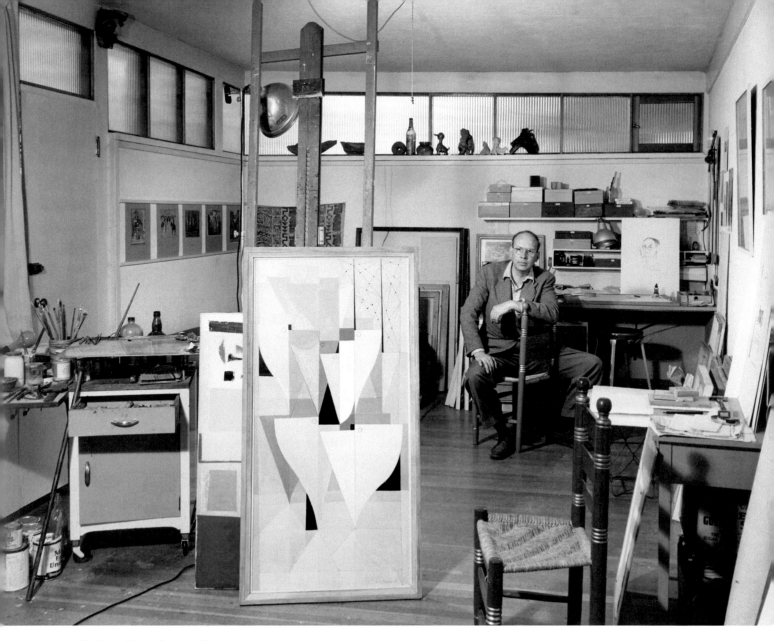

Binning in his studio, 1950. The easel
and the work table are placed near
the full-size windows at the left (off the
photo).

facing page Newspaper clipping
reporting on the visit of Richard Neutra
and his wife to Vancouver as guests
of "Mr. and Mrs. B.C. Benning" (*sic*),
Vancouver Province, March 14, 1946

Neutra's meeting with the students in the school, Binning arranged an evening for him to meet and chat with young architects in the appropriate atmosphere of the Binning house. Neutra returned on two subsequent occasions, providing more young people with the memory of having sprawled on Bert and Jessie's white living-room carpet and the rare opportunity of sitting at the feet of and conversing with a renowned practitioner in their chosen field.[20]

In his development as an artist and campaigner for public recognition of the arts, Binning was significantly supported by and gained strength from Jessie. Jessie's patience, devotion and acceptance of the frugalities necessitated by a life shared with a struggling artist provided Binning with a solid foundation through difficult times. Jessie quickly recognized and applauded every success and progression in Bert's artistic development, holding his hand as they leaped together over the succession of obstacles that every maturing artist must overcome.

Throughout his teaching career Binning continued to pursue the role of a promulgator of art in his community as a respected practitioner among Canadian artists. It was during the early years at UBC that he began to receive commissions for murals. It was especially satisfying for him to be able to integrate his art with architecture, creating an art that was intended for public enjoyment, an art that was integral to the public's environment and day-to-day experience.

In 1952 the O'Brien advertising agency in Vancouver commissioned Binning to create two murals on inside walls of their new offices. Binning enjoyed boasting that the one near the entrance had an essentially outdoor function, since it could be seen through the streetside windows by passers-by on foot or in vehicles.

The most spectacular of his public art efforts began in 1952–53 when Binning collaborated on a design for a three-storey electric substation. The B.C. Electric Company knew they had to make their new building palatable to a public already tired of the drabness of the downtown street on which it was to be built.

The president of the electric company, Albert Edward "Dal" Grauer, was a cultured and sensitive appreciator of the arts who understood the aesthetic potential of such a monumental example of industrial technology. He agreed with Binning's suggestion to the architect Ned Pratt that the entire exterior wall facing the street should be curtained with glass to reveal the interior architectural composition to the public.[21] Binning created a composition of brilliant colours to enhance the meticulously

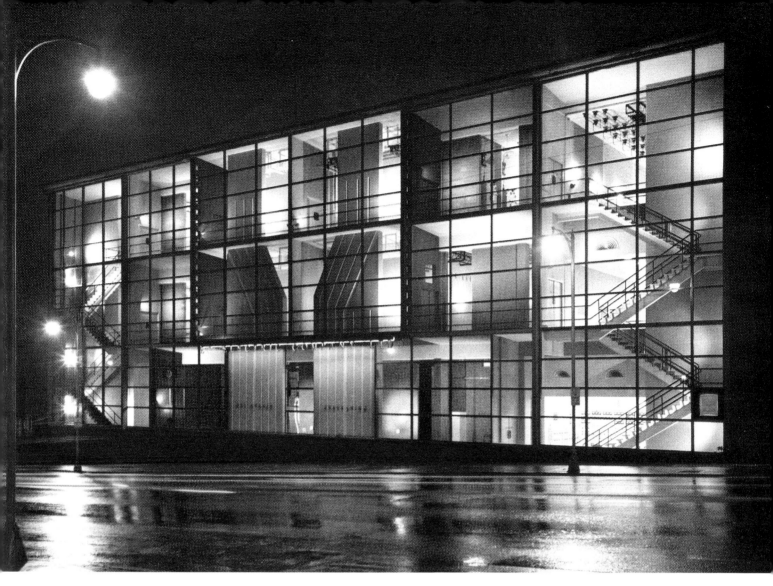

B.C. Electric (Dal Grauer) Substation,
Vancouver, 1952–53

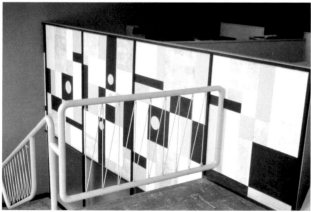

One of two murals painted for the
O'Brien Advertising Centre, circa 1952.
This mural was visible from the street.

Tile mosaic on the B.C. Electric
Building showing the distinctive
colours and diamond pattern, 1956

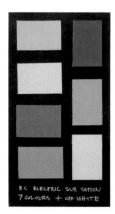

Original colour
palette, Dal Grauer
Substation, 1952–53

arranged architectural and industrial elements that, like the O'Brien mural, slowed traffic on the street as people prolonged the moment to observe and enjoy it. It was one of the important sights recommended to visitors to the city.

Although the original Dal Grauer Substation colour scheme was successful, Binning changed the colours in 1956 to bring the substation into harmony with the colours he had recommended for the design of the tall office building of the B.C. Electric Company rising next to the substation.[22] Binning's approach to colour was now deeply influenced by his study of the regional character of the natural context of the city. He was convinced that the most appropriate colouration of buildings in Vancouver would best enhance the urban scene by harmonizing with the northerly latitude and climate of Vancouver, with its surrounding rainforest, interlacing waterways, mist-catching mountains and greyer skies. Binning's attention to architectural colour now began to emphasize greens, blues and greys, the scheme he applied to the new B.C. Electric Building and to the revised colour coding of the three-dimensional "mural" of its contiguous substation. This was not only a reflection of the abandonment of strident southern colour schemes, but was also reflective of British Columbia's gradually increasing independence of the prevailing influence from the south, especially California. Architects and artists in B.C. were not only becoming more sensitive to the character and demands of their own region, but were also beginning to look to eastern Canada both politically and culturally. Their ties with the coastal region to the south were weakening, becoming less American and decidedly more Canadian. Regional influence became one of the important elements that Binning energetically urged his students to absorb.

This does not suggest that Binning's attraction towards international cultures was at all lessened. In 1957, he fought for permission to use Venetian glass tile for a large, spectacular mural to be installed in a new building for the Imperial Bank of Commerce in Vancouver.[23] Working closely with the architects gave him the opportunity and satisfaction of integrating his work so completely within the architectural design that the mural would transcend any notion of serving as mere "decoration," but would complete and enhance the architectural experience, playing a truly integral role in the structural expression of the building.[24]

The experience of working on the bank mural in Venice became one of the high-lights in Binning's life. Visiting the Murano glass factory to choose the colours for his

Mosaic mural, Imperial Bank
of Commerce, depicting the basic
resources and industries of B.C.

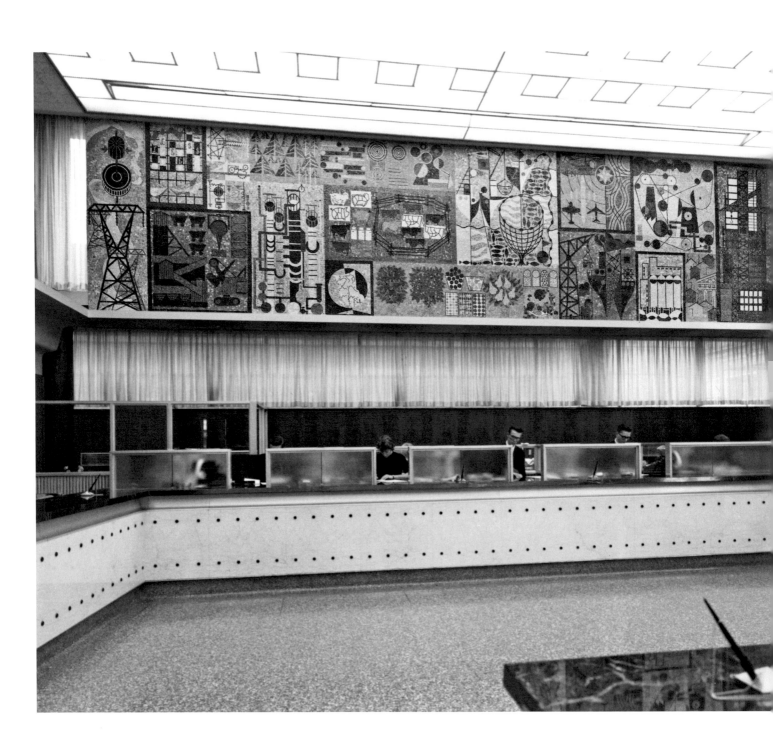

mural, mixing Italian marble (a medium of the great Italian sculptors of history) with the glass tesserae, consulting with Venetian art experts, becoming an authentic participant in real, non-tourist Venice, while being immersed in the magical atmosphere of the ancient city, afforded him a profoundly enjoyable romantic experience.

Binning became one of Canada's most noted muralists. He was asked to submit a number of designs for murals across the country, but as is often the case, not all resulted in a commission. However, two more of his architectural murals brought additional public enthusiasm for his work. One was an extensive geometric design along a corridor wall in the Edmonton air terminal designed in 1963. The mural had to be appreciated kinetically by debarking passengers as they moved through the long walkway from the plane to the main terminal.[25]

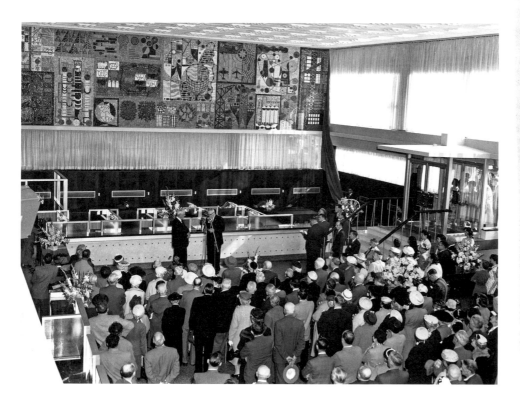

Wall Into Beauty

Editor, The Sun: Sir,—Since I was so openly critical concerning the sculpture and the main lobby ceramic mural in the new post office, perhaps you would be good enough to publish this letter of mine in praise of something.

I think the main lobby of the new Imperial Bank building is nothing short of tremendous in its space concept, the beauty of its fittings and, above all, in its bold and imaginative conception of the true function of a mural.

This mural completely spanning the upper space of the end wall, gorgeous in surface and telling its message in simple pictographs, is a great achievement. That B. C. Binning is a consummate architectural decorator goes without saying; but here is a new Binning in magnificent Venetian mosaic, a masterpiece in Canadian or any other terms and an exciting example of inspired co-ordination between architect and artist.

And guess who did this building? I am told—and I am most happy to acknowledge—the same architect who did the post office.

JACK SHADBOLT.
461 N. Glynde.

The other commission was the creation of a large mosaic mural in the entrance lobby of a new Vancouver radio station, CKWX, built in 1954.[26] Like the O'Brien mural, this one also suffered the fate of belonging to a building that was demolished after only a few decades of existence. However, whereas the O'Brien mural disappeared after its removal,[27] an awakened preservation consciousness in Vancouver inspired a group of art and architecture lovers to campaign successfully for the saving of the CKWX mural, which now is stored at the University of British Columbia and slated to be installed in a future university building.[28]

The mosaics on the B.C. Electric Building (later known as the B.C. Hydro Building) continue to enjoy their original life on the building, which has since been converted to a residential condominium (renamed The Electra). The architect Paul Merrick altered the configuration of the building's curtain wall, but carefully preserved the mosaic surfaces of the entrance level. However, Binning's work on the substation, which still stands, was sadly obscured after an internal explosion in 1985 when B.C. Hydro, for safety, replaced the glass of the facade with Plexiglas, which soon darkened to near opacity.

Even as Binning was in the midst of carrying out the commissions for some of his most important murals, he had to struggle to convince art committees of the rightness of his choices of colours and materials. He remained adamant, firm and articulate, and convince them he did.

The saga of the Binning murals might today be considered a small event in Canada's artistic history, but its place in Binning's personal history is crucial. By 1963, when Binning was commissioned to advise on the colour scheme for the new Port Mann Bridge over the Fraser River connecting Surrey with Coquitlam, he had become acutely sensitive to the distinctive colouration of the land and water along British Columbia's waterways. (He had spent years wandering the coast in his little sailboat, the *Skookumchuck*, exploring and delighting in the ambience of its endless inlets and coves.)[29] He wanted the bridge to contrast with yet respect its natural setting.

Because this bridge will surely become known as one of the most unique and beautiful in North America, special attention should be made with regard to its colour.

The setting, on the Fraser River at Port Mann, as unique and beautiful within itself, competes with the bridge for attention. It is in fact a beautiful bridge in a magnificent landscape.

For these reasons, the accompanying colour scheme is proposed, chosen to set the bridge in contrast with the surrounding landscape, to emphasize its beauty and draw attention to the idea of the bridge as a Portal or Gateway ... Orange is reserved for the centre arched span bringing attention to its graceful curves ... yellow, stresses the long taut horizontal line of the deck ...[30]

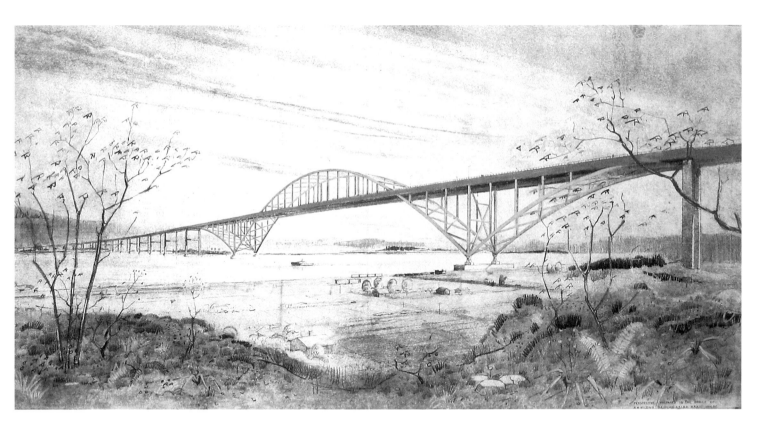

Preliminary colour rendering of the design for the Port Mann Bridge, circa 1963

Binning was also requested to advise on the colour coding of the piping and machinery in British Columbia pulp mills, a coding that was required not merely for aesthetic reasons, but for safety purposes as well. The completion of the murals and other public art commissions reinforced Binning's confidence in his ability to fulfill his obsessive wish to bring good art to the general public and to integrate it into their everyday lives.

Yet his reputation as a campaigner for the serious understanding of the role of public art in the twentieth century did not pass without some vile vituperation in the press by those whose vision of art remained nostalgically attached to the mythicized past. A typical manifestation of Binning's battle of Modernism against the philistines occurred in 1952 when Major J.S. Matthews, the Vancouver city archivist, urged the erection of a statue of Lord Stanley in the eponymous city park, a jewel of Vancouver's urban scene. Binning was not at all against the placement of sculpture in the park, but objected to the mawkish sentimentality of the proposed statue's design, which would have been a life-size "realistic" effigy of Lord Stanley gesturing to the heavens in thanks for the Maker's gift of the natural beauty surrounding him.[31]

Binning once summed up his attitude towards public responses to the arts as epitomized by three types of people: "1. Those who have no interest in [the arts] and possess an inborn hatred of the spirit. You can't do a damn thing about them. As soon as I detect I am talking to that type … I clam up. 2. Those who may not be able to paint or write poetry or music, but who just love anything connected with the arts … They don't need me, or anybody else to help them along. 3. The people who are curious, who may not know much about the arts, but who are ready to listen if approached in the right way … those who eventually become leaders in the community. Those are the people I've always thought we should go after—to educate them in the arts and the appreciation of the arts."[32]

While Binning's artistic endeavours reflected his love and understanding of coastal British Columbia, his awareness of and curiosity about other cultures helped to crystallize his own philosophy of art. He was always especially attracted to Japan and the hints of its culture that touched the shore of Western Canada. He often referred to the delight he had experienced as a youth when he wandered to the port where ships from the Orient were unloading products destined to find their way into nearly every home on the coast. The sights and smells that he experienced during those contacts with lands across the Pacific remained among his most nostalgic memories. Adding to his

experience with things Oriental was his later relationship with his father-in-law, an importer of goods from the Far East. "This city has always been influenced by the Far East," Binning told an interviewer. "Our only physical contact with any foreign land came to us by way of those great *Empress* liners which docked at the foot of Granville Street."[33]

As his knowledge of Japan and its arts increased, Binning became more and more admiring of Japan's ancient and refined attitude towards art and craft, something he believed should be better known in Canada. In the Japanese approach to architecture, art and craft, he saw, as did a growing number of adherents of Modernism, a corroboration of much of what Modernism was striving to achieve. To Binning, the Japanese temperament seemed akin to his own. "There is a rightness about them, and there is a joy in their lives … The simplicity of their lives, the objects they make, and the buildings they make and live in—all of this has a great attraction for me … There is a certain quality of Buddhism which [seems] far more joyous a religion than Christianity. [My wish] to be gregarious and, on the other hand, to be private now and then, and away from it all, is awfully similar to the Japanese."[34]

In 1958 the Binnings made their first of several visits to Japan. These visits led them to an acquaintance with Professor Shuichi Kato, a knowledgeable scholar of Japanese culture, whom Binning invited to teach in the Fine Arts department of UBC. They also became close friends of Bishop Kojo Sakamoto of the Kiyoshi Kojin Seichoji Temple in Takarazuka. The bishop was a consummate artist in calligraphy, and Binning was

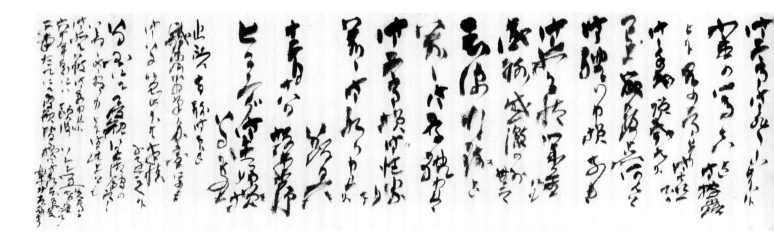

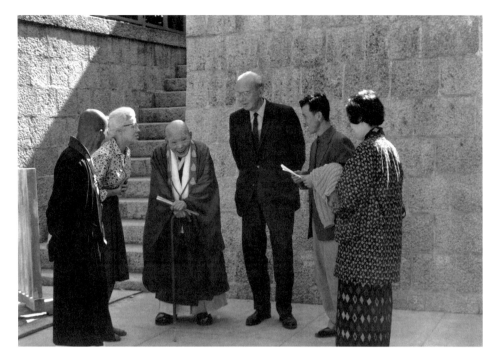

Jessie and Bert Binning meet Bishop
Sakamoto (centre) in Japan, 1958

below Calligraphy letter to the
Binnings from Bishop Sakamoto,
circa 1958–59

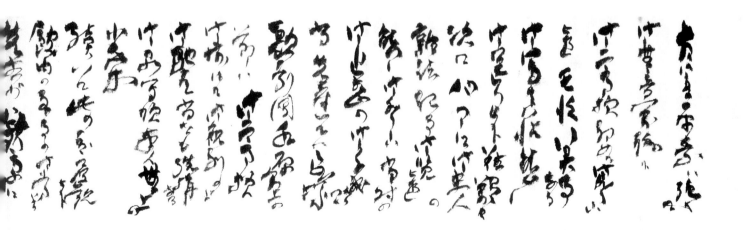

able to bring him to Vancouver and to mount an exhibition of his calligraphic scrolls. The artist presented the Binnings with one of his finest works, which Jessie later donated to the Vancouver Art Gallery.

The Binnings' admiration of Japanese culture also led to a major undertaking at the university. With the ever-faithful support of President MacKenzie, Binning consulted with the Japanese consul in Vancouver, Muneo Tanabe, the local Japanese-Canadian community and the Japanese government to gather the funds and expertise to build a spectacular Japanese garden on the UBC campus. Begun in 1958, the Nitobe Memorial Garden was designed by one of Japan's most respected landscape architects, Kanosuke Mori, a professor at Chiba University. Opened in 1964, it is considered one the most authentic Japanese gardens outside of Japan.

Binning also became fascinated with the work of the Japanese artist Tessai, who had worked contemporaneously with Cezanne. Binning saw an intriguing relationship between the two artists and arranged an exhibition of Tessai's work in Vancouver. He also gave several lectures on the artist in Vancouver and Japan, emphasizing the mutual influences of Eastern and Western art.

As the fifties came to a close the isolated character of Vancouver inexorably began to change from that of a decidedly unsophisticated city. With its antiquated drinking laws and its lack of cultural activities, Vancouver had been until this time "at land's end," too far from the cultural amenities available elsewhere to be considered seriously within the family of important world cities.[35] Bert Binning played a major part in the initiation and inspiration of this cultural change, which resulted in the period 1955 to 1970 being referred to as Vancouver's "Golden Age."[36] He became a veteran in the campaign to bring Vancouver's culture into the twentieth century, a battle joined by many Vancouver families concerned that their children grow up and learn in a more sophisticated and cultured environment than that which existed when they first settled in the city.[37] It was these families who, from the 1920s and '30s through to the 1950s, had urged and supported the founding of such institutions as the art gallery, the symphony, a chamber music society, an opera society, a community arts council, the university school of architecture and, of course, an independent art school.

In 1958, these early Vancouver families saw their efforts beginning to thrive. But most cultural events happening elsewhere were still coming only sporadically to British Columbia.[38] The original group of cultural supporters was now joined by an

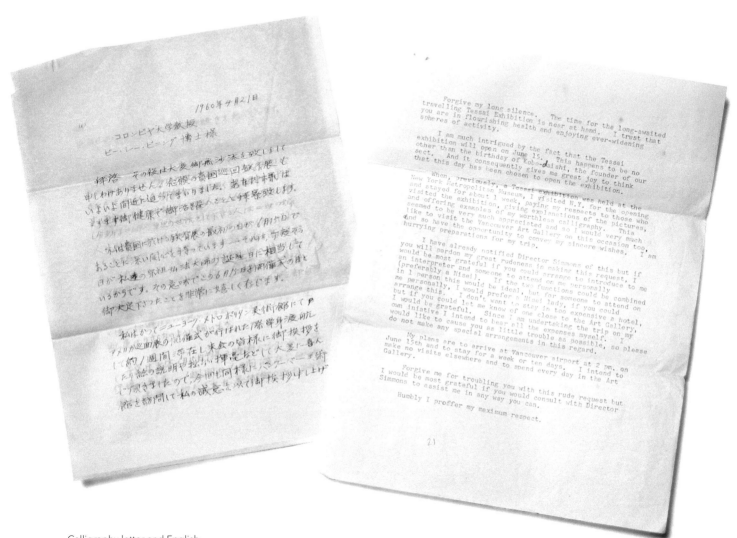

Calligraphy letter and English
translation to the Binnings from
Tessai, April 2, 1960, regarding
his upcoming visit and exhibition
at the Vancouver Art Gallery

active, wealthier knot of Europeans who had escaped to Canada during the period of war and totalitarianism in Europe. They too deplored the lack of vital contact with the greater world of the arts that was still evident in this "distant" place. In an attempt to spur international arts celebrities to come to the city, Iby Koerner, the Hungarian-born wife of Otto Koerner, a member of a philanthropic Czech family that had settled in Vancouver, invited Nicholas (Nicky) Goldschmidt, "a musician with a flair for administration and … drive,"[39] to travel abroad and gather a glittering array of stars. The intention was to create a festival with a crowded schedule that would be an impressive explosion of world talent. The Vancouver International Festival, repeated over the next several years, kindled a veritable feeding frenzy for those Vancouverites yearning for contact with the living world of the arts, a contact commonly enjoyed east of Saskatchewan but still intermittent in Vancouver.

At the University of British Columbia, an effort to attract important visiting arts practitioners for the enlightenment, entertainment and education of the students was already well under way. Started in 1951, a Fine Arts Committee assembled by Fred Lasserre began a decade of programs of serious arts presentations, which were scheduled mainly for the noon-hour break between classes. The committee was comprised of both students and faculty from the various arts departments. Poetry

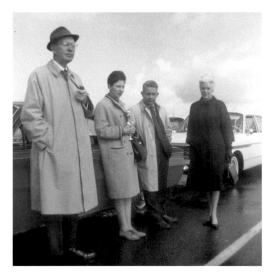

Bert Binning, Belinda McDonald, Don Jarvis and Jessie Binning en route to Victoria to jury the Canadian Group of Painters show, circa 1960

readings, concerts, art exhibitions and dramatic performances were held around the campus. Binning chaired and provided both the impetus and the general administration for the committee until 1960. At the meeting of that year, he, together with like-minded students and faculty who were encouraged and inspired by the success of the Vancouver International Festival, discussed the possibility of creating a university festival that would be a crowded program of art events of more than one hour a day over several days.

At this meeting Binning steered the discussion towards a novel idea. The Vancouver International Festival emphasized experiences with the great arts of the past. The university festival would distinguish itself by emphasizing the contemporary, the avant-garde and the experimental. It would be called the UBC Festival of the Contemporary Arts and would take place early in the 1961 spring semester. Binning's knack for stimulating the students, cajoling the university administration and convincing public and private funding sources made it possible for students and faculty to travel on recruiting trips to attract the most prominent artists who would enrich the festival programs. The committee was able to offer the participants travel expenses and honoraria, but most were happy to be a part of the festival for very little money. The sense of euphoric optimism and promise these programs inspired in those who planned and executed them, together with the enthusiasm of the participating artists, was intense and enormously invigorating. Several students on the organizing committee went on to become prominent members of Canada's cultural scene.

The first festival was a resounding success, attracting wide audiences from the general community as well as the university. "It was a wonderful thing to have on campus," Binning proudly reported to President MacKenzie.[40] The excitement and renown of the UBC festival reached its peak in 1964 and 1965. The 1964 festival featured Marshall McLuhan with reflections of his observations as revealed in the contemporary arts. The reverberations of the so-called McLuhan Festival carried over into the next year's festival, which by now had attracted the attention of the press beyond Vancouver. While the 1965 festival filled its program with visits from a brilliant roster of avant-garde notables, one event intrigued the journalists of *Maclean's* magazine in Canada and journals such as *Harper's* and *Life* magazine in the U.S.[41] It was also cynically commented on by Tom Wolfe in his book *The Pump House Gang*, but later carefully described in a biography of McLuhan by Philip Marchand and in

McLuhan in Space, by Richard Cavell.[42] "The Medium Is the Message" festival production continued to be mentioned for decades in articles referring to McLuhan's influence on the arts.[43]

The event in question was intended as a modest demonstration of the use of contemporary media as employed by a variety of experimenters in various arts. The idea was conceived by a group of artists involved with the planning of the festival, who named the event "The Medium Is the Message," the title of one of McLuhan's books and a McLuhan phrase that had become a popular slogan, referring to his theory of the role of non-literary media in contemporary life. The event, inspired in part by the art "happenings" current at the time, was staged in a barnlike armoury building on the campus. It brought together in a single space a half-hour of simultaneous demonstrations of avant-garde film, music and dance lit by a mass of constantly changing abstract colourful slides painted directly on film by the artist Takao Tanabe and aimed randomly by a number of students handholding twenty or more slide projectors strategically dispersed above and about the activities. The colourful projections, constantly moving, changing and intermingling, transformed an array of long, raised and lowered white banners, together with the performers and visitors, into a magical world. The ceiling-to-floor banners became a three-dimensional stage set through which visitors could move at will.[44]

If "The Medium Is the Message" was inspired by a tenuous reference to McLuhan's philosophy, it was decidedly more closely informed by Bert Binning's life-long dream of an art that might arise from some future integration of all the arts with the most casual experiences of daily life. He enthusiastically supported the presentation and relished its success.[45] Of course, it was to be expected that the attention that such an event attracted would not be entirely positive. Like many of those produced during successive festivals, it intrigued many, puzzled many more and enraged the rest.[46] One unimpressed professor demanded an explanation of a work which "had no beginning, no middle and no end!" To this day the world seems to be divided among Binning's three kinds of people quoted earlier.

The list is long of the notable innovators and experimenters in the arts who participated in the ten Festivals of the Contemporary Arts. It included the poets Robert Duncan, Robert Creely, Robin Blaser, Daryl Hine, Gerd Stern and Margaret Atwood (who had not yet published any novels). Among the dancer-choreographers were

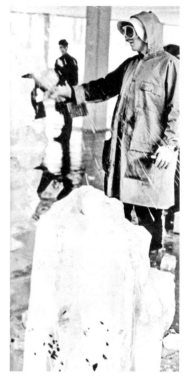

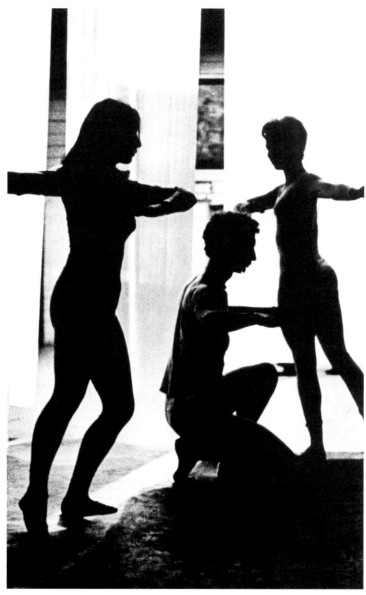

top Sherrard Grauer participating in the "Art in Action" demonstration at the Festival of the Contemporary Arts, 1965. Painters, sculptors and craftspeople worked under the gaze of the public.

centre Dancers, choreographed by Helen Goodwin, silhouetted against long translucent curtains during the simultaneous demonstration of the contemporary uses of media, UBC Festival of the Contemporary Arts, 1965. The public moved among the colourfully lit curtains and the dancers, who created animated bas-relief tableaux by pressing against a large jersey cloth stretched on a frame.

right Iain Baxter carving blocks of ice with an acetylene torch during the UBC Festival of the Contemporary Arts, 1965

Art Becomes Reality, the first large-scale exhibition of pop art in Canada, at the UBC Fine Arts Gallery as part of the 1964 Festival of the Contemporary Arts. The show was based on the collection of Mr. and Mrs. Bagley Wright of Seattle.

Helen Goodwin, Ann Halprin and Jean Erdman. Erdman's husband, Joseph Campbell, lectured on his book *A Skeleton Key to Finnegan's Wake*. Memorable also were talks by Pauline Kael and films by Stan Brakhage. The 1964 festival dominated by Marshall McLuhan and the subsequent one inspired by his revolutionary observations were the high points of the festival's history. Performances by the San Francisco Tape Center, a group experimenting in electronic music, and the art exhibitions of Bruce Connor and the group show Art Becomes Reality (the first major pop art exhibition in Canada) instigated shock, surprise and much comment.[47]

The dream was in the air of the emergence of a new art arising from the serious interrelation of all the arts. In 1967 one hundred leading figures of Vancouver's art world joined to form a society, which they named Intermedia. The society was to be dedicated to the encouragement and support of projects that reflected a professional attempt to integrate the so-called disparate arts. Curiously, Binning's name does not appear among them. The onset of ill health at the time may have convinced him to reduce his activities. He resigned his position as director of the Department of Fine Arts not many months later.

While numerous specialized art festivals now flourish in Vancouver, changes in the city's cultural life and in the interests of students towards the end of the 1960s foretold the weakening of inclusive arts festivals. The need for such efforts to attract major arts events declined with the development of the city, its increased population and its consequent burgeoning of arts presentations throughout the year. On the campus, the growing politicization of student concerns (considerably galvanized by the Vietnam War) began to leave students with little time or energy to be concerned with the arts, and student audiences for the arts dwindled. The student newspaper, the *Ubyssey,* which heretofore had assiduously covered campus arts events, turned less and less

attention to non-politically oriented news. A student periodical called *The Artisan,* devoted to news, discussion and criticism related to the arts, ceased operation entirely. Added to this was the youth movement known as the "Hippy Revolution." While instigating a social consciousness which, in its earliest manifestations, had turned the young towards a vigorous interest in the arts, the "revolution" later began to include the "established" arts institutions in its general resentment of all things they believed to be in the grip of a previous generation, anathematized in the slogan "Don't trust anyone over thirty!"

The aggressive aspects of "Hippy" philosophy were often manifested in belligerent political activism and an understandable drive to protect Canadian identity and culture. "Establishment" institutions of whatever philosophy or intention became fair game for playfully humorous but sometimes violent disruption—or active disdain.

The zealousness to shatter the domination of the powers-that-be turned much of its resentment against influences from south of the border. Inviting American artists to perform in Canadian universities, previously welcomed, now came to be viewed in some youth circles with suspicion and grumbling hostility. Ironically, Binning was less concerned about American influences. Regional integrity was more important to him, even to the point of being more skeptical of the influence on British Columbia of eastern Canada and its implied British-dominated culture, which he felt was alien to the culture of the West Coast. After the 1966 festival, the members of the organizing committee in their post-mortem comments noted a loss of lustre in that year's festival.[48] Student activists impatient with the "arty" character of the festivals argued to use the festival events to further "the revolution,"[49] or at least to transform the festivals into mammoth parties to entertain masses of students in less mind-taxing events than avant-garde productions.[50]

The struggle to prevail within an atmosphere of hostility was discouraging and enervating. Binning's soldierly courage and determination sustained his weary patience and tenaciousness throughout his life. His unending support of new generations entering the fray had a deep and lasting influence on the cultural life of Canadians, and produced a parade of leaders in the arts whose influence in their communities continues to be stronger than ever. But every battle takes its toll. Even Binning began to tire, physically, if not mentally. When he began to leave the festival planning and execution to others, the festivals declined in seriousness

and lost the attention of the student and non-student public. The last festival took place in 1971.

Murray Farr, one of the students who participated in festival planning and who later became an important impresario, wrote:

B.C. Binning appeared to me as a "philosopher king" in the classical sense in his dealings with other human beings. He chaired meetings of the committee that directed the Annual Festival of Contemporary Arts with a deft and sure hand: he was a shaper and moulder of men and their ideas for coming together in a celebration. He was always Mr. Binning, not "Bert" or "Sir" [to the students], and his sense of order was firm, necessary and friendly. In planning the festivals, budget was definitely a guiding consideration, but Mr. Binning placed ideas and their expression foremost.[51]

The writer George Woodcock added the following:

What one remembers most vividly from Binning's years at UBC are the Festivals of Contemporary Arts which he organized … and which year after year presented extra-ordinary conjunctions of *avant garde* events … Bert Binning presided over the occasions with an exuberant jovial zest, organizing events, entertaining guests, chairing lectures that interested him (I remember him beside me when I talked of Apollinaire, of whom nobody but Bert and I seemed to have heard) … The total effect of the festivals … was to help change the world of the arts in Vancouver radically, from a provincial to a cosmopolitan one.[52]

It would be unfair to put all the blame for the decline of the festivals on the dominant politicization of the students. Just as with the Vancouver International Festival, the very success of the first five UBC Festivals of the Contemporary Arts was bound to sow the seeds of the festival's demise. The publicity they engendered and the growing awareness of Vancouver as a viable centre for the appreciation of the arts accomplished what Binning and his contemporaries were striving for all along: the maturity of their community as a sustaining audience for the arts. Impresarios had become emboldened to bring impressive productions to the city, and combined with a developing confidence in local creative talent that spurred the initiation of an explosion of galleries, production companies in theatre, opera and ballet and other cultural activities, the need for all-inclusive arts festivals became far less urgent.

Over the years, Binning's campaign to establish a concentrated arts centre on campus was gradually brought to fruition with the erection of an art, architecture and community planning building in 1962, followed by the completion of buildings for theatre and music as well as an anthropology museum nearby. The final unit for the centre, a proper art gallery, which Binning tirelessly campaigned for and dreamed of seeing in his lifetime, was not built on the campus until several years after his passing.[53]

Binning has been commemorated at UBC by the B.C. Binning Memorial Scholarship, established by a committee headed by Geoff Andrew in 1976 and first offered in

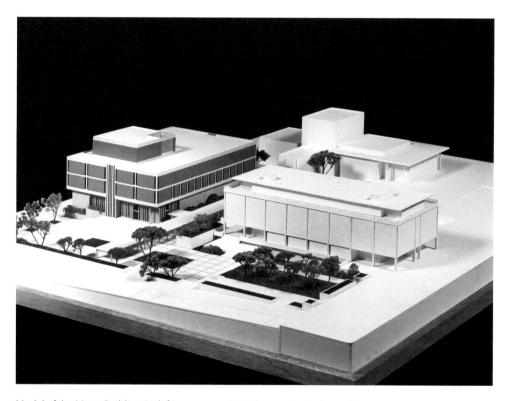

Model of the Music Building (at left) prepared by the architects Gardiner Thornton and Gathé Associates showing the first three buildings of the Fine Arts Complex at UBC, circa 1963. The empty site facing the Fine Arts and Theatre buildings was reserved for the gallery building, which was delayed until many years after Binning's death.

1980. As well, his name has been given to the larger exhibition space of the civically supported Contemporary Art Gallery built in 1999 in Vancouver. However, the construction of a new University Fine Arts Gallery remained at the bottom of UBC priorities until 1995, when a new gallery opened. Largely subsidized by a private donor, and named for the donor, it omitted any mention of Binning. The moment, on the occasion of Binning's retirement, that Alvin Balkind melancholically labelled "the end of the Binning Era," was already a thing of the distant past.[54]

Binning's character, his power to influence, and the romantic basis of his persona modified by his love of classical rationalism affected the lives of his students and those around him. Everyone benefited from his art and the arts programs he had spiritedly and effectively defended and supported with devotion and determination, tempered with much good humour and joy.

Bert Binning,
circa 1973

ADELE WEDER **THE HOUSE**

THE STORY OF THE BINNING HOUSE is crystallized in a vintage photograph from 1945, a few years after its construction. Glass doors are flung open to a swathe of giant conifers, while on the terrace, a man and a woman bask in domestic languor as sunlight pours into the room. The man and woman seem to be both outside and inside; even the living-room carpet, mottled by sunlight and speared with the shadow of leaves, reads like moss-cover in a forest. The image is a luminous vignette of post-war Modernism and, to borrow a phrase from critic Adam Gopnik, a catalogue of our desires: she loves me, it won't rain, nobody dies.[1] Such is its venerated status that to a cult of architectural critics and admirers, it is known simply as "the House." It has stood serenely in this leafy slope of West Vancouver for the past sixty-five years, even as the neighbourhood transforms harshly around it. Its future longevity owes something to the conferral of official heritage status in 2000,[2] and its early renderings and blueprints have been archived for posterity at the Canadian Centre for Architecture in Montreal. But the preservation of the House to date is due to the steadfast care of Jessie Binning, who lives there still.

B.C. Binning's 1941 bungalow, designed by the artist himself, has become one of the most iconic houses in Canadian history. In its pioneering role as demonstration house for the once-new Modern idea, it is an object of near reverence for the heritage and design communities. Its renown has grown over the ensuing decades as successive generations of historians, students and visiting architects make their pilgrimages to the House.

Here in the twenty-first century, with Modernism long entrenched in everyday life, it is difficult to grasp how revolutionary its basic tenets once were to the dark, fusty housing approach of previous centuries. First and foremost, the Modern house would emphasize physical and mental health: large windows and open spaces would provide light, airiness and ease of cleaning. Second, the Modern house would be more affordable, by incorporating factory-made components, multi-use rooms, and no ornamentation. Third, the Modern house would emphasize a clear, balanced composition of simple volumes with minimal mixing of materials on a single surface.

While the House is thus clearly modern—one of the first truly modern houses[3] on the West Coast, in fact—any further categorization becomes a challenge. Critics and historians fall back on the rhetoric of early Modernism, describing it as Purist or

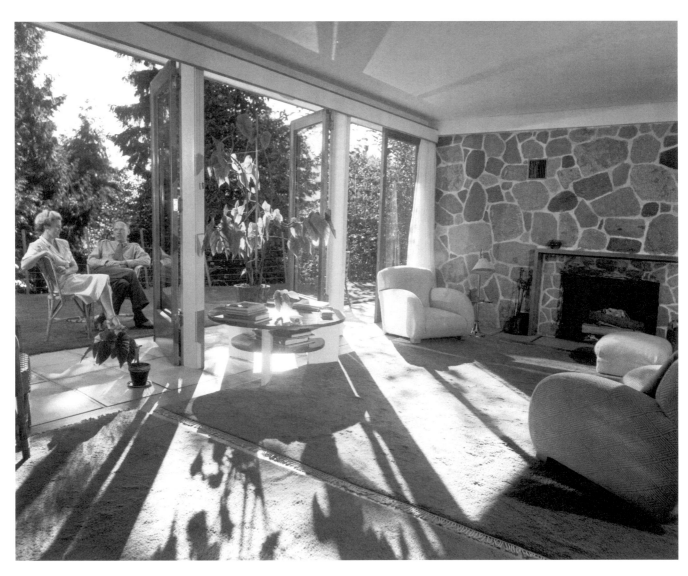

Binning House, view from
living room to terrace, with Jessie
and Bert Binning, 1945.

Blueprint, early plan of Binning House.
Elements of this scheme were signifi-
cantly altered in the final construction,
but its general form and approach were
maintained.

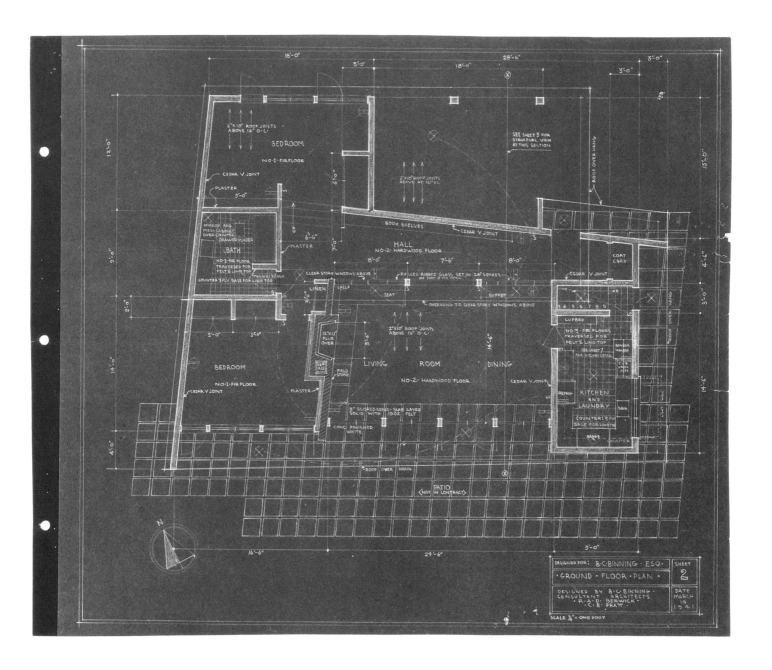

Rationalist or Functionalist. Strictly speaking, the Binning House is not really any of the above, but quite in its own category.

The House itself is compact, off-white and—to contemporary eyes—unassuming on the surface. As is the case with most Canadian icons, though, its outward simplicity conceals its marvellous innate eccentricity. It is a house that appears to embody the rigorous geometry of Modernism, yet somehow it seems organic. Its interlaying volumes bespeak clarity, and yet invoke enigma.

The experience of walking through the Binning House generates a feeling of intrigue. First, you are standing at the front entrance, turning to behold the gallery-corridor that fans out before you. The impression is one of welcome, of being situated at the launch of a narrative. As you step into the gallery, the living area opens up on your left to display a theatre of subdued light, with the living area as proscenium and the glass wall presenting a backdrop of tree, sky, and ocean.

The once-expansive ocean view is now contained by a framework of encroaching greenery. Still, something leads your eyes towards it, beyond the obvious lure of the scenic. Phyllis Lambert, founding director of the Canadian Centre for Architecture and a long-standing champion of the house, attributes this allure to Binning's use of painting as a strategy for experiencing space. "The approach begins with the fresco at the entrance to the house," observes Lambert. "After entering and being forced to turn to the right by a blank wall, the visitor is drawn to a second wall painting at the end of an angled and curved[4] corridor. In being drawn forward by the second painting, the visitor is propelled toward the burst of light. When no longer compressed, space opens to the outside beyond the glass doors and onto the lawn allowing a view of the bay beyond dark conifers. At this place of opening, a third painting along the curved spine wall, and perpendicular to the other two, asserts its role as a boundary—and as a means of gently propelling the visitor toward the lawn."[5]

The more private zones—bedroom, study area and studio—have borders, implicitly delineated by the placement of artworks. But the visitor who crosses these borders enters a spatial experience that is, in some ways, even richer. From the studio's subtly expanding clerestory window to the fireplace wall that anchors the house, the architecture embodies curiously acute and oblique angles, as though wilfully defiant of forming a proper 90-degree angle. The oblique fireplace wall meets the glass-door facade at an acute angle, which in turn generates a chorus line of rhomboid paving

stones. Sometimes it takes a measuring tool: ruler, level and right angle—to ascertain this subtly distinctive characteristic of the Binning House: far from being composed of a series of rectangular boxes, it teems with inflected angles.[6]

The Binning House is an unusual house in many ways for this era. In the context of Vancouver circa 1940, the Binning House was an odd sight indeed: a house that didn't fit any existing idea of what a house should look like. It lacked the traditional cues— pitched roof, gables, decorative window shutters—that marked a building as a *house*. Some of these cues were just architectural add-ons having nothing to do with the region and its climate. But even as Vancouver grew and the regional housing shortage became more acute, variations of the traditional house had remained the norm. Tradition—or at least the *idea* of tradition—ruled the marketplace, then as now. Even into the first years of World War II, architects and the public focussed their energies and resources into reproductions of nineteenth-century styles.

Bertram Charles Binning was an architect *manqué*. When he was of college age in the late 1920s, there was no architecture school west of Manitoba. Illness and financial constraints sidelined his thoughts of heading east to study, but throughout his life, an architect's sensibility informed all of his work. During a summer session in Oregon studying sculpture with Eugen Steinhof, he wrote a love letter to Jessie with interwoven commentary—not on sculpture, but on his everyday architectural environment. "Everything is very standard so to speak," he wrote of Omega Hall, his dormitory residence, "but on the grand manner—vaulted arch passage ways— high ceilinged & beamed dining halls panelled doors, a Tudor sort of heavy furniture, all very wonderful & college & 'oxford-istic' but gives you the pseudo feeling—a little over stressed—at least to me … at anyrate here's the plan of MY STUDY."[7] At the bottom of the letter is his scribbled floor plan of the dorm room complete with furniture placement, north-south direction indicator and a suggested reconfiguration.

Decades later, Binning would wistfully refer to his early career aspirations, but usually concluding with measured gratitude that he ended up as an artist. Yet the fact that his career was primarily in art, rather than architecture, was in certain ways an advantage in designing a groundbreaking home. Working on the periphery of the design profession, he would not have been pressured to undertake practical but unimaginative projects, nor would he have been pressured to align himself with architectural fashion or ideology.

46

A 1936 letter home to Jessie contains an annotated sketch of his study-room with a note that demonstrates an architect's compulsion to document and alter his environment: "I think I will move this desk over where the hat rack is."

with a pal (MALE) from Alaska. Everything is very standard so to speak but on the grand manner — vaulted arch passage ways — high ceilinged + beamed dinning halls pannelled doors, a Tudor sort of heavy furniture, all very wonderful + college + "oxford-istic" but gives you the psudo feeling — a little over stressed — at least to me — from what I have seen everything is that way here — more about it later —— at anyrate here's the plan of MY STUDY. It is obviously for two blokes but I'm king here for 6 weeks.

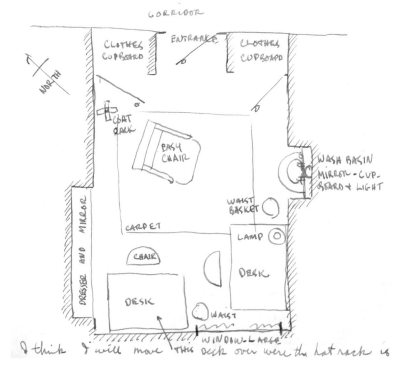

I think I will move THIS desk over were the hat rack is

Modernism had already emerged in Continental Europe after World War I, and by the mid-1930s, the word had seeped north to England and west to the Americas. In California the transplanted Austrian Richard Neutra was championing the open plan and indoor-outdoor living. Around Vancouver, though, the climate was still rather sleepy. The primary catalyst for the Modern house—the need to build affordable housing for the masses—was as big an issue on the Canadian west coast as elsewhere. But the response was limited to low-budget echoes of the Arts and Craft bungalow or manor.

Meanwhile, Bert Binning, aspiring painter, had married Jessie Wyllie and wanted to build a house for himself and his bride. They had been considering various housing styles, from Cape Cod to Craftsman, but a final decision would come later. Before they could settle on a design for the house, Binning had taken leave of his teaching position at the Vancouver School of Art to do a year of study abroad.

The evolution of the Binning House began with this life-altering year, which took the Binnings to London, England, in 1938, and included travel to Continental Europe. The year was capped with a formative short stay in New York. Bert and Jessie Binning boarded the *Royal Britannia* for a sojourn that upended their notions of art, architecture and conventional living.

Binning had been lured to London by the prospect of studying with the celebrated Purist painter Amédée Ozenfant, whom he revered. As it turned out, Ozenfant was en route to a sabbatical year in Seattle; their ships almost literally passed in the night. At the Ozenfant Academy of Art, Binning instead found himself under the wing of sculptor Henry Moore.

As well as the Ozenfant Academy, Binning attended two other schools, rounding out his year with further studies under the notable painters Mark Gertler and Bernard Meninsky. Binning did manage to meet Ozenfant when he returned from Seattle to London for a short time, and Ozenfant would remain an authoritative figure to Binning for the rest of his life. But it was Moore, who was then breaking new ground in sculpture, with whom Binning would find the most direct artistic kinship.

In the late 1930s, Moore's sculptural explorations were swelling with dynamic tension. (See *Maquette for Head,* 1937, page 49.) Inspired in part by pre-Columbian sculpture, Moore was inclined towards direct carving, a laborious approach that infused his sculpture with a sense of vitality.

Moore's close friend and colleague, Berthold Lubetkin, was arguably the sculptor's architectural counterpart. A Russian émigré and artist with neo-constructivist leanings, Lubetkin headed the Tecton Group. Like Moore, Lubetkin explored the use of oblique lines, organic curves and the solid-void relationship in ways that many architects of the day found capricious, incomprehensible or both. Moore and Lubetkin also campaigned vigorously for the integration of art and architecture, as Binning later would.

Around that time, London was home to a number of Canadian expatriates and soon-to-be Canadians whose socializing revolved around the activities of the Architectural Association school of architecture, among them Peter Oberlander, Peter Thornton, John Bland, Harold Spence-Sales and Wells Coates. Oberlander remembers Lubetkin as "a highly significant influence on that whole group of Canadians. [He] was very enigmatic and highly charismatic … the leading light of the A.A."[8] Lubetkin had in his employ a young architect named Fred Lasserre, a key designer in Lubetkin's office. Lasserre would later move to Vancouver and establish the University of British Columbia School of Architecture. He became a close friend of Bert Binning and worked with him, ultimately hiring him as a professor at the school.

Maquette for Head, by Henry Moore, original plaster, 1937. During this period, which coincided with Binning's study under Moore, the British sculptor's work typically contained organic curves and oblique angles.

Binning arrived in London just at the moment when the city was opening its arms to experimentation. On both sides of the English Channel, the talk of the time was, first and foremost, all about *space*—its philosophic essence, its aesthetics, its scientific and mathematical qualities, and its embodiment within architecture. Architectural historian Sigfried Giedion was undertaking a programmatic study entitled "Space, Time and Architecture" and publicizing his findings in a series of lectures and essays throughout 1938–39. (Its 1941 hardcover publication would become one of the most important books in modern architectural history. Binning's own shopworn copy of *Space, Time and Architecture* is still shelved above his trapezoidal desktop at the Binning House.)

At the time, the twin catalysts of burgeoning populations and wartime destruction set off an explosion of discourse regarding architectural space: how to conceive, distribute, reconsider and reconfigure it.

In the wake of radical new ideas, England's establishment and citizenry had been wary of change, but not its cultural and scientific leaders. London's premier architectural school, the Architectural Association, still offered a beaux arts curriculum, yet between seminars its corridors were filled with talk of the Modern Idea. By the late 1930s, foreign architects were fleeing the economic paralysis and Nazi threat in Europe to settle in England. In 1937, Lubetkin observed a reversal of the usual order of France breaking tradition and England maintaining it: "England, which had so long lagged behind the continent in accepting new architectural and technical ideas, now leads the world in this domain."[9]

Binning, studying and socializing at the periphery of this ideological infighting, would have been distanced from much of the fray but nevertheless intensely receiving it by way of Moore. Moore was already gaining fame and notoriety for his abstractions of the human form and its organic rhythms that featured irregular voids and asymmetric swellings. The young Bert Binning, transfixed by his hero, would soon incorporate these haunting irregularities and asymmetries into his own art and architecture.

Moore's organic approach stood in contrast to the international design community's own *isms*, particularly Purism, Rationalism and Functionalism. Ozenfant's Purism had become much less influential by the mid-1930s, yet continued to inform architectural thought with its unattainable but tantalizing concept of purity. Lubetkin

responded in 1936 with what he called the "Whipsnade Manifesto," arguably an anti-manifesto against the rhetorical dictatorship in architecture. The designer of the Modern house, proclaims the Manifesto, "admits that there is, on the walls of the W.C., a collection of cold-blooded tropical butterflies; while the bedspreads have little bells sewn on to them to brighten the dreams of the occupants."[10]

The little bells and butterflies—an acknowledgement of life beyond the architect's control—provided a symbolic retort to the pure, rational, functional priests of High Modernism. (Ozenfant's "Purist Manifesto," published almost twenty years earlier as a starting shot, had declared the following: "PURISM expresses the invariant, not the variations … PURISM fears the bizarre and the 'original.'"[11])

This kind of defiant stance would have strong appeal to the more independent-minded artists and architects of the day. Bert Binning was one such artist.

On their return to North America the Binnings landed in New York, which was then hosting and celebrating the World's Fair with a series of concurrent cultural events. On the afternoon of June 4, 1939, Bert and Jessie Binning headed to the brand new 53rd Street building of the Museum of Modern Art and paid 25 cents admission to see a show that would change their lives. The exhibition title, Art in Our Time, was at once boastful and yet straightforward. The content itself rose to its ambitious title, including as it did work by the most influential artists of the previous half-century—Cézanne, Braque, Picasso, Mondrian, Arp, Moore and others. The exhibition distinguished itself as the only event of the World's Fair to include photography, cinema, furniture and architecture—the new art categories of the twentieth century.

The architecture section brought together in one room the titans of Modernism: Le Corbusier, Gropius, Neutra, Lubetkin, Mies van der Rohe, Alvar Aalto, Frank Lloyd Wright, Buckminster Fuller and William Lescaze. It was this section that made the deepest impression upon the couple. Jessie wrote in a letter to her mother that very evening: "It is inspiring to see that Bert's ideas are right along these progressive lines … Even before we went away, Bert was intensely interested in all such things, and since we have been here on our travels, I find that all the ideas that are out there and discussed by men that are years ahead of their time, that Bert is quite at home with them and understands what they are trying to do."[12]

The eponymous brick-thick catalogue to the show still sits on the study bookshelf at the Binning House, a catalogue not only of the exhibition itself but, in some ways,

focussed almost exclusively on detached houses and apartment buildings, housing being the urgent issue of the day. Yet the anonymous catalogue writer also noted the ineffable aspect of *art* within architecture. " 'Functionalism' is surely a word too restricted in meaning to describe modern architecture accurately," asserts the text. "It may be a convenient name."[13]

Binning's year in London would have prepared him to understand and synthesize the varied modern architecture on display at the Museum of Modern Art. And since his vocation was art rather than architecture, a focussed display of these major names in Modernism would likely have been more of an intense revelation to Binning than to a career architect.

The exhibition provided an immediate composite influence, although no individual scheme on display bore a closely literal resemblance to the house that Binning would soon design. The Mies and Gropius homes boasted clean lines and layouts, but not much else that resonates with the Binning House. Frank Lloyd Wright's L-shaped Jacobs House was more about technical ingenuity than aesthetics; it was even bereft of Wright's trademark hearth as an anchoring feature (although Binning would shortly incorporate that feature in his own house). Even the "Superplywood" prefab house by Neutra, Binning's acknowledged hero, offers few hints of Neutra's future influence. It may, however, have reconfirmed Neutra's iconic status in the eyes of Binning, who likely had already seen photographs of other Neutra California houses in journals.

It is Lubetkin's Whipsnade Bungalow plan that clearly stands out from the others in the exhibition: it evokes the Binning House, not so much in terms of literal resemblance as in its sense of intrinsic movement. Each of these two house plans boasts as its focal point a distinctly tapered hallway that generates much of the rest of the plan and imbues it with a sense of motion. Far from Functionalist, the Whipsnade and Binning schemes wilfully depart from the machine-age orthogonal grid. They are emotive and lyrical, like Moore's sculpture and Binning's paintings—architecture deliberately skewed off the rectilinear grid.

Shortly after, settled back in Vancouver, Binning immediately set about designing the House. He had at his disposal *Architectural Graphic Standards,* a 1935 tome describing basic construction methods as well as the precise specifications of beaux arts detailing. There is just one annotation in the entire book: a large red *X* scrawled on the page headlined "Wood Joist & Rafter Sizes." These dry calculations of rafter loads and

Floor plan of the Whipsnade Bunga-
low, by Berthold Lubetkin, from the
Art in Our Time exhibition catalogue.
Binning viewed the plan and photo-
graphs of this 1936 milestone at
the Museum of Modern Art while in
New York in 1939.

Binning House floor plan depicting
the house as it was actually built in
1940, with enclosed studio on ele-
vated grade; repositioned entrance,
kitchen, bedroom and bathroom, and
an unintended bend in the tapered
gallery. The rear terrace tiling
is current.

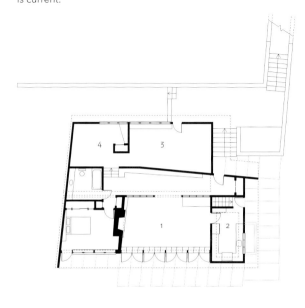

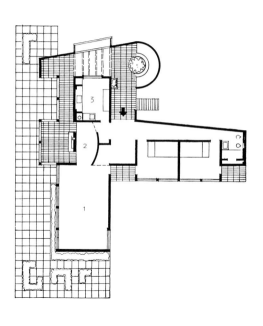

1 living room
2 dining room
3 kitchen

5 0 10 feet

1 living room / dining room
2 kitchen
3 studio
4 guest room / study

5 0 10 feet

detailing. There is just one annotation in the entire book: a large red *X* scrawled on the page headlined "Wood Joist & Rafter Sizes." These dry calculations of rafter loads and measurements would become indispensable for the modern west coast architect.

Binning created more than one plan. His initial scheme placed the kitchen and the bathroom in the reverse order of their eventual construction. (Jessie avers that she convinced her husband to switch the orientation.)[14] Where the original plan specified a carport, the existing house contains Binning's art studio in its place. No trace can be found of any drawing showing the incorporation of the studio and its distinctive clerestory. Most likely Binning made this change and others during the actual construction of the house, seized with the realization that his paintbrush was a more indispensable tool in his life than his car.

The ad hoc process of designing and building his house was more in keeping with the sensibility of an artist than an architect. (His site planning was also rather impromptu: when he wanted an extra few feet of space along the west side of the house, he informally "bought" a strip of plot from his next-door neighbour for $600, without procuring a proper deed or registering the "sale" with the city.)[15] Binning's lack of conventional architectural rigour is evident in the awkwardly steep stairs to the upper studio level (required after he raised the level on the north side of the house during construction)[16] and in the impractically uneven daylight filtering into the studio itself. The House construction could be deemed either artisanal or haphazard, depending on your perspective: in addition to the obviously oblique angles, there are many very slightly off-the-orthogonal angles, by chance rather than design.[17]

Art also manifests itself through the *trompe l'oeil* qualities of the House. Standing at the narrow end of the gallery, the visitor perceives the wall mural at the wider opposite end of the gallery as closer than it really is, because of the foreshortening effect generated by the tapering. And, in the living room, the magnificent vista is emphasized by Binning's splaying of the fireplace wall towards what was once a more widely framed ocean view. In this way, Binning had devised his house as did Lubetkin his bungalow, which, according to the 1939 MOMA exhibition catalogue, "literally *aimed* like a camera at the superb view."[18]

Most emphatically, the House bears the hallmark of an artist with its series of celebrated murals, which Binning painted directly onto the walls. The highly expressive original front-entry mural was, years later, sanded off to make way for a

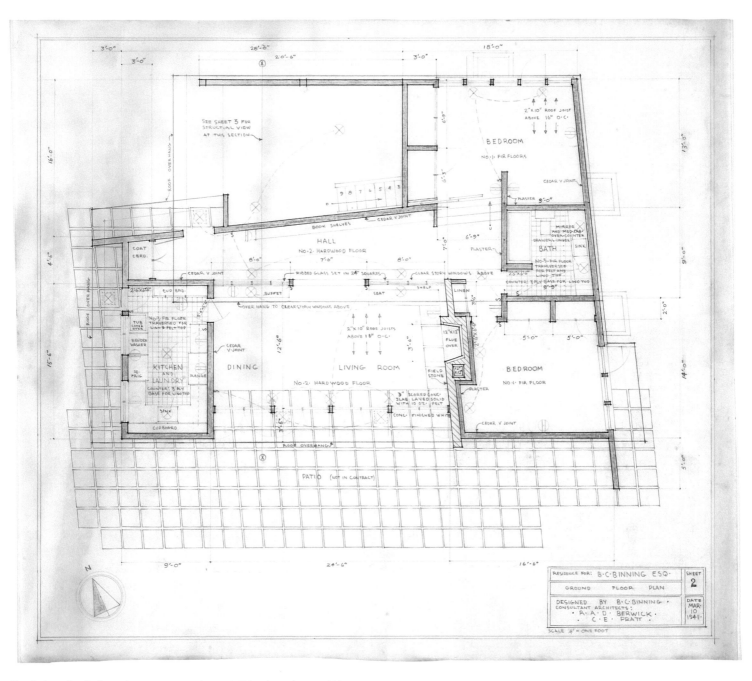

Rendering of main floor plan, alternative scheme, 1940. The main entrance and kitchen in this scheme are located on the west side, with the master bedroom and bathroom on the east; this orientation would be switched in the final construction. This early scheme also indicated an open carport in place of the studio.

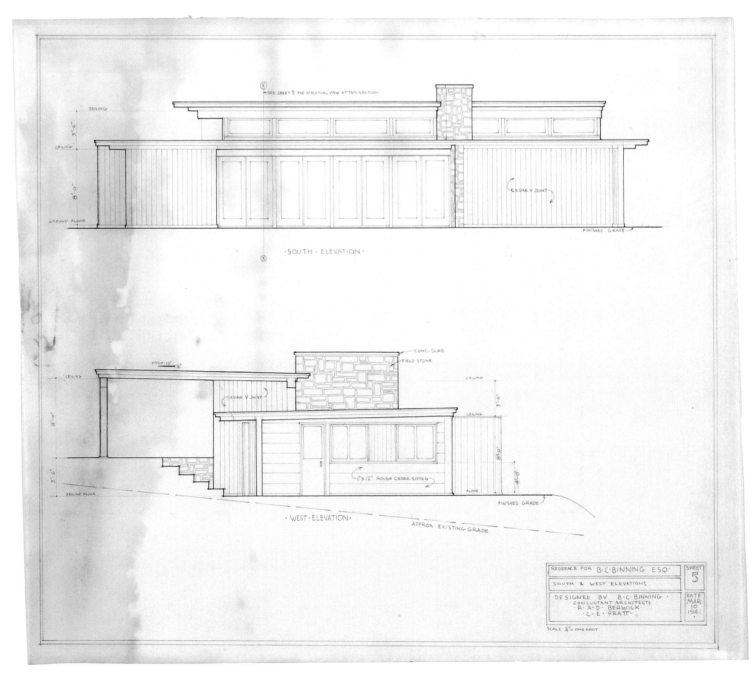

Within the drawing, various labels appear:

- SEE SHEET 3 FOR STRUCTURAL VIEW AT THIS SECTION
- CEILING
- 3'-6"
- CEILING
- 8'-0"
- GROUND FLOOR
- CEDAR V JOINT
- FINISHED GRADE
- ·SOUTH · ELEVATION ·
- CONC· SLAB
- FIELD STONE
- PITCH 1½"
- CEILING
- CEDAR V JOINT
- CEILING
- 3'-6"
- 8'-0"
- CEILING
- 8'-0"
- 1"×12" ROUGH CEDAR SIDING
- FLOOR
- 4'-0"
- GROUND FLOOR
- FINISHED GRADE
- · WEST · ELEVATION ·
- APPROX · EXISTING GRADE

RESIDENCE FOR B·C·BINNING ESQ· SHEET 5
SOUTH & WEST ELEVATIONS
DESIGNED BY B·C·BINNING·
CONSULTANT ARCHITECTS
·R·A·D· BERWICK·
·C·E· PRATT·
DATE MAR 10 1941
SCALE ⅜"= ONE FOOT

Rendering of south and west elevations, Binning house alternative scheme, 1940. The archival elevation renderings show the slight tilt to the roofline, which facilitated drainage, and the built-up platform of earth on which the house sits.

facing page Central gallery of the House, the main defining element of the plan, 1950. The gallery's tapering creates the illusion of fore-shortening.

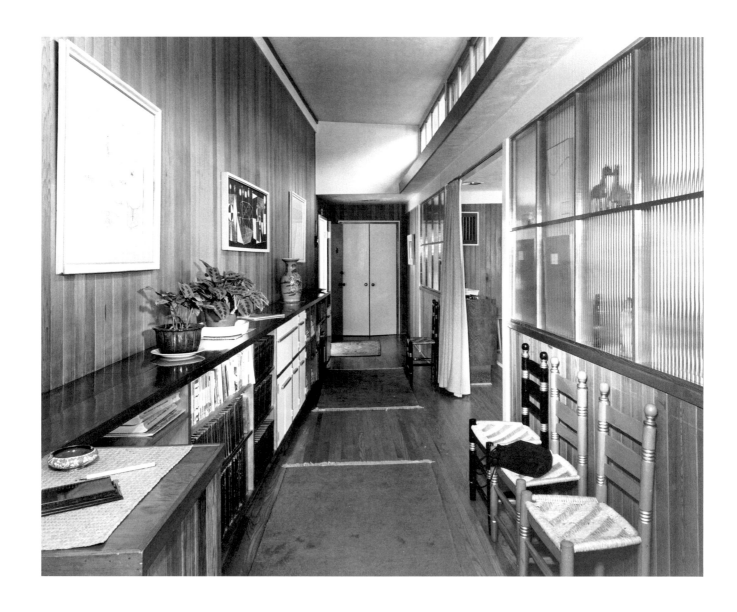

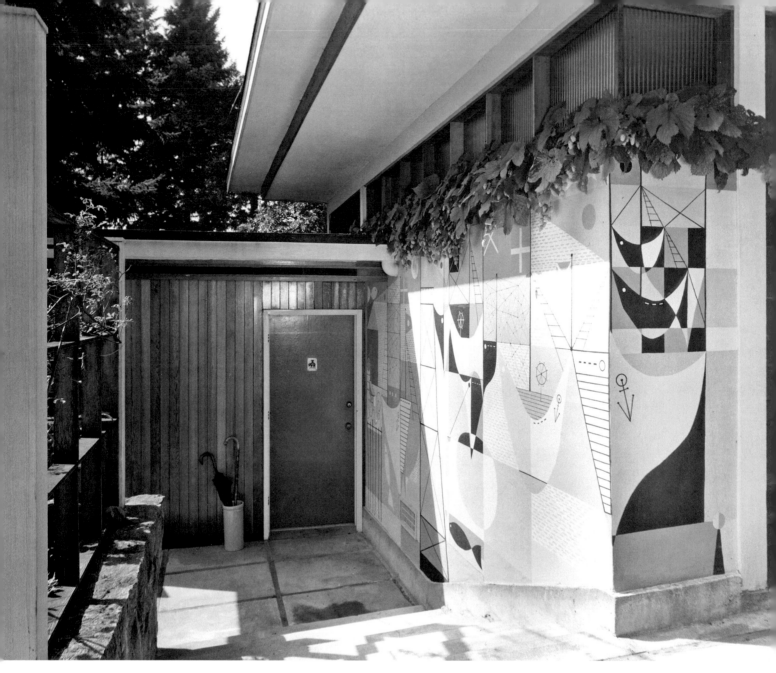

Binning House, entrance facade
showing mural by B.C. Binning,
original unpainted woodwork and
hop vines growing on the clerestory
sill, 1950. The vines were later
removed.

second mural, which in turn was replaced with the stark, highly geometric yellow-and-white composition of the present day.

With its murals, perspectival qualities, and paintings-as-orientation-tools, the Binning House is a hybrid of architecture and art, a category unrecognized by many of the High Modernists. These were the architects that Binning later dubbed the "Denialists," and he railed at their hubris. "They will have nothing to do with me—with murals, mosaics, sculpture or anything else," declared Binning. "They want their work to stand uncompromised, unenriched, in its own architectural grandeur and purity, radiating itself in its own light, space, mass and structure."[19]

Although Binning was the designer of the House, he asked Ned Pratt, a registered architect, to handle the drafting and to sign off the blueprints. The involvement of Pratt, a friend and trusted colleague, triggered a long-standing and false assumption that Pratt himself designed the house. In fact, although Pratt suggested several preliminary schemes, these were so heavily altered or outright rejected by Binning that Pratt cannot be said to have had a significant role in its basic design, as Pratt himself occasionally conceded.[20] That this is Binning's design and his alone is evident in details of the House itself.

It is uncanny how closely the House reflects the experience of Binning's year of travel, from its expanding lines (Moore) to its wall of factory-issue doors (Gropius and the Bauhaus) to its indoor/outdoor ambiguity (Neutra) to its plinthed siting and splayed plan (Lubetkin).

The Binning House appears to burrow into the slope, its roofline just peeking over the hillside as you approach the front entry. Beaux arts architecture tended to ignore the site; some modern landmarks showed exaggerated deference to it (Wright's 1936 Fallingwater, for instance). The Binning House is far more nuanced: it steps down the slope only once; its southern elevation is actually built on a platform of earth specifically constructed for this.

What John Allan wrote of Whipsnade could equally apply to the Binning House: it was not an outgrowth of the landscape as in the approach of Frank Lloyd Wright, nor was it imposed over and above it, as Le Corbusier's *piloti* suggested; "The relationship was to signify neither camouflage nor conquest: it was a dialogue, a benign intervention suggesting, in Lubetkin's favourite phrase, the vision of 'nature tamed, not with a fist but with a smile.'"[21]

In the years to come, Binning would design two more residences: the Keays House and the Harrison House. These two are muted echoes of his own, but Binning would have been far more restricted in a design for someone other than himself. Perhaps the most important legacy of these houses is how they affirm Binning's capabilities as a professional designer. Their execution and ethos (clean lines, open plan, interflowing volumes, even the wink of a trapezoidal desktop) show that Binning was neither a first-time-lucky amateur nor a credit-taker for Pratt's work, but a gifted practitioner in his own right.

Unflaggingly loyal Jessie has, of course, always asserted her husband's authorship of the design, but more importantly, her recollections help confirm the circumstantial evidence. Jessie Binning describes her husband's decision to deviate from the standard grid as very deliberate, aside from the accidental bend halfway down the gallery. She recalls that her husband devised these angled walls to "open up" the rooms, literally to the outside view, but also in a metaphoric spirit of extension. Speaking on this subject once, she allowed herself a rare burst of frustration: "I think he overdid it. It got so complicated; we had to make furniture a special way to get it to fit with the walls. It made things a lot more difficult and more expensive. It was ridiculous!"[22]

The angled components of the House generated a kind of domino effect. The tapered walls compelled Binning to design the built-in headboards in the main bedroom and guest area as trapezoidal shapes; the gesture allows the master bed to be parallel to the bedroom walls. The slight tilting of the roofline[23] required a subtly trapezoidal clerestory window in the studio (see page 17). The clerestory appears at first glance to be "normal," but on closer examination reveals a slowly inflected sweep towards the front facade. This slant is so subtle that visitors usually "see" it as a conventional rectilinear window strip; some observers have even "straightened" its slant in renderings for public exhibitions.[24] Continuing this theme is the scored concrete strip along the south wall,[25] which imitates a line of slant-sided paving tiles. To the visitor standing in the gallery or living room, the trapezoidal faux tiles lead the eye through the wall of doors and onto the terrace. The scored forms echo the geometry of the site itself: a narrow lot shaped like a parallelogram.

Beyond formal and academic influences, the design of the House is informed deeply by Binning's own life, pleasures and memories. Jessie and Bert spent languid days at Gleneagles, the verdant West Vancouver shore where Jessie's family had

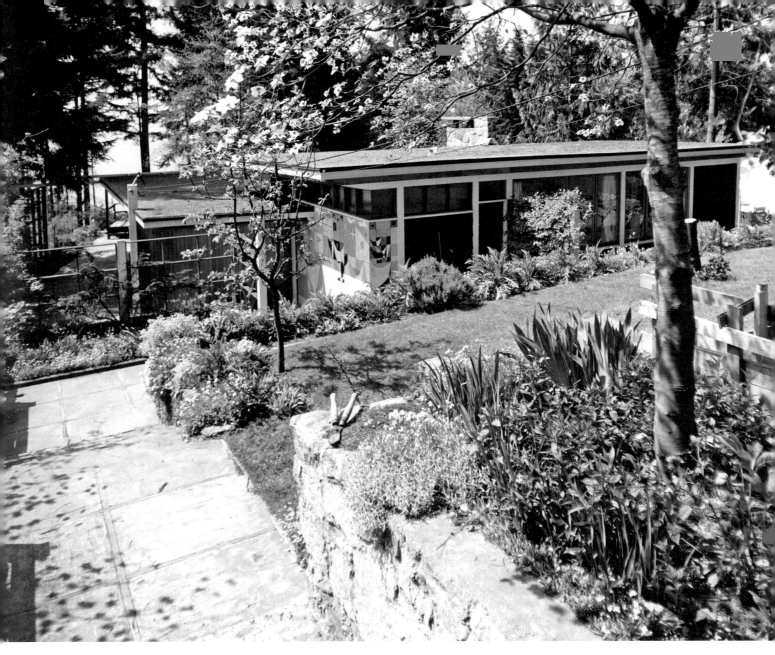

Binning House in situ, 1950. The House is nestled down in the site, half-hidden from the road above, an unusual concept in 1940 when the house was built.

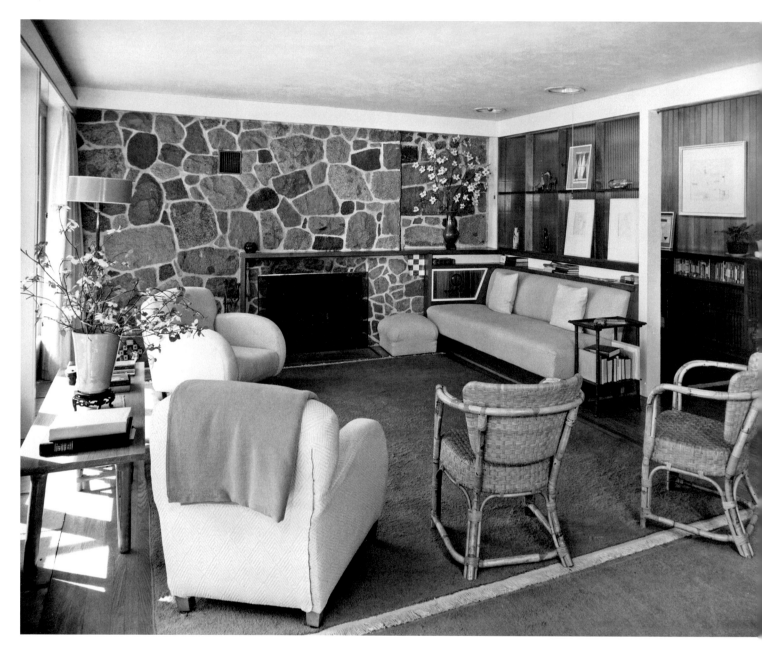

Living room, 1950. The stone fireplace
wall tapers out towards the view,
enhancing the vista and opening up
the space.

facing page Kitchen of the House,
configured like the compact cabinetry
of a boat, 1950. The kitchen has since
been fitted with a skylight.

construction. The built-in furniture, particularly the kitchen and washroom cabinetry, evoke the space-saving interior cabinetry of boats. The form of a boat is suggested by the bend in the gallery wall, even though unintended. The overhead beam had accidentally bent during construction,[26] a serendipity that Binning accepted and incorporated as a feature of the House.

These are gestures and evocations predicated on a moving line. Just as Binning used art—discrete paintings—as gestures to manipulate the visitor's journey through the house, he used art in another way, with the floors, walls, windows and ceilings serving as elements of a drawing. A conventional architectural reading of the house comes up short: the House needs to be read as a work of art.

Binning's line drawings of that time—his main medium at that stage of his career—show a remarkable similarity to his house. *Jessie at Tea Table* (page 65), for example, exhibits the same strikingly oblique line within the breakfast tray. The tray's trapezoidal contours were no doubt deliberate, given Binning's oft-professed attentiveness to compositional form.

Over the next four years, Binning's drawings exhibited this same distinctive approach: a strong anchoring line that disgorges wildly oblique lines while, in the background, boats, trees, cars float around, unfettered by gravity or perspective. It made little difference whether the subject matter was a rural landscape (*Untitled,* 1941, page 85), a still life (*Birdcage,* 1942, page 92) or a streetscape (*Study for 555,* page 65). The drawings all display the same skewing away from the Cartesian grid. Any one of these drawings can be read as an analogy for the design of Binning's house. In *Study for 555,* the implied parallels fan away from each other, just like the gallery wall of his house, while in the background of the drawing, a quartet of automobiles float capriciously in the air, much like the whimsical abstract elements of his original front-entry mural. Binning, it seems, was creating his own manifesto.

The symbiosis of Binning's art and architecture cannot be overstated. What Charles H. Scott once wrote about Binning's drawings can equally apply to his architecture: "Mr. Binning is genuinely interested in form and pattern, a form lightly dramatised by deforming and a pattern that partakes of the 'spot' or 'all-over' variety."[27] Binning himself rarely spoke directly about his approach to the design of his house, but in his discussion of his drawings, one can see a similar approach of beginning with a clear, emphatic plan and diverging along the way: "You had this general idea and you worked out your main composition," recalled Binning late in his career, "then you began to fill in and enrich and give the whole drawing a kind of textural interest on this framework."[28] In his approach to painting, the interface of architecture and art was more pointedly acknowledged: "Architecture has always been a force in my life. I came from a family of architects, and I was slated to become an architect, but for a lot of reasons, I didn't become one—and am just as glad now I didn't." As a painter, recalled Binning, "there was a kind of realization of building something permanent, and I suppose this whole architectural attitude came into it … I am not a romantic person, so it would seem to me that this whole classical idea of art or architecture is something that I would naturally lean to—so then you have this idea of architecture itself

JESSIE AT TEA TABLE (1940)
by B.C. Binning (Vancouver Art
Gallery, Gift of Mrs. Jessie Binning).
The mannered tea tray evokes the
trapezoidal forms in the Binning
House, from the built-in study
desktop to the studio clerestory
window.

STUDY FOR 555 (1944) by B.C.
Binning (Vancouver Art Gallery,
Gift of Mrs. Jessie Binning). In the
background, the freely drawn
perspective results in the impression
of a tapered street.

as [with] painting, as something to be built; you have this already established idea of a fixation on a certain subject."[29]

Binning's architectural approach can be called artful, poetic, dynamic, neo-constructivist—but it cannot be called functionalist or rationalist. Despite the oft-repeated assumption that it was designed as a model of budget housing,[30] archival evidence confirms that its artisanal features swelled construction costs to roughly $4,500,[31] almost twice the price of local similar-sized economy housing of the day.[32] Even the Modernist design criterion of using local materials was, in some ways, more art than economics. On one hand, the varnished cedar v-joint walls were a sensible and affordable choice for the age. (Jessie painted the age-darkened cedar white after her husband's death.) On the other hand, the fireplace wall, made of stone from the nearby Squamish quarry, was hauled to the site at no small cost, constructed by masons, and was not the cheapest option for the purpose. But it enriches the minimalist character of early Modernism.

The House is also enriched by its many built-in features: desk, bookshelves, headboards and cabinets detailed with beautifully simple wooden drawer pulls. In custom-crafting the furniture, walls and windows, Binning was following the path of Frank Lloyd Wright and rejecting the industrially oriented cookie-cutter dictum. "The choice of which material to use," Binning wrote in 1954, "is not always dependent on structural or functional reasons but often concerned with the aesthetic requirements of the building."[33]

Binning believed art and architecture to be integrated—even interchangeable—concepts. The severe functionalism espoused by many of the High Modernists was anathema to him. "You, as Architects, as we, as Artists, have looked searchingly back at those better days when both arts seemed to intermingle easily, complementing and contrasting one another in dynamic unity," he wrote in 1950, "when sculpture fused with architecture so that no man could say where one left off and the other began; when light coloured by the design of stained glass filled the architectural space to the approval of both Architect and Artist; when painting and decoration seemed the flowing of the building from which it grew; when, indeed, the Artist was very often also the Architect—or, if you prefer, the Architect was also the Artist."[34]

Binning recognized the importance of design distinctiveness in the theatre of the everyday. The visitor descends from the roadside to the front of the house in a ritual

that is conceptually inverted from the grand ascent to the entrance of a manor. From this procession of descent, the House is entered as a kind of sanctuary nestled in the slope. The outdoor light filters through the central gallery's clerestory into the core of the house and illuminates the art displayed on its walls. The evening gin-and-tonic is taken on the terrace, with the warmth of the indoors a few steps away.

Through his house and his teaching, Binning had a profound influence on a generation of west coast Modernists who would, in turn, transform the region into one of the most exciting centres of contemporary architecture in North America. One of Binning's best students at the Vancouver School of Art was Ron Thom, who would later became one of the finest and most respected architects in Canadian history. From his use of the fireplace hearth as the anchor of the house to his artful arrangement of line and massing, Thom was a disciple of Binning. "Binning taught me to see, and he taught me to think," Thom later said. "He was one of the most important teachers in my life. The strongest thing he taught us, which has had a profound effect on everything I've done in architecture since, was that every aspect of the design had to respond directly to the world around it, whether it be colour or form, or where the light came in, or the views looking out."[35]

As a teacher, mentor and architectural activist, Binning used his home as a salon and showcase for Modernism. In 1946, Binning and Lasserre invited Neutra to lecture in Vancouver and stay at the Binning House, enhancing a cross-influence that may even have exported some aspects of Vancouver Modernism back south to California. Neutra would make two more visits to Vancouver at Binning's invitation, staying at the house each time, extending his influence upon a number of Vancouver's young architects and emerging talents.[36]

Together with Fred Amess and other members of the Art in Living Group, Binning later tried to establish a true model of low-cost housing, but their efforts in that realm failed to produce enduring results. Binning's true strength was not as a practical housing expert, but as a hybrid artist-architect. He went on to work closely with architects throughout his career, most famously as the designer of the colour scheme of the 1953 Dal Grauer Substation (see page 19) and the mosaic of the 1956 B.C. Electric Building (see page 20), projects which earned lasting acclaim. Binning was at his best when his artistic sensibility infused his ambition to build. "As it is not within me to interpret the 'struggles, tragedies and evils' of life I have therefore turned naturally

to the 'lyric idea.' In doing so I have tried to find form and colour expressive of this idea and at the same time characterize the influences of my time and place."[37]

It is something of a miracle that the House is still standing, and still in good condition, amid the aggressive new development. Enriched by its nuanced forms, the House is its own Rosetta stone, rewarding those visitors who are patient enough to understand its secrets, and enchanting even those who merely feel their suggestion. In this regard, it serves as a kind of cipher, translating a series of abstract and often-coarse debates into something "familiar, poignant and local."[38]

That its most distinctive gestures are in fact covert, rather than broadcast as an architectural manifesto, suggests the integrity of substance over salesmanship. As Giedion wrote in *Space, Time and Architecture:* "An architecture may be called into being by all sorts of external conditions, but once it appears it constitutes an organism in itself, with its own character and its own continuing life."[39]

And Binning, the architect *manqué,* came to recognize that even as he remained an outsider among his peers in professional practice, he had been drawn to a higher calling, the same ache to change the world. "We had much in common," reflected Binning in 1950 of the artists and architects of emerging Modernism. "We both felt the social and spiritual change of the atmosphere, we both realized we must find new forms to express this change of climate and, what is more important, we set out together to find these new forms with a creative spirit we had not felt for more than three hundred years."[40]

SIMON SCOTT **BINNING HOUSE, PHOTOGRAPH PORTFOLIO**

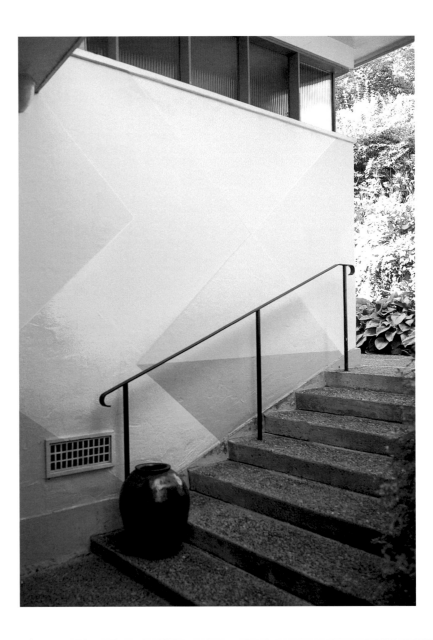

Gallery, view to main entrance.
Optional Modules, 1969-70, on wall.

facing page Gallery, view to west wall
with mural

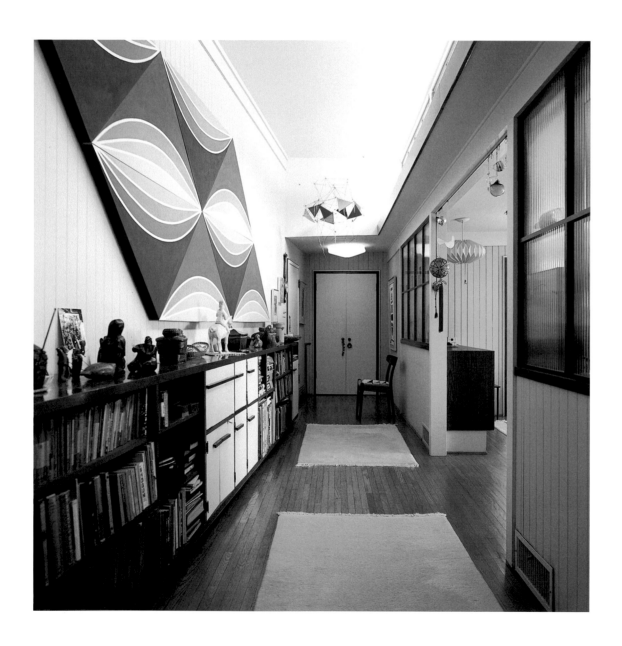

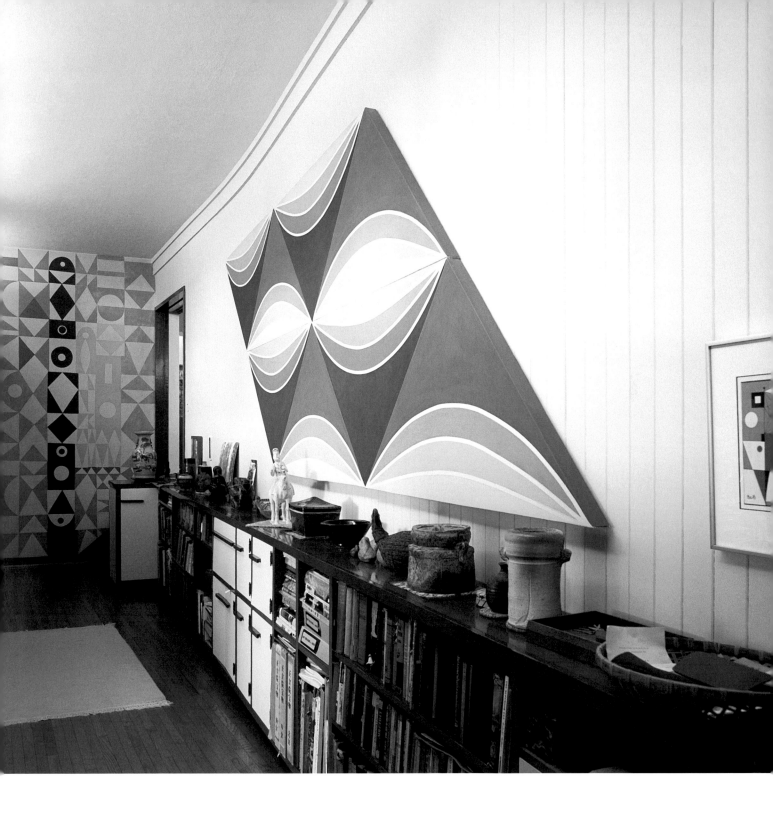

Marine-influenced cabinetry of
bathroom

facing page Looking south from living
room to rear terrace, with an ocean
view now closely framed by greenery

pages 76–77 Living room, locale of
Binning's famous gatherings

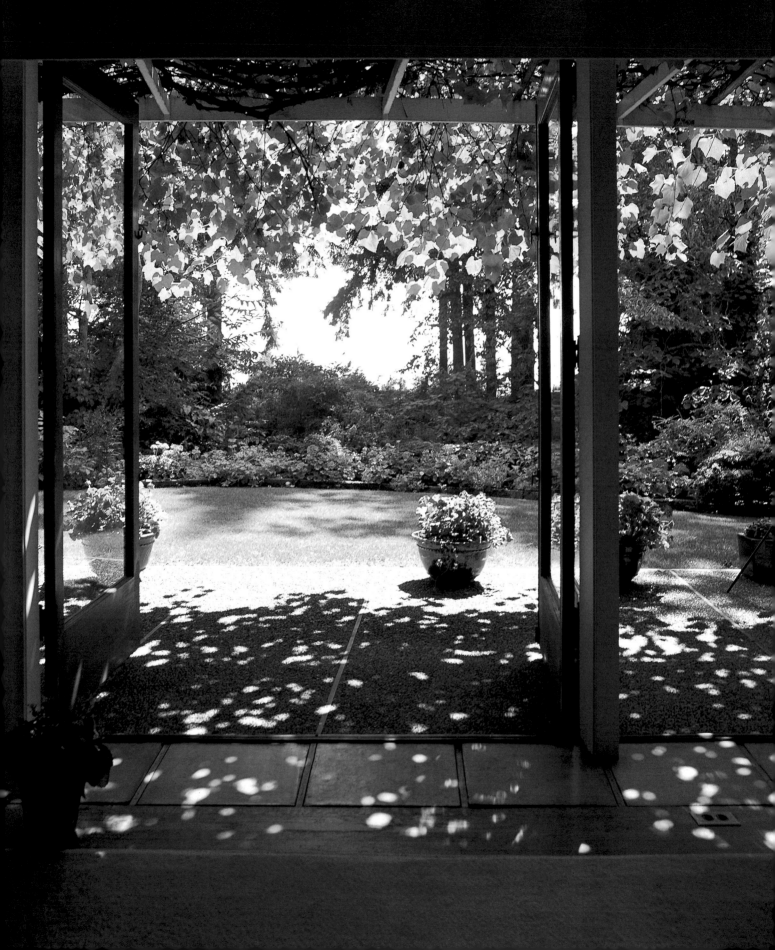

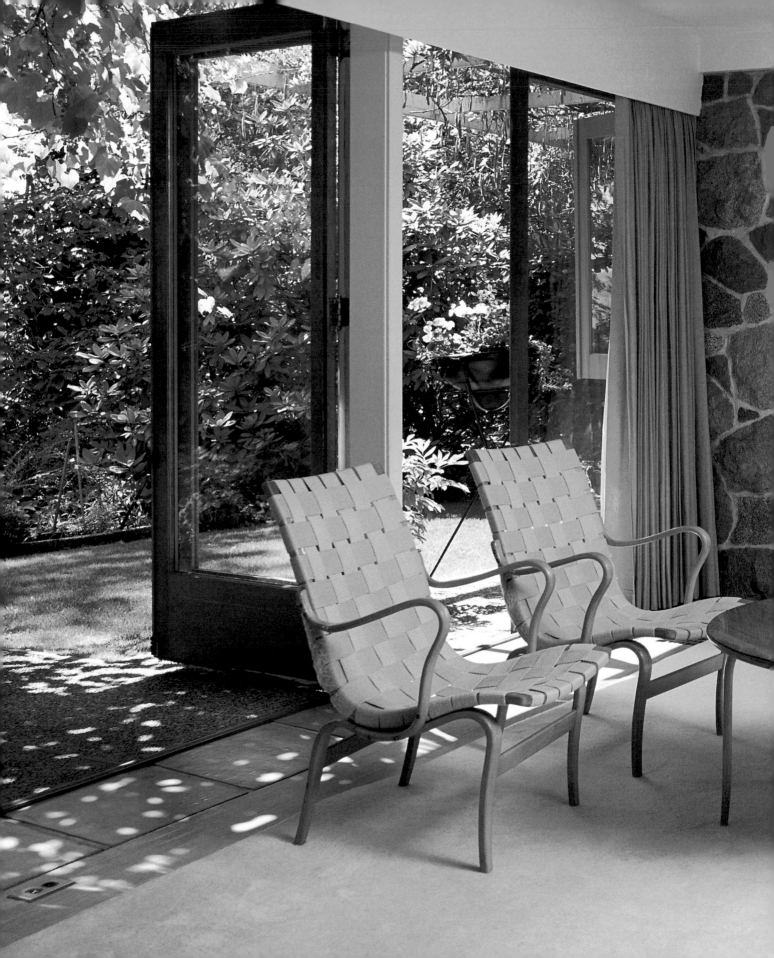

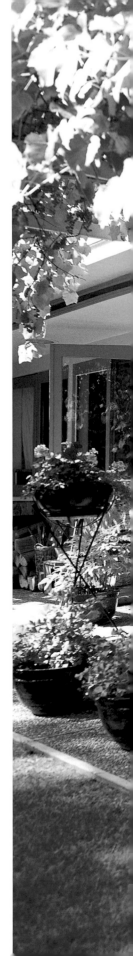

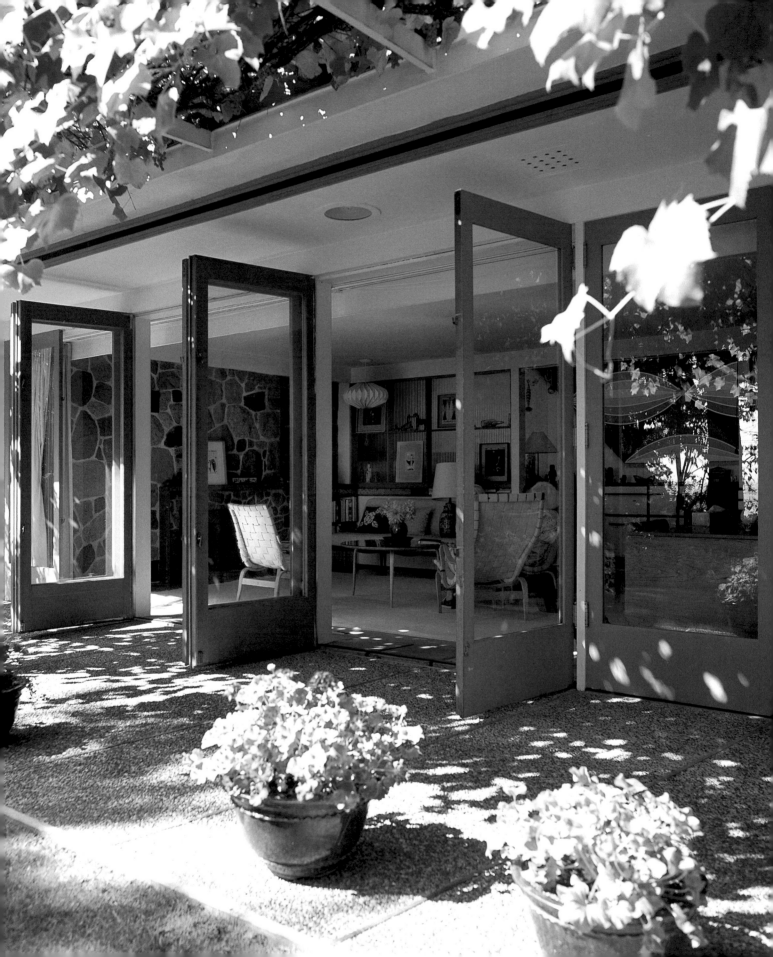

If one word were chosen to best qualify fine drawing perhaps "clarity" would do. Clarity of mental and emotional intention, clarity of interpretation and clarity of means. **B.C. BINNING**

B.C.

. BINNING ENROLLED at the Vancouver School of Decorative and Applied Arts (later the Vancouver School of Art) in 1927. From the beginning, he was one of the most accomplished students and there was little doubt that he would pursue an artistic career. At the school his teachers, working under the principal Charles H. Scott, were W.P. Weston, Jock Macdonald and, most importantly, Fred Varley. He took painting and drawing from Varley, and while there is only one extant drawing that directly betrays the influence of Varley, *Portrait of H. Mortimer-Lamb,* 1935 (collection of the Art Gallery of Greater Victoria),[1] another drawing strongly influenced by Varley is reproduced in the 1930 edition of *The Paintbox.*[2] In addition to stylistic affinities, he would have been taught the importance of drawing within the artistic process while studying with Varley.[3] Indeed, drawing became the basis for all of Binning's artistic activities, and his 1947 article "The Teaching of Drawing" reaffirms this position: "If drawing is considered as a subject for development, research and discovery, it can be a vital and important preparatory study toward painting, sculpture and architecture. In other words drawing should be considered as a means to an end, making the experience or study of more value than the product."[4]

Binning's period at the Vancouver School of Art[5] was followed by a year during which we have no idea of his activities. In 1933, he joined the school as an instructor in the wake of the radical shift in the structure of the school.[6] He taught drawing and commercial art but by 1936 was already seeking to expand his knowledge base and, in the summer of that year, trained with the little-known sculptor Eugen Steinhof at the University of Oregon. Unfortunately, nothing of his work remains from this period, but perhaps the experience of dealing with sculptural form gave Binning a strong desire to convey a sense of the third dimension.

In 1938–39, Binning took an unpaid educational leave from his duties at the school and travelled extensively in the United States and Canada (visiting San Francisco, Chicago, Washington, D.C., Boston, Rhode Island, New York and Nova Scotia) before sailing to London. Upon his arrival in August 1938, Binning met with fellow Vancouverite Jack Shadbolt and, following Shadbolt's recommendations, visited a number of teaching institutions before deciding where to train.[7] He decided on three schools or, more accurately perhaps, three teachers: the Central School of Art, with Bernard Meninsky; the Ozenfant Academy of Art, where he studied briefly with Amédée Ozenfant (who, ironically, spent much of the time Binning was in

STILL-LIFE
1938–39, graphite, charcoal,
crayon, 46.1 x 30.5 cm
Vancouver Art Gallery
Gift of Mrs. Jessie Binning

London in Seattle) and with Henry Moore, after Ozenfant travelled to Seattle; and the Westminster School of Art, with Mark Gertler.

Binning's commitment to his artistic education was considerable when one considers that by this point he had worked for several years as a teacher himself and already had an exhibition career. He enrolled in classes in both the Westminster and Central schools, working from Monday to Friday at both painting and drawing. Binning was pleased with Meninsky and Gertler—"two good men with whom I am well satisfied"[8]—and received encouragement from both.[9]

Gertler, from whom he took painting classes, particularly impressed him, and Binning was invited to visit him early in 1939. "My Painting teacher invited me out to his studio for tea & to show me his pictures—needless to say I felt very proud & had a very interesting afternoon & by talking to him personally like that I also learned a great deal—I think he is a very good painter if not one of the best in England."[10] While this period, 1938–39, was a period of great difficulty in Gertler's own life, he had an important and lasting significance in Binning's career. Binning addressed abstraction and the figure with Gertler, and there may be some affinity between the linear patterns Binning adopted later and the drawings of other Gertler students.[11]

Binning's other teacher in the fall of 1938, Bernard Meninsky, taught painting and drawing at the Central School of Art. Binning seems to have taken classes in both from Meninsky, and a small panel, *The White Horse*, circa 1939 (page 121),[12] the only work he brought back from England with him, reflects the influence of Meninsky's figurative style. Meninsky's drawings do not relate directly to Binning's except in that they share a use of line, without shading or elaboration. Meninsky apparently emphasized the use of pure line and encouraged all of his students to devote significant time to developing their skills as draftsmen.

In addition to going to classes, Binning visited exhibitions in London and reported visiting a large Picasso show in March of 1939, where he saw *Guernica*[13] and several cubist works. A small untitled gouache (page 119) betrays a first-hand knowledge of cubist ideas and was perhaps influenced by what Binning perceived in Picasso. At the end of the year, Binning decided to leave the Central School and begin at the Ozenfant Academy, which he described as "very lively & much more advanced than the usual sort around London."[14]

UNTITLED
(FARM IN THE CARIBOO)
1941, graphite, 53.3 x 38.2 cm
Vancouver Art Gallery
Gift of Mrs. Jessie Binning

The strongly linear patterns in a good deal of Ozenfant's work would have appealed to Binning, as would the emphasis on volume and shape in Ozenfant's painting. There is also an important element of pattern, albeit much more severe than in Binning's mature work, which would have been of significance to Binning. The early charcoal *Still-life* (page 83) was probably done during the time Binning studied at the Ozenfant Academy. It has the architectonic quality of Ozenfant's work and a strong sense of the importance of the third dimension. (The idea of the colour progression also appears in Ozenfant's work.) It is certainly a great deal removed from the Varley-influenced work of 1935.

Although Binning found Ozenfant a good teacher, the majority of his time at the Ozenfant Academy was spent studying drawing with Henry Moore.[15] At the time, Binning described Moore as "a very nice man & a good artist for a critic"[16] and reported that he spent most of his time drawing "from the model—each drawing which is usually very large takes about 2 weeks to a month to do—all very finely finished & designed."[17] Although their drawings have little in common, the experience of working with Moore was important to Binning. Moore encouraged him to explore balance and relationships between forms. As Binning later related in an interview:

It was a matter of putting these forms together in some particular way, where the concave flatness of this foiled itself with the round fullness of other form or in such a relationship that the whole thing created a kind of impact on the beholder … It's the artist's job to learn about how to do these things and one of the ways, which Henry Moore also of course assured me, was finding out about this from drawing from nature itself, in other words, from these incidental things that were around you, these twisted bits of roots or strange stones and bone for him, and I had my own collection of things that I was more interested in and so it goes.[18]

The sense of a relationship between a tree and its roots and foliage, a relationship between the constituent parts of nature, is a base from which derive Binning's best compositions. There must be rightness to the relationships that allows us to experience the more complex dynamics of his compositions. In short, if we are not convinced by the parts we will never be convinced by the whole.

Although the Binnings had planned to go to Paris, the coming hostilities of World War II caused them to leave London in the spring of 1939 and travel to New York.

FIVE DINGHIES, MOORED
SAILBOAT, TREE
1941–42, graphite, 30.3 x 45.5 cm
Vancouver Art Gallery
Gift of Mrs. Jessie Binning

TABLE & STILL-LIFE
1942, graphite, 23.9 x 38.2 cm
Vancouver Art Gallery
Gift of Mrs. Jessie Binning

There Binning worked briefly at the Art Students League with Morris Kantor. The return to New York was a disappointment for Binning but several positive things resulted from this turn of events. In Morris Kantor he found an inspiring teacher and a man who stressed "design, form and structure in composition."[19] Binning wrote to his mother that he felt Kantor was "very good" and that the Art Students League was "very much better than the London Schools."[20]

While in New York, the Binnings visited exhibitions at private galleries, the Metropolitan Museum, the World's Fair and the newly opened Museum of Modern Art. The Binnings enjoyed visiting these exhibitions. What was probably of most importance was the opportunity to see a good deal of work by Picasso and Matisse at the Museum of Modern Art.

In addition to the specific lessons Binning gained from his teachers, these travels exposed Binning to a wide variety of other influences. These included Matisse and

Picasso, as already noted, but also, for example, the drawings of Ben Nicholson. Most significantly, the trip reaffirmed the importance of drawing to Binning and his work.

For Binning, the *making* of a drawing was the most important act—the actual work was of interest but less so than the translation of the intense looking into a new creation. In other words, the reality of the drawing was within the drawing itself and not measured as a reflection of the realities of the world. In Binning's work there is little interest in verisimilitude or the "reality" of perspectival space. These works are strikingly artificial and formal in their nature and intentionally so. Binning was "interested in making an expressive statement—bordering on symbolism rather than realism."[21]

Binning began his exhibiting career showing works on paper and, until the late forties, his public acclaim came from his drawings and, to a lesser extent, watercolours. Indeed, it appears that until 1947 (except for the period of study in London and New York), little of his time was occupied with oil painting. His first exhibited works, watercolours and prints shown in 1933–34, were sporadically followed by watercolours and a few oils.[22] Unfortunately, as noted, there are no works from this period that we can securely date.

THIS RATHER LENGTHY PREAMBLE is intended to suggest that there were many disparate influences in the creation of Binning's mature graphic style. That his drawings had a notable accomplishment and strength is suggested by the fact that he was awarded the Beatrice Stone Medal for Drawing in 1941.[23] At the time the critic Max Maynard wrote: "There are hints of Picasso in Mr. Binning's line. Hints also, perhaps, of Matisse. Obviously he has admired the precision and grace of these masters, their nervous, sensitive caligraphy [sic] and economy of means. But Mr. Binning's work is not Picasso, nor Matisse. It is decidedly, by some magic, B.C. Binning himself. Distinguished work."[24]

The accomplishment and maturity of these works was quickly noted and Binning began to be collected and exhibited across the country.[25] Nor did these drawings go unnoticed by the critics. In addition to local commentary in 1944,[26] Charles H. Scott mentioned Binning's one-person show at the Vancouver Art Gallery in a general article written on the Vancouver scene, and in 1946, Doris Shadbolt wrote what remains one of the most persuasive articles about his drawings. Both articles appeared in *Canadian Art.*[27]

FEMALE FIGURE
1942, ink, 45.3 x 30.4 cm
Vancouver Art Gallery
Gift of Mrs. Jessie Binning

BIRDCAGE
1942, ink, 30.4 x 39.6 cm
Vancouver Art Gallery
Gift of Mrs. Jessie Binning

Of the 1944 show, his first one-person exhibition, the critic J. Delisle Parker wrote: "He sustains his theory that drawing is the basis of the arts by showing numerous admirable exhibits of analytical and creative power."[28] We cannot, alas, securely identify any of the drawings from the 1944 show, except for a drawing of the Binning's dog Lucy. It is a confident and amusing pen and ink drawing singled out by Parker as having "characterful clean-cut lines," a description suggesting the economy and skill that characterize all of Binning's best drawings. Parker's description of the drawings as analytical is appropriate, and he further notes that Binning's drawings "composed of single lines, clear and definite in their purpose, stand in their own right as solid artistic achievements."[29]

The show included pencil and pen and ink drawings as well as some in which Binning employed a stick or bamboo pen, and it is Binning's ability in this variety of

NUDE
circa 1942, ink, 30.5 x 45.4 cm
Private collection

drawing media that attracted another critic, Mildred Valley Thornton. She noted that "he shows fine selective ability, drawing with freedom and fancy, yet never offending the dictates of good taste, or exceeding the confines of verity."[30] Browni Wingate was equally enthusiastic about Binning's work. While noting his debt to Matisse and Picasso, she commented that "Binning has developed an astringent personal style of drawing that is sensitive and attains solidity of form by an economical use of line."[31]

All the critics remarked on the simplicity of Binning's approach and the fact that they felt an authenticity in his approach to mark-making and composition. Thornton is right when she suggests that these drawings are done with the "consciousness of a man who is sure of himself, and of what he wants to do."[32] It is, however, a mistake to imagine that the drawings are a naïve transcription of his subject. As Charles H. Scott more perceptively noted, "These drawings must be considered as a poetical expression of form, rather than one of imitation."[33] Scott further comments: "Mr. Binning is genuinely interested in form and pattern, a form lightly dramatised by deforming, and a pattern that partakes of the 'spot' or 'all-over' variety. What he has done has obviously given him pleasure, and the discerning mind and eye can share that pleasure with him."[34] The drawings, in the words of Wingate, use "a witty line—drawn with pen or ink stick, seemingly casual but never failing to make its point."[35]

The early forties seem to have been a period of exceptional activity for Binning. Following his return from New York in the summer of 1939, he produced a large body of drawings in the next six years. Working at the art school, in his studio, on sketching trips, on bicycle and in his boat, he produced hundreds of drawings. His subjects ranged from art school models to children taking art classes to the forest, but most importantly, he devoted himself to the coastal life of West Vancouver. At their best the drawings seem to have, as Doris Shadbolt has noted, a remarkable unity of means and message. "Not only is the form the exact counterpart of the idea, it is the equivalent as well."[36] Further, Binning's drawings work both as depictions of objects within the world and as exercises in "pattern in which straight and curved lines, areas of grey texture, white spaces, dark spots, are balanced in a surface design which sports across the paper."[37]

Binning is able to combine an attention to the individual part or object with a keen sense of the overall composition. The great achievement of these drawings is that they appear effortlessly casual, as if they had simply been wished upon the page,

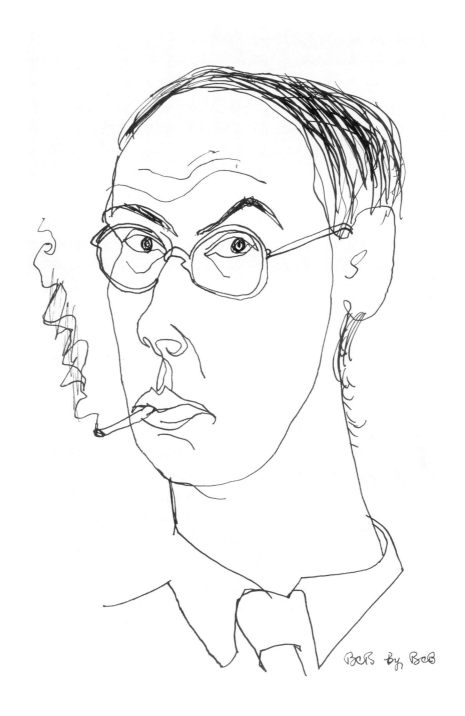

BCB BY BCB
circa 1942, ink, 29.5 x 21.0 cm
Private collection

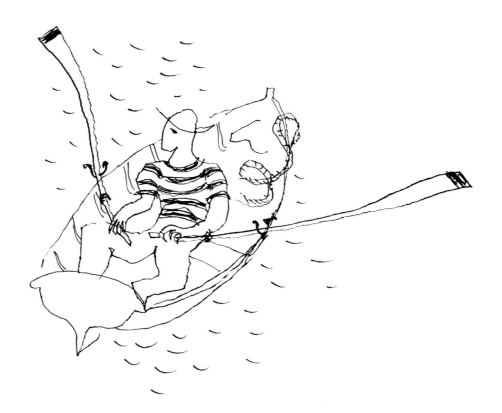

while they are, in fact, rigorously controlled. Objects, wrote Shadbolt, are "formalized and reduced to the state fundamental for its purpose, relieved of any unessential complexities, so that relationships between objects are immediately clear and direct."[38]

Doris Shadbolt's *Canadian Art* article marked Binning's second one-person show at the Vancouver Art Gallery. Again, Binning received extremely positive criticism at home. Palette wrote of these works: "After selecting elements to be used, and with the faculty of eliminating non-essentials, he has then proceeded with decision, sense of balance and order and with an eye to overall design, to state what he has to say surely and spontaneously. Artistic quality seems to fit in naturally and easily, as he expresses simply, but with verve, his initial experiences of the scene and its human significance."[39]

Much of the charm of Binning's drawings, and the pleasure we derive from them, comes from this sense that they are casual and spontaneous works. The paradox of these images is that they are spontaneous but within parameters closely defined by Binning. They have a degree of precision hinted at in a description of his working methods Binning gave years later:

Well, in one way the approach to drawing was very simple and in another way, I suppose, rather complicated. Simple from a technical point of view. As you know, so many of my drawings—in fact all my later drawings—were in pen and ink. Now, one could, of course, assume that one made a sketch first—a small preliminary sketch in pencil or blocked it in or in the large sheet and then worked from there on. I didn't do that.

What I did was, I took a great deal of trouble in selecting my subject and at one time I used a bicycle for that very reason, and I'm afraid I became a kind of figure of amusement around Horseshoe Bay and Fisherman's Cove and Garrow Bay and those places. The man with the bicycle and the sketch pad under his arm and a carrier full of implements and lunch and so on. Racing from one place to another stopping and standing and staring and then probably shaking his head and going on to another place and repeating the whole process again.

Well, what I was doing really was simply this: I was trying to visualize exactly what the possibilities of the subject were. And by finally deciding on what I wanted to draw first of all—which subject I was going to choose—which may have taken me half the morning, and then spending another hour or so looking at it very intently and deciding exactly how I wanted to do it.

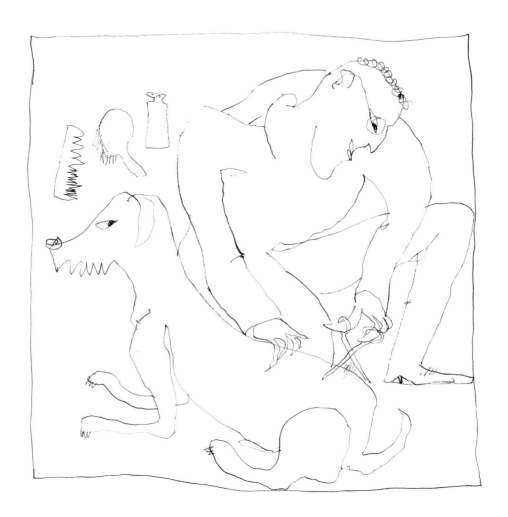

WILSON GROOMING HIS DOG
circa 1943, ink, 28.4 x 27.4 cm
Vancouver Art Gallery
Gift of Mrs. Jessie Binning

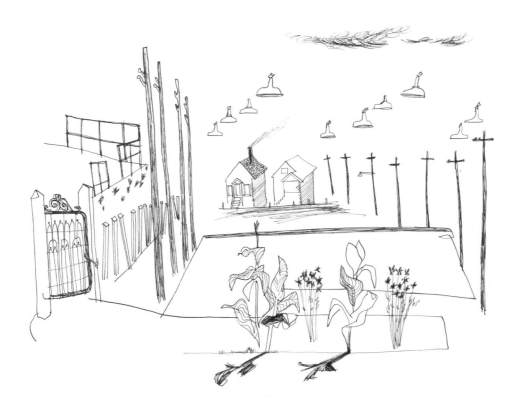

**PLANTS, POWERPOLES,
TWO HOUSES**
circa 1943, ink, 30.5 x 39.3 cm
Vancouver Art Gallery
Gift of Mrs. Jessie Binning

facing page
GARDEN POTTING SHED
circa 1944, ink, 60 x 45 cm
Vancouver Art Gallery
Gift of Mrs. Jessie Binning

Now when I say exactly I mean, probably, in general terms. The general composition and letting the smaller parts and details build up in a more or less haphazard way on the framework of that general composition, which I had pretty firmly in my mind. One of the cardinal principles of my drawing is this whole business of selection and rejection. What is it you want to say exactly—what do you want to put down—and what do you want to throw out, and being quite ruthless about this process, of using only those parts that would enhance the design and my intentions—and ignore everything else, and indeed sometimes perhaps turning slightly to the left or to the right and picking up some objects there and transporting them into the picture itself by way of pen and ink.

And so, once the general composition was in my mind I began and went at the thing in a pretty bold manner. And then letting the thing grow from there. There was a certain growth in those drawings in that you had this general idea and you worked out your

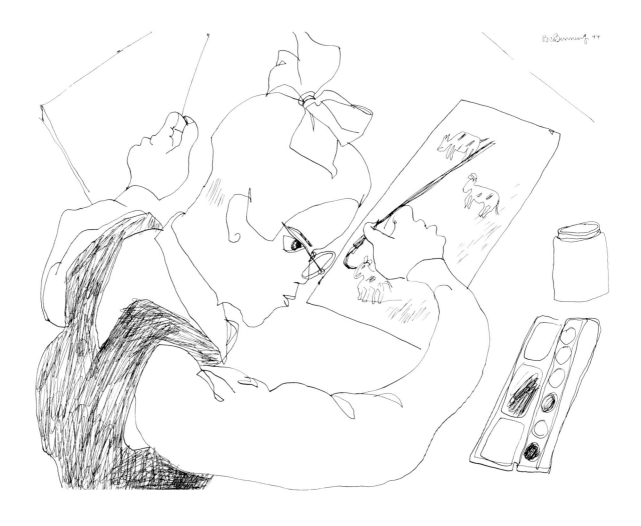

YOUNG PAINTER
1944, ink, 40.4 x 53.8 cm
Vancouver Art Gallery
Gift of Mrs. Jessie Binning

main composition as I've said, then you began to fill in and enrich and give the whole drawing a kind of textural interest on this framework. The other thing, of course, as Chekhov once said, art is knowing when to stop, and there was a point when you had to very shrewdly say "Okay, it's finished." And to have the courage sometimes to stop there and not just carry on for the sake of carrying on.

Now there was also a great mortality rate in these drawings too, in that a good many of them never saw the light of day after the one day they had on the drawing pad—they went directly into the basket. Sometimes they did, in fact, by this accident prove to be a preliminary drawing that I saw through this mess or this mistake, I had made that didn't come off, I saw the possibility of something else there that I hadn't the wit to see at the beginning, and I would often save those drawings rather than throwing them away as a preliminary drawing. In other words, I would perhaps go back to the scene of the crime and I would bring this drawing along with me and put it on the ground beside me and draw really from both the drawing and the scene again but making these various changes, you see. It was sometimes a matter of keeping certain things I had done and changing other things.

It was sometimes a matter of radically changing the whole thing but keeping a kind of spirit of what had been in the first one and so on. It varied. But it was this kind of way in which I worked and so the drawings never looked laboured … They kept, at least I hope they did, kept a kind of spontaneity in them because there was, really you had the confidence of knowing your minor discoveries would work all the while, once you had established the main structure, and so you let yourself go within this main structure. But the main structure, I can assure you, was very carefully thought out.[40]

Binning's approach to drawing remained essentially the same throughout the period 1940 to 1945. He occasionally used drawings for different purposes but always produced drawings through the process of distillation described above.

WITH THE EXCEPTION of the two still lifes, all the works illustrated date from after 1940. Binning quickly established his working methods (outlined above) and initially used pencil, later moving to pen and ink. He also used sticks, bamboo nibs and reed pens as drawing tools. Most of the watercolours are not dated but, on stylistic grounds, it is reasonable to assume that they also fall within the period of 1940–46.

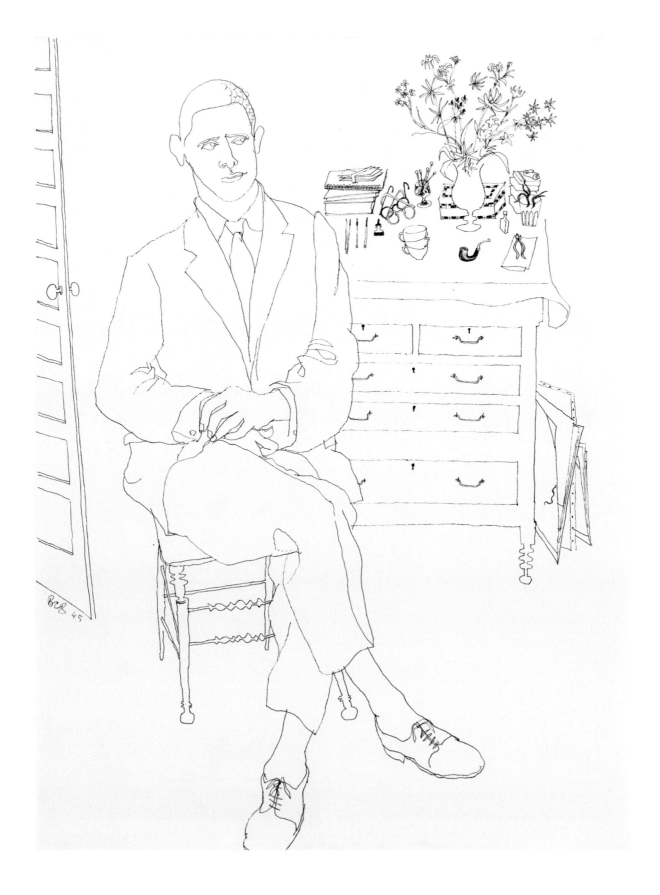

MAN SEATED BY BUREAU
1945, ink, 60.9 x 45.5 cm
Vancouver Art Gallery
Gift of Mrs. Jessie Binning

SKETCH FOR JESSIE AND BERT (PICNIC)
circa 1945, ink, 45.7 x 62 cm
Vancouver Art Gallery
Gift of Mrs. Jessie Binning
[Verso: Figure with cup]

BOAT
circa 1945, ink, 11.8 x 21.7 cm
Private collection

facing page
SUNDAY MORNING
1945, watercolour, 60.5 x 45.5 cm
Vancouver Art Gallery
Gift of Mrs. Jessie Binning

We have no drawings or watercolours dated after 1946, and when Binning exhibited a large group of drawings in 1950, all of them seem to have been old ones. In 1947 Binning seems to have decided to give up drawing in favour of painting and did not seriously exhibit drawings again.

The subjects of Binning's drawings can be broadly grouped into four categories: the figure, the landscape/architecture, interiors/still life, and boating subjects. Within each of these his achievements are considerable. What most of the works share is a reliance on simple line—contour and defining line to develop our sense of volume. There is little shading and often less information rather than more—Binning often leaves out the table leg, the roof or walls of a building or collapses space radically with vertiginous perspective. As has been suggested, the drawings do not attempt to portray their subjects but rather to capture enough of the essence to allow us to use them to create our own experience.

The pencil drawings, such as *Untitled* (page 86) and the complex series of drawings *Untitled (Farm in the Cariboo)* (page 85), display an almost bravura confidence— whether spare or almost overwhelmed by detail. Binning is always careful to keep the

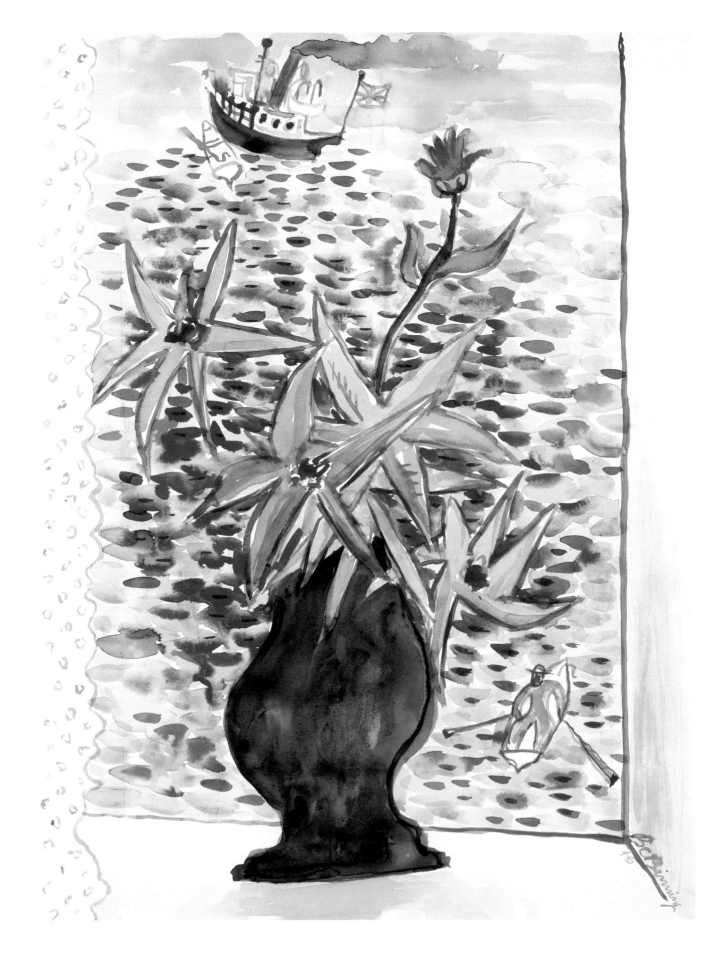

WEST BAY
1945, ink, 44.2 x 59.4 cm
Vancouver Art Gallery
Gift of the Vancouver Art Gallery
Women's Auxiliary

PREPARATION FOR TEA
AT ROCKCLIFFE
circa 1945, ink, 45.6 x 61 cm
Vancouver Art Gallery
Gift of Mrs. Jessie Binning

composition in control. *Untitled* is very simple, using only line, but Binning has created an extremely complex spatial system within the confines of this small drawing. A world is seen through a porthole or window, but where the space of the composition begins and our space ends is ambiguous. A single line at the left of the composition serves as frame, side of the cliff, edge of the roadway and device to direct our vision. The movement within the image is similarly complex—as the road leads towards the viewer, so a parallel movement is traced through the rocks down to the house below. Binning has taken considerable liberties with scale—note the size of the distant boats—but the whole works perfectly.

Binning explored a variety of drawing tools but seems to have preferred an extremely hard pencil that gives a crisp and carefully defined line. The care with which these drawings are conceived is clear in *Table & Still-Life* (page 89). Here, as in the *Cariboo* drawing, Binning has balanced differing textures and shapes, but he made an error and had to erase an entire chair. The same pattern of composition—blank versus shaded areas, lines that define both physical elements and space—is seen in most of these drawings, but *Five dinghies, moored sailboat, tree* (page 88) is perhaps the most accomplished. The composition is at once rigorous and apparently casual, minimal means used to great effect.

Binning soon moved to the more unforgiving medium of ink. Here his mistakes could not be erased and if he failed he had to begin again. The drawing *Sketch for Jessie and Bert (Picnic)* (page 105) has a futile beginning on its verso. Binning ranges freely in his subject matter—students from the art school, models, his wife and family appear frequently, boats and boating and, occasionally, a wry self-portrait, such as BCB *by* BCB (page 95).

It is in these works that Binning is at his best as a draftsman. He is able to bring his great powers of concentration to bear on a subject and distill the essential information, eliminating the "extra" element. Notice how in *Garden potting shed* (page 101) he neglects to define how the building sits on the ground, or the walls, roof, and so on, yet we clearly understand that there was a building. Although there is a certain debt to Matisse in particular in drawings such as *Female Figure* (page 90), the drawings are instantly recognizable as Binning's own.

Part of the success of these works is Binning's imagination. For him reality is a starting point not an end in itself. His imagination is brought to bear—a simple

domestic scene such as *Birdcage* (page 92) is enlivened by impossibly large, vinelike plants and the view through the window to an unlikely congregation of boaters. Boaters such as these and the single figure in *Rowboat #2* (page 96) might be called Binning's trademark. They appear in drawing after drawing. Gently amusing, these figures provide a human touch as well as define space and contribute to the overall pattern of the image.

Binning used watercolour sparingly throughout this period but to great effect, particularly when he used it alone in works such as *Sunday Morning* (page 107). Although these works had been rehearsed in Binning's mind, they were executed in a rush of activity and have a freshness and vitality, which marks all of his best work, and combine observation and fantasy.

As noted above, the approach of World War II forced the Binnings to change their plans in 1939, and the war was ongoing during the period of most of these drawings. Unlike his colleagues Charles H. Scott and Jack Shadbolt, both of whom used the war (soldiers, bomb damage, machinery, etc.) as subject matter, Binning never addressed the war directly in his work. There are, however, a number of drawings from 1943–44 that may reflect Binning's awareness of and concern about the war. Works such as *Plants, powerpoles, two houses* (page 100) are darker and unsettling in comparison to many of the drawings.

Most disturbing are drawings such as *Forest* (page 97). Dense, tangled images, they have none of the sprightly clarity of the beach drawings or the domestic scenes. Binning once observed that "in the woods … it was awfully hard to thin out and find the essential kind of form."[41] Perhaps this inability to see a way to the essential form is Binning dealing with the darker side of life in the early forties. The use of ink is more forceful and he often employs sticks and bamboo nibs, blunt instruments, to emphasize the lines. While it would be a mistake to push this analogy too far, there is little doubt that the forest drawings have a quite distinct character within his oeuvre.

More typical in spirit are images such as *Self Portrait in Ship's Cabin,* 1945 (pages 114–15) and *West Bay,* 1945 (pages 108–9), which reflect a somewhat idyllic summer life on the shores of West Vancouver and Howe Sound. What all the drawings, regardless of subject, share is a seriousness of approach and a dedication to line. *Self Portait in a Ship's Cabin* is a splendid example of Binning's ability to command space within his drawings. It is both a self-portrait and a bemused commentary on his working process.

209 PLAZA HOTEL 1° BELOW ZERO KAMLOOPS

209 PLAZA HOTEL, 1 DEGREE
BELOW ZERO, KAMLOOPS
1946, ink, 30.7 x 39.3 cm
Vancouver Art Gallery
Gift of Mrs. Jessie Binning

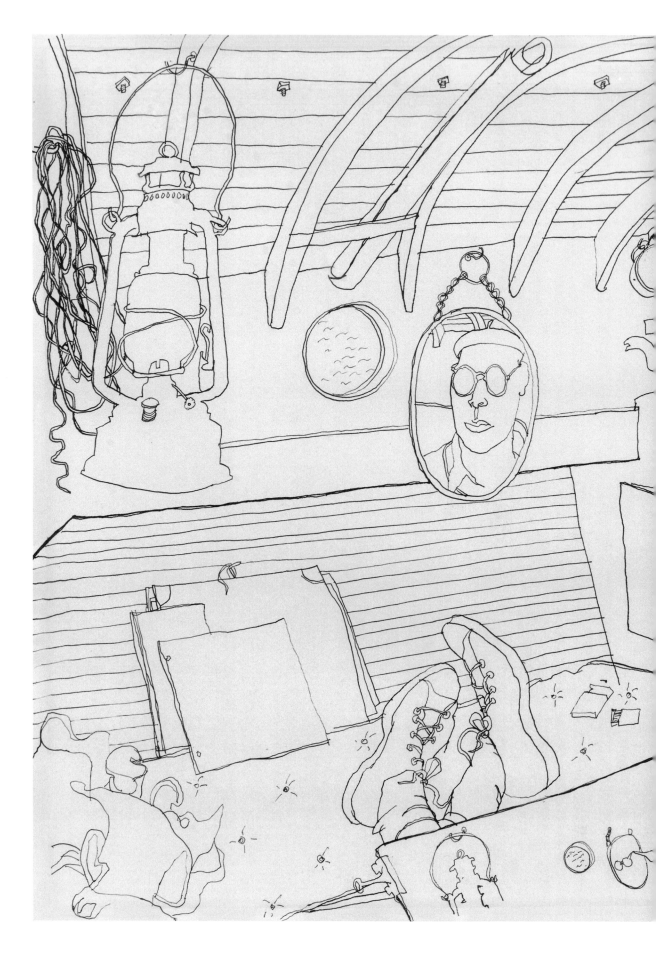

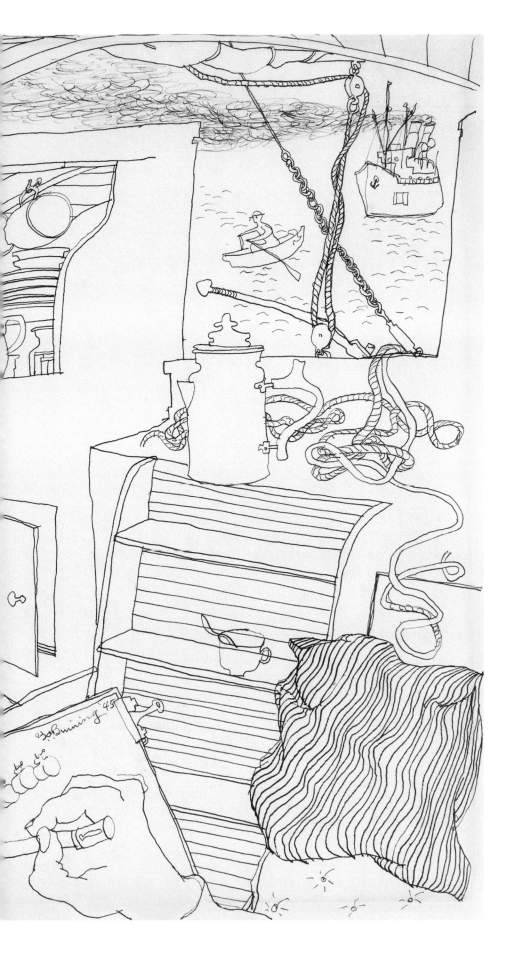

SELF PORTRAIT IN SHIP'S CABIN
1945, ink, approx. 44 x 59.5 cm
Private collection

We see the confines of the cabin and the larger world outside the hatch; a self-portrait drawing and the beginnings of a second self-portrait "drawing" within the larger patterns of the first; the artist's face (as reflected in the mirror), his feet and most importantly, his hand and pen. This is a work of considerable complexity but, as with all his best work, the drawing wears the complication very lightly.

Although he seems to have largely abandoned drawing as an end in itself after 1946,[42] it is clear that for Binning, "Drawing, drawing and more drawing is the basis for all creative art."[43]

IAN M. THOM **BINNING AS A PAINTER**

BINNING'S CAREER AS A PAINTER must be seen as divided—the private and the public painter. He seems to have been interested in painting all his life but exhibited few works prior to 1948, when he asserted himself as a public rather than a private painter. Although we are certain that he took painting studies at the Vancouver School of Decorative and Applied Arts with Frederick Varley, none of his work from this period seems to have survived. Prior to his travels to England in 1938, he seems to have exhibited only very rarely. An oil entitled *Fisherman's Shack* (present location unknown) was shown in 1937.[1] Binning in a later interview stated that he had not had an opportunity to see "a modern picture until the late thirties."[2] The insularity of the art scene in Vancouver was such that "when we heard about people like Picasso and Matisse—that is, the ones of us who were more inquiring than the others—we heard about them as faraway people living on another planet almost."[3]

If we are uncertain of his work at the time, what is clear is that by the end of the thirties Binning had realized that to expand his creative outlook he needed to leave Vancouver. His view of the local artistic community at the time is clear when he said "as far as innovative things happening with any fruitfulness about them and creativeness—it just didn't exist."[4] Binning and his wife Jessie had saved the modest salary from his position at the Vancouver School of Decorative and Applied Arts and in 1938 departed for London. The fact that Binning, who had graduated from the Vancouver school just six years before, was not only willing but also eager to return to studying suggests a fairly deep level of dissatisfaction.

When Binning arrived in London he met with fellow artist Jack Shadbolt, from whom he received advice about the best schools, and in September 1938 he began an intense period of study.[5] Presumably anxious to get the most out of his time, Binning divided his attention between two schools: the Westminster School of Art, where he took advanced drawing with Bernard Meninsky, advanced life painting with Mark Gertler, drawing with William Roberts and abstract painting with Gilbert Owens Roberts; and the Central School of Art, where he took painting with Meninsky.[6] We have only a tantalizing comment in a letter written by his wife to suggest what Binning was doing at the time. "He brought one of his abstract canvases home and I am greatly impressed with the thought and work he has put in it—also the color and different textures of the paint."[7]

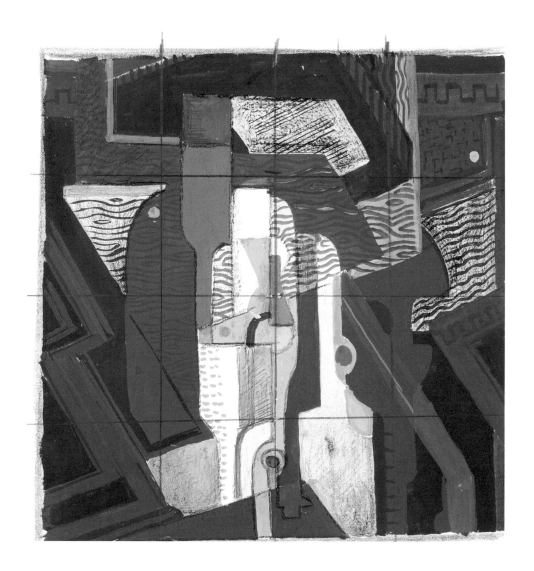

UNTITLED
circa 1939, gouache, watercolour,
graphite on paper, 26.3 x 22.2 cm
Vancouver Art Gallery
Gift of Mrs. Jessie Binning

By the end of 1938, Binning had decided to give up his studies at the Central School of Art and enroll in the Ozenfant Academy of Art. His classes began there in January.[8] Ironically, Binning had little time to study with Amédée Ozenfant, who left soon after to teach in Seattle. In his absence, the school was run by a young British artist, Henry Moore.[9]

London provided for Binning, in addition to the benefits of his studies, the opportunity to look at other art. In particular, Binning was very impressed by an exhibition of the work of Picasso he saw in March.[10] The growing unease in Europe and the realization that war was probably inevitable, combined with pressure from Jessie's family, led the Binnings to leave London in April. Binning felt that he had "attained something constructive."[11]

The Binnings went to New York and there, in May, Binning enrolled at the Art Students League, taking classes from Morris Kantor and Robert Brackman.[12] Although Binning felt that the classes at the Art Students League were "very much better"[13] than those he had taken in London, perhaps the most important influences on him were the New York World's Fair, the newly opened Museum of Modern Art and the opportunity to view work at commercial galleries. In any event the Binnings left New York in early July, travelling across the U.S. visiting Toledo, Chicago and Detroit and spending a few days in San Francisco visiting the Golden Gate Exposition.[14]

Binning, back in Vancouver in the fall of 1939, had been exposed to a wide variety of influences and teachers. How did these influences manifest themselves in his work? The lack of paintings from this period forces us to examine some works on paper for evidence of his intentions.

Two early works on paper, both of which seem to be studies of paintings, suggest that Binning was already very interested in a degree of abstraction. What is probably the earlier of the two perhaps dates to his time in London in 1939, when he was studying at the Ozenfant Academy with Henry Moore. The simplified forms of the still-life objects (page 83) suggest something of the style of Ozenfant's Purism (a modified form of cubism), but what is more striking are the colour annotations on the drawing that suggest a flow of colour around the image with a reduced colour palette. A stronger influence of Picasso and cubism is present in the untitled still life (page 119). Clearly Binning is aware of the example of the earlier artist, using a fragmentation

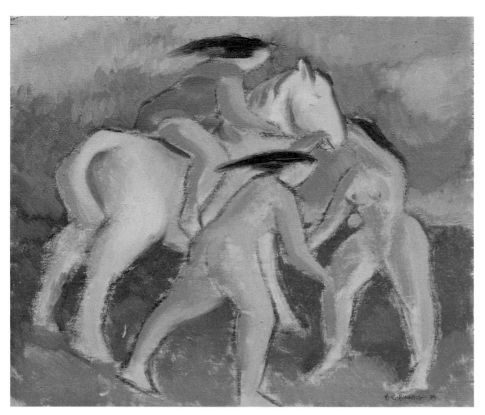

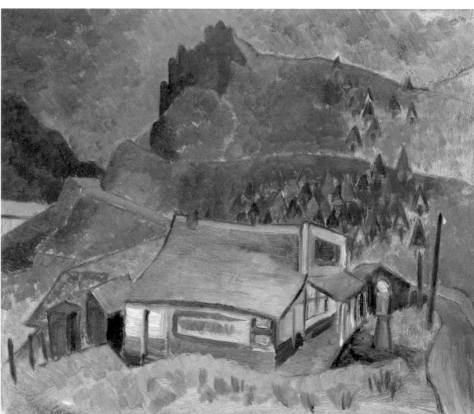

THE WHITE HORSE
circa 1939, oil, graphite on
board, 24 x 28 cm
Vancouver Art Gallery
Gift of Mrs. Jessie Binning

CARIBOO
1941, oil on paper, 28 x 33.8 cm (image)
Vancouver Art Gallery
Gift of Mrs. Jessie Binning

NUDE FIGURE
1940, oil on board, 45.1 x 29.8 cm
Heffel Gallery Limited

FEMALE FIGURE
1943, oil on paper, 25.4 x 35.6 cm
Heffel Gallery Limited

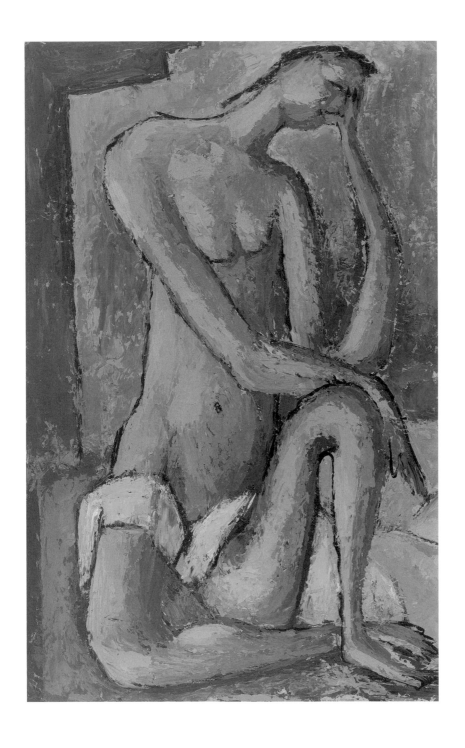

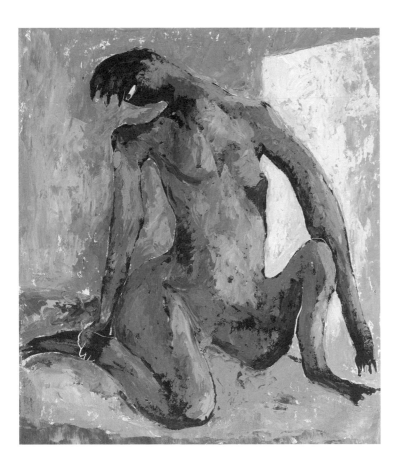

of the still-life elements, *trompe l'oeil* wood grain patterns, and the relatively reduced range of colour that is found in early cubist works.

Binning seems to have used oil throughout the early forties, but it was as a drafts-man that he began to achieve some degree of fame. A comparison of the works extant suggests that, unlike his graphic style, there was a degree of uncertainty in the direc-tion his painting should take. A further problem is the difficulty in dating several of these early works. The works that can be securely dated provide an indication of the range of the work. *Cariboo* (page 121), an oil on paper, can be positively dated to a trip that Binning took in the company of his teacher Charles H. Scott and fellow former student Irene Hoffar Reid in 1941 to the Pavilion area of the Cariboo. Binning's composition is somewhat conventional in terms of spatial development and use of colour, but a continuing interest in abstraction can be seen in the stylized shapes of the trees, which contrast with the reasonably realistic depiction of the architecture and the gas pumps in the foreground.

Early oils, such as *The White Horse,* circa 1939 (page 121), and two oils on paper, circa 1940–43—*Nude Figure,* 1940 (page 122), and *Female Figure,* 1943 (this page)—suggest that Binning was influenced by the example of all his teachers—Gertler, Meninsky, Kantor, and to a lesser extent Picasso, in his figural work. The use of colour is somewhat

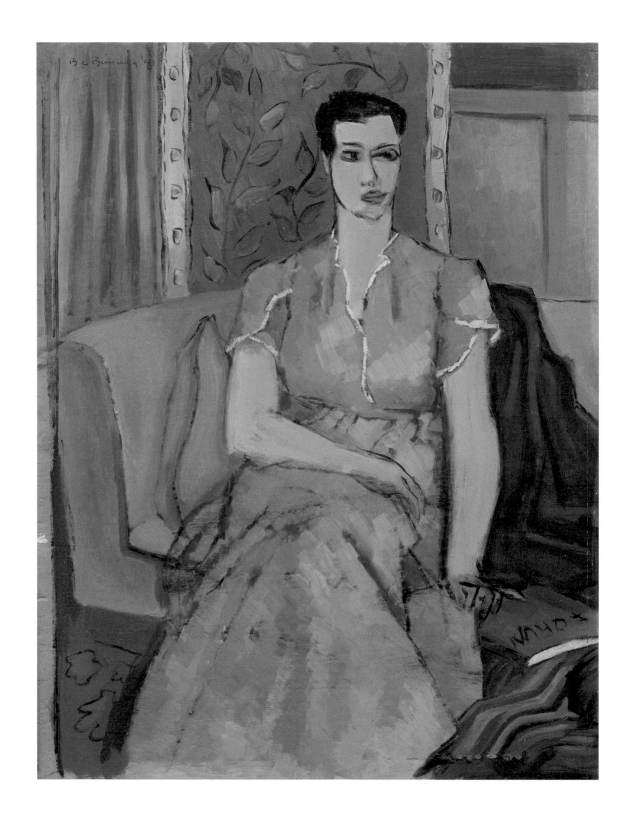

124

sombre and the figures are blocky and abstracted. The paintings of nudes, likely executed in studio sessions with Irene Hoffar Reid and others, also betray at least a passing interest in surrealism, notably in the distortion of limbs and the single eyes of the figures. This, however, does not seem to have been a direction that Binning felt comfortable pursuing.

Another, more successful image from the period is *Portrait of Jessie*, 1941 (page 124). Here Binning has clearly been influenced by the example of Matisse. The use of bright decorative colours, the strong sense of pattern and the shallow pictorial space all suggest a close study of Matisse's images of women.

We know that Binning exhibited a few oils in the early to mid-forties but these have been lost, and not until 1948 does Binning really emerge as a painter of national importance, the public painter. While Binning had achieved considerable distinction as a draftsman, it was clear that he wanted to "make the jump from drawing to painting."[15] In 1947, he took a leave of absence from his job as a teacher at the Vancouver School of Art. Of this period Binning wrote:

It was a year of revaluation [*sic*] and experiment, brooding, despair and in the end a small ray of hope: ten large canvases and a few small ones. In looking at myself I saw with a certain amount of justification (because both of my grandfathers were architects) a strong feeling toward these qualities known as 'architectural' in painting. The quality may have accentuated itself, just then, because I was also designing and supervising the building of two houses. Whatever the reason, I began to feel greatly both the discipline of Architecture and its formal ideas, things like: the flat of the picture plane, the strong boundaries of the frame, the simple strength of the truly architectural form and its relating space, the contrasting play of line, the force of colour when freed from atmosphere and effect. Or perhaps it was the sudden realization of what can happen creatively when one frees not only colour, but form and everything else, from visual accident and recreates through the formal and architectural approach. Whatever it was, it hit me like a ton of architectural bricks.[16]

The group of paintings executed in 1948 remains among the most important of his career, and these works soon found their way into major Canadian collections—the Vancouver Art Gallery, the Art Gallery of Toronto (now the Art Gallery of Ontario), the National Gallery of Canada and several important private collections. These

PORTRAIT OF JESSIE
1941, oil on plywood, 45.4 x 36 cm
Vancouver Art Gallery
Gift of Mrs. Jessie Binning

elegant images of boats and maritime life reveal Binning's sure command of line, colour and composition. They are unlike anything produced in Canada at the time and clearly mark him as an original thinker.

Two rather different paintings from this period of intense activity bear special attention. *Ships in Classical Calm* (page 127) and *Ships and Tower* (page 129) both date from 1948. We are fortunate to have Binning's comments on some of these works. Of the creation of *Ships in Classical Calm*, Binning stated:

It was in the fall, and I went up the Indian Arm on a little excursion boat, as a matter of fact, and it was just after the war and there were a whole number of ships in one of the coves on the way up there … a whole fleet of World War II ships that had been tied up and now, when you're a small boat and low to the water, and these great hulks towering above you and these great shapes which to me are terribly impressive, there's something—I don't know—about a ship viewed, especially bow on, that has a regalness about it, a real elegance. We passed these going up the Arm, and then coming back home again, and they fascinated me, and there they sat—absolutely still in this calm water and there was something sad about them too in a way … simply sitting there with all their glory stripped from them.[17]

The sense of awe that Binning felt at seeing these ships is reflected in the paintings in the ships' towering forms, and the grey west coast atmosphere is suggested in the choices of colour. The composition is a harmonious play of greys, blues and blacks. It is strongly architectural and has a grid pattern embedded in the composition. The stillness that Binning observed when he saw the boats is present but it is counterbalanced by the elegant play of curved and angular shapes. The fascination with line, so present in the earlier drawings, is allowed some free play in the pattern of the rigging, and the portholes give the otherwise sober image a playful touch.

As Donald Buchanan has pointed out, Binning's "problem" was "to fuse the lyric idea, which was so present in his earlier drawings, with these new architectural values."[18] For Binning, boats were an ideal subject matter because, in his own words, "Being a seaside person, small boats, ships and things of the sea are old loves of mine—I know them well and I find them ready forms for interpretation. They can be lyric, no doubt about that, grand and elegant with dignity and power, or jolly and happy for joy. They abstract well …"[19]

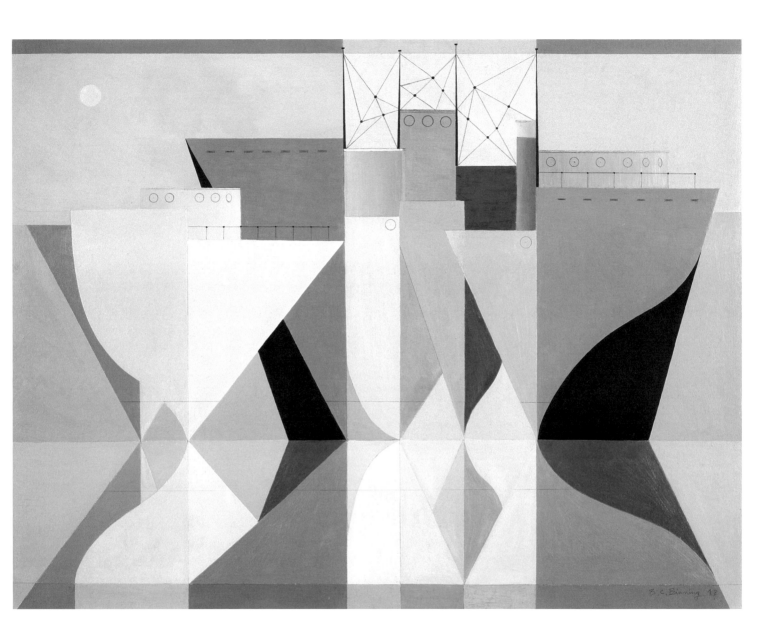

SHIPS IN CLASSICAL CALM
1948, oil on paperboard,
81.5 x 103.8 cm
National Gallery of Canada,
Ottawa, purchased 1949

A significantly greater degree of abstraction is present in *Reflected Ship,* 1950 (page 130). The work is initially somewhat hard to read, as Binning plays with shape, texture and colour. The strong linear pattern of the rigging recalls the vivid drawings of the earlier forties, but this degree of abstraction of form is something entirely new. In a later interview Binning characterized the shift from drawing to painting: "I think the main change, I suppose that it's a psychological one, that came when I went into painting was from the particular to the general."[20] This shift was perhaps strengthened by the working method that Binning adopted for his painting. Each of the larger works was preceded by "quite finished little sketches of what I was going to do."[21] This "classical approach to art" allowed Binning to concentrate on "the idea of form, space, colour, texture." As he noted, "These things are of cardinal interest to me when I approach any kind of visual thing."[22]

I would argue that there is a slight tension between this strongly formalist impulse and a more playful side of Binning in much of his painting. In Binning's own words, the work is about "this business of serious joy."[23] Its formality is not divorced from the simple pleasures of delight and even, on occasion, whimsy.

Ships and Tower combines both a strong formal sense and a delight in fanciful drawing. The grid, which regulates the composition, is balanced by a vivid pattern of colour, shifts in texture, graceful curves, and elegant linear patterns that define the space.

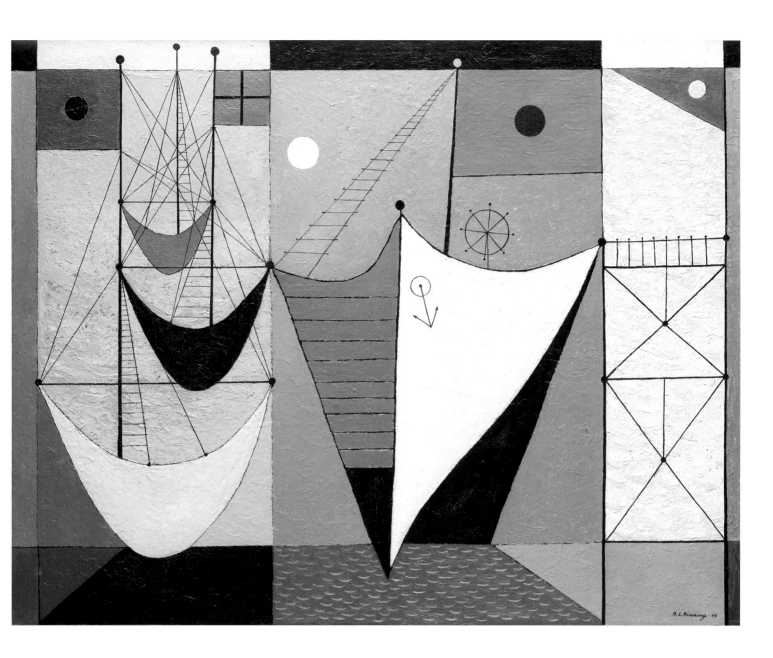

SHIPS AND TOWER
1948, oil on panel, 81.1 x 102.4 cm
Vancouver Art Gallery
Gift of J. Ron Longstaffe

REFLECTED SHIP
1950, oil and graphite on paperboard,
120.8 x 50.1 cm
Art Gallery of Ontario, Toronto
Gift from the J.S. McLean Collection, 1969
Donated by the Ontario Heritage
Foundation, 1988

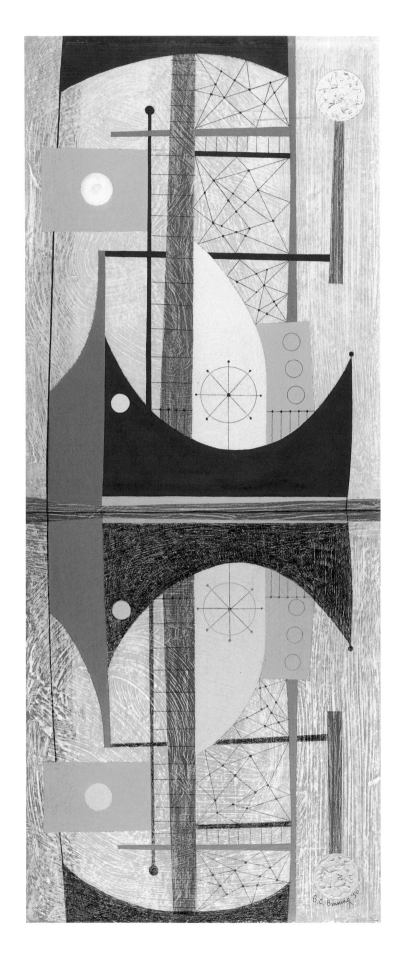

130

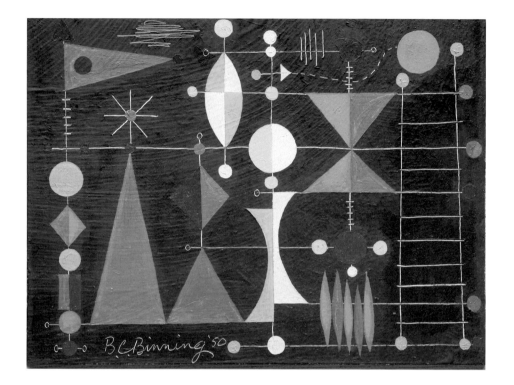

Binning's interest in producing dramatically different compositions is evident when we compare two small works from 1950, *Night Harbour* (this page) and *Three Ships and Reflections* (page 132). Of the first Binning commented: "*Night Harbour* came about when I was coming home from another excursion, over from Vancouver Island I think. It may have been the Victoria-Nanaimo boat, and we were coming into the harbour in Vancouver and you know when you come around Brockton Point there and suddenly you break out into all the lights of the harbour and the ships and so on, and all this black velvety summer night again with all these signals, lights flashing and neon signs—all this activity going on at night. You know it's really quite stirring."[24]

The flickering, intense colours of the flags, buoys and other shapes suggest the nighttime effects of lights on the water and reflections, which sometimes make the space of the work difficult to read. Binning is able to subtly balance a keen interest in linear pattern with a bold use of colour, and the resultant image is an imaginative recapturing of his experience entering the inner harbour.

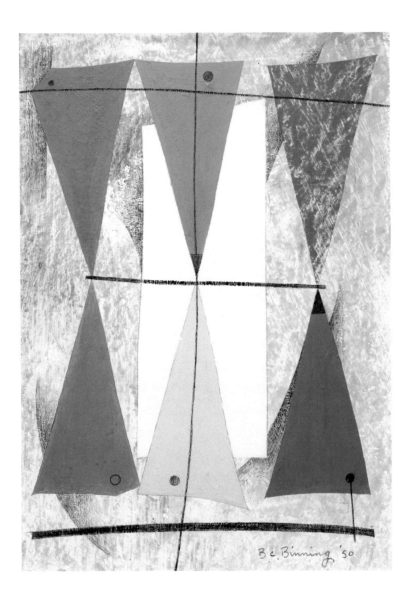

Three Ships and Reflections is no less ambitious, if a significantly more austere image. At first it seems to be entirely abstract but, in fact, the triangular shapes recall the shapes of ship hulls seen in earlier works. The use of colour is carefully balanced and the work encapsulates perfectly Binning's desire for "serious joy."

The impulse to abstraction, "the idea of form, space, colour, texture," led a willingness to explore considerable degrees of abstraction on Binning's part. The painting *Squally Weather*, 1948–50 (page 133), is a brilliant example of his skill at evoking an emotive response through abstract means. The contrast of textures, shapes and the linear pattern (another disrupted grid) all suggest the buffeting that one experiences in *Squally Weather*. Binning was soon to explore this growing interest in abstraction in two very different murals at his residence.

SQUALLY WEATHER
1948–50, oil on paperboard, 81.3 x 102.9 cm
Art Gallery of Ontario, Toronto
Gift from the Albert H. Robson Memorial
Subscription Fund, 1951

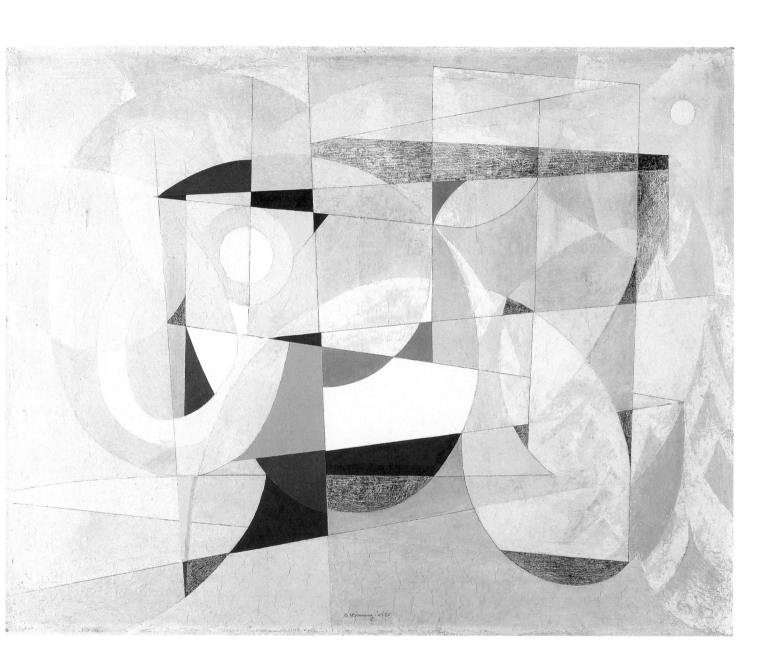

The construction of the Binning house in 1940 allowed Binning to play with large-scale painting for the first time. He completed murals for both the interior and exterior of the house. The first exterior mural (page 58) was an outgrowth of the ideas present in the paintings of 1948–49 and was probably completed in either 1949 or early 1950. The photographic evidence suggests that the mural was a spirited assemblage of maritime motifs—flags, boats, clouds, fish, lifeguard towers, and so on. In tandem with this playful aspect of Binning's work was a somewhat more formal side. The interior mural (page 73), which survives in its first form, is an interesting example of Binning's work as an abstractionist. Closely allied with the work that Binning produced slightly later for the O'Brien advertising studio in 1953–54 (page 135), the mural is a subtle play of shapes and colours that animates a difficult, oddly shaped wall at the end of the principal corridor in the Binning residence.

The mural is based on a series of shapes—squares, diamonds, rectangles, circles and half-circles all within a generalized grid form. Binning, however, never allows the grid to achieve supremacy in these images. The diamonds are not quite regular in shape and the roughness of the drawing is enhanced by a growing interest in texture. Binning began to explore the use of sand in his pigment, he applied areas of paint differently, and he used incising and a variety of painting supports—canvas, masonite, paperboard and jute.

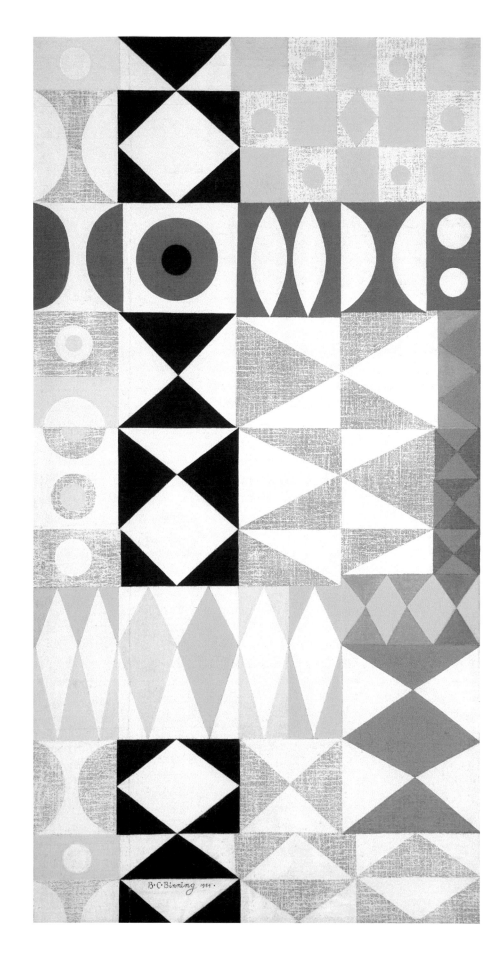

UNTITLED
(O'BRIEN ADVERTISING MURAL)
1954, oil on burlap, 241.3 x 125.7 cm
Vancouver Art Gallery Acquisition Fund

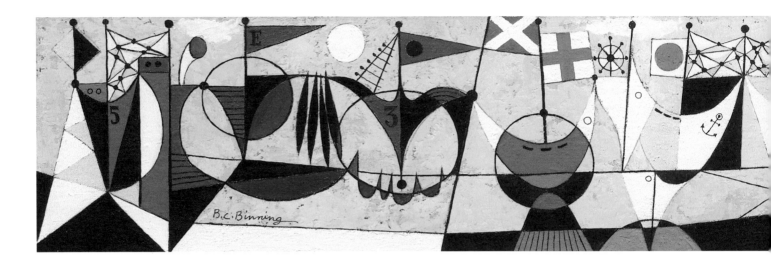

Although Binning continued to produce delightful maritime images throughout the fifties—*Ships of the Line Sailing in Review* (pages 136–37) and *Flotilla in Primary Colours* (page 137) are but two examples—the direction suggested by works such as *Squally Weather* led to a series of *Theme Paintings* beginning as early as 1954. These works, which continued into the fifties, at first recall the example of Piet Mondrian, Theo van Doesberg and early works by Binning's American contemporary Burgoyne Diller, but they are, in the end, very much in Binning's own idiom. For Binning *Theme Painting,* 1954 (page 138), presents a world in which "one finds clarity, elegance, purity, balance, beauty, order, completeness and with that a satisfaction." There is in these paintings, as Binning notes, "nothing terribly mysterious … nothing untidy, nothing awkward"; they are "a terribly orderly [visual] journey."[25]

Such a description would seem to imply very pedestrian images, yet the *Theme* paintings are anything but pedestrian. Like Mondrian before him, Binning is sensitive to the placement of a shape, the size of a field of colour, the choice of colour, and variations in texture. The paintings can sometimes be read as urban environments but are more likely arrangements of shape and form, which pleased Binning. Subtle touches give a sense of energy to these works. For example, not one of the rectangles in *Theme Painting* is the same size, and the placement of the brightest colour element, the yellow, leads the eye around the whole canvas. Binning is clearly aware of the surface of the

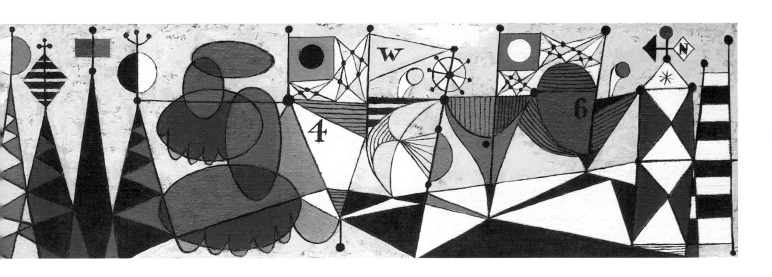

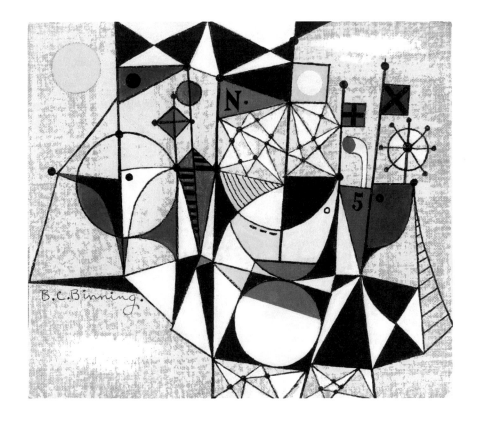

SHIPS OF THE LINE SAILING
IN REVIEW
1955, oil on board, 17 x 111.8 cm
Private collection

FLOTILLA IN PRIMARY COLOURS
1955, oil, gesso on burlap,
21.5 x 24.5 cm
Vancouver Art Gallery
Gift of Mr. and Mrs. Joseph Peacock

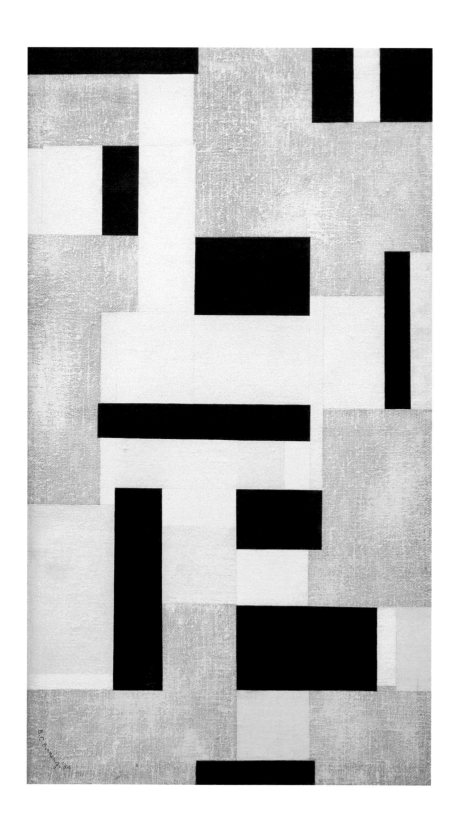

THEME PAINTING
1954, oil on burlap, 74.5 x 130 cm
Morris and Helen Belkin Art Gallery,
University of British Columbia
Gift of Mrs. B.C. Binning, 1991

RELATED COLOUR FORMS
1957, 86.5 x 114.3 cm, oil and
gesso on burlap
National Gallery of Canada,
Ottawa, purchased 1957

painting, the edges of the canvas, and the play between figure and ground that is accomplished through the varied texture of the surface.[26]

At times, in paintings such as *Related Colour Forms*, 1957 (this page), the painted elements seem to hover above the roughly painted "background"; at other times the "background" seems to float forward. While these observations in no way discount Binning's description quoted above, I suggest that these works have a quality that transcends prosaic arrangements of geometric (or, in some cases, slightly askew) shapes and rise to "a plane that is quite above the ordinary."[27] Here, and in a number of his more serious paintings, Binning is hinting at the spiritual, and in this he has links to his friend Lawren Harris.

Binning's great personal interest in architecture manifested itself in a variety of ways—the design and building of his own house, a series of architectural commissions, and in a series of triptych works he executed in the fifties. These works, which

UNTITLED *front view*
circa 1955, oil on composition board, wood,
metal hardware, 104.4 x 85.5 x 7.6 cm
Vancouver Art Gallery Acquisition Fund

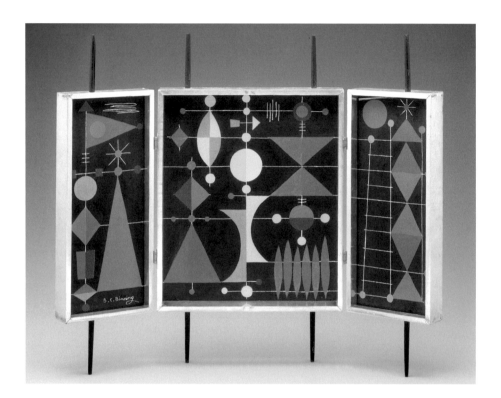

**MARINER'S TRIPTYCH:
FOR NIGHT NAVIGATION**
1955, tempera on composition board,
wood, silver leaf, metal hardware,
57.3 x 67.2 x 4.8 cm
Vancouver Art Gallery
Women's Auxiliary Provincial
School Scheme

recall the work of Renaissance artists,[28] are secular altarpieces and reveal Binning's great sense of design, his appreciation for three-dimensional space and, often, his sense of humour and delight.

These works were meticulously crafted. Working initially with a scale model, Binning careful planned the frames, using silver leaf and rods at both top and bottom, and was highly conscious of the reading of the images when the wings of the paintings were opened or closed. *Mariner's Triptych: For Night Navigation*, 1955 (this page), recalls the earlier *Night Harbour*; indeed, it repeats a number of the shapes and motifs, but it has a significant, sculptural presence. *Untitled*, circa 1955 (pages 141 and 142), is the most ambitious of the triptychs and the only one known to be conceived as freestanding rather than as a painting to be hung on the wall. The simple geometric shapes and the strong colours give the work a vitality and, despite its relatively modest scale, a real presence in a room.

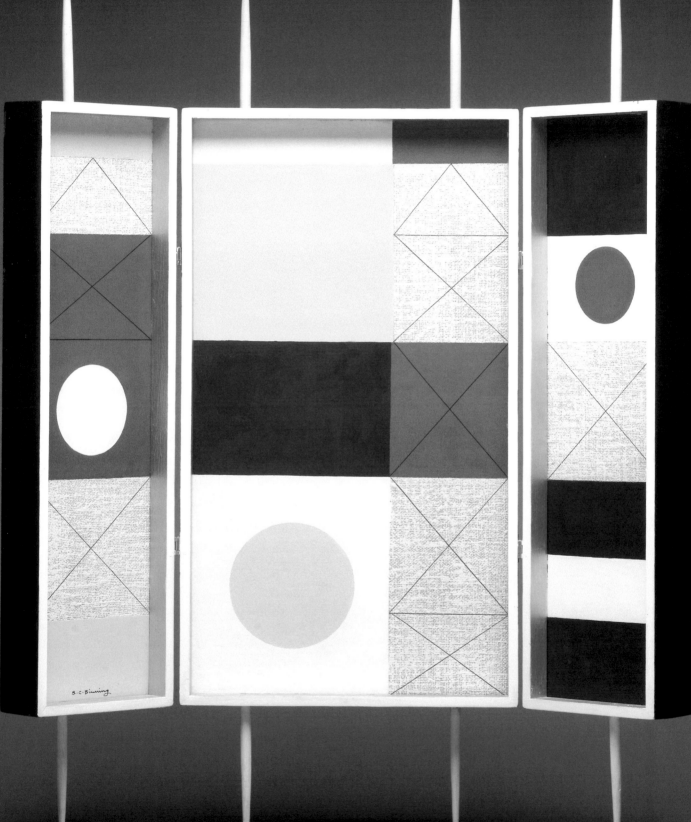

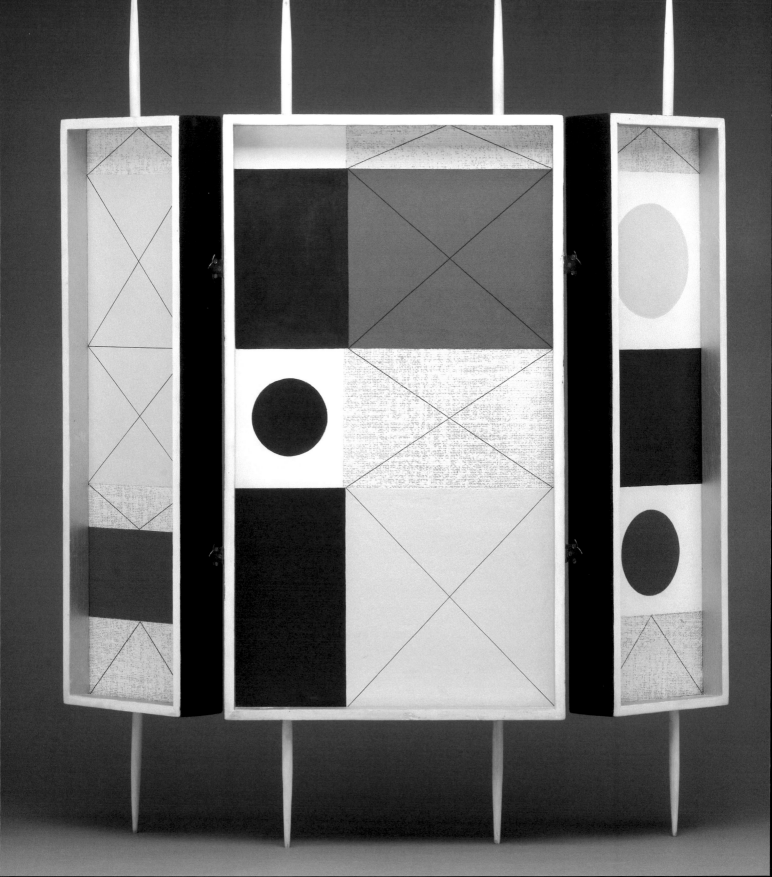

In 1957, Binning was commissioned to design a mosaic mural for a branch of the Imperial Bank of Canada. The maquette of the mural (pages 144–45) is, in many ways, a summation of the first decade of Binning's painting. A stylized survey of the industrial life of the province, including images that relate to fishing, fruit growing, aviation, shipping, railways, the pulp and paper industry, plywood production, livestock farming, the oil industry, grain elevators and the financial industry, the painting is a compartmentalized composition (recalling the first Binning house mural). The work combines extremely diagrammatic illustrations (for example, the lumber section) with almost naïve depictions (such as the fish and the helicopter).

When Binning next exhibited his work in a solo show at the Vancouver Art Gallery in 1961, he had made another significant shift in his approach to painting.[29] Geometric shapes had for the most part disappeared and the work achieved a new simplicity of form. The previous several years had been much occupied by his work on the bank and other murals as well as his work as head of the Fine Arts department at the University of British Columbia. His painting, therefore, had in large measure ceased. The completion of the bank mural in early 1958 had allowed Binning to take up a Canada Council grant he had been awarded in 1957 and make a trip to Japan. Although it is probably an oversimplification to see the simplicity inherent in much Japanese design in Binning's new direction, the emergence of this new approach to painting following a very successful trip to Japan is certainly suggestive. For his own part, Binning wrote of these works:

Coming back to painting after several years taken up mainly with mural and architectural work, I find the environment of the sea still holds me. But it is no longer the ships and activity on it that is my main concern—rather the sea itself, its mood and expanse.

This exhibition represents a transition from my previous painting into a new world for me of space and colour. I am hopeful that by emphasis on space and colour the varying moods of the subject are implied: or in other words, the painting will generate an emotional impact paralleling the one I experience with the same subject.

To heighten the impact, in many cases I have used other colours than those that would have appeared, and have strengthened tensions in space in order to add breadth to the experience.

MAQUETTE FOR THE IMPERIAL BANK MURAL
1957, oil on composition board, 58.1 x 241 cm
Vancouver Art Gallery Acquisition Fund

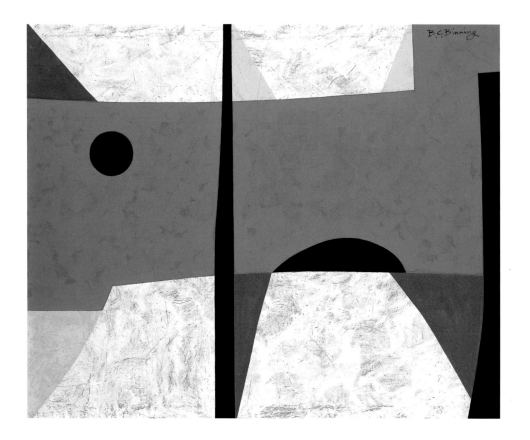

BLACK ISLAND
1960, oil on canvas, 89 x 107 cm
University of Lethbridge Art Gallery
Gift of Mrs. B.C. Binning

Therefore I have had to interpret colour and space in other than actual or representational terms. At the same time I am still interested—and I suppose I always will be—in the architectural discipline of the canvas.[30]

The shift in the images is, in fact, quite startling. Binning uses almost electric colours and the application of the paint changes radically. While images such as *Black Island* (this page) and *Sunset Sea* (page 147) retain recognizable elements of landscape, the use of brilliant colour gives the works an almost dazzling quality, and the scumbling of the paint surface recalls Binning's earlier experiments with texture. One cannot look at these images without thinking of the brilliantly coloured images of Matisse and Binning's early admiration of his work.

The vivid colour of *White Shadow* (page 148) and the inversion of our expectations—a brown/black cloud and a white shadow—help to enhance the emotion of the image and confound our reading of the space. The white shadow appears in the middle of

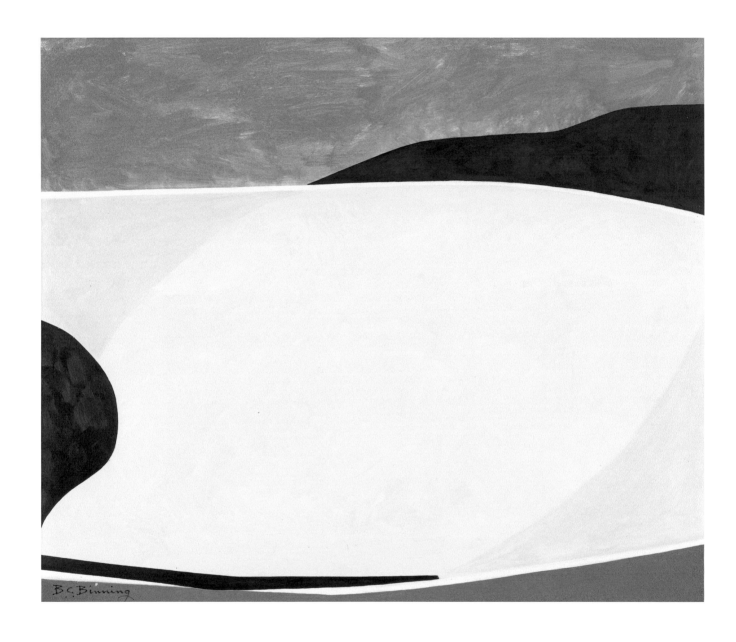

SUNSET SEA
1960, oil on canvas, 89 x 107.5 cm
Private collection

a field of white, which is presumably the ocean, but one is given no other clues beyond the variation in paint texture. This work, with its broad horizontal divisions, also recalls the work of the great American abstractionist Mark Rothko.[31] This connection is even more vividly seen in the colours and forms of *Purple Calm* (page 149).

One striking element of all these paintings is the careful placement of Binning's signature in each. In these, as in most of the works from the fifties on, it has an important function within the composition. His intrinsic sense of design was always extremely deft, and if the signatures were removed from these works, the balance of the composition would suffer.

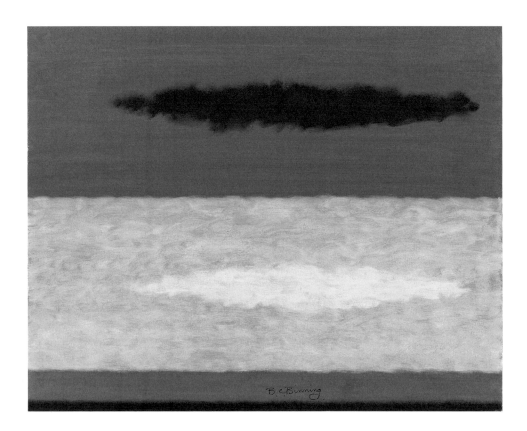

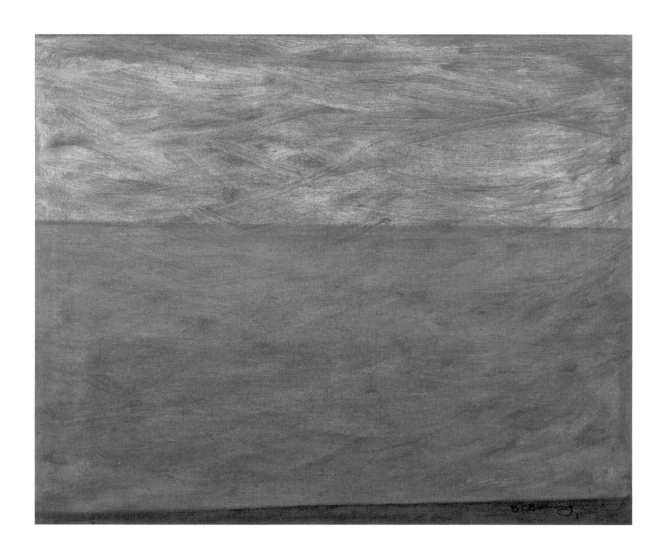

WHITE SHADOW
1960, oil on canvas, 71.8 x 89.5 cm
Vancouver Art Gallery
Gift of Mrs. Jessie Binning

PURPLE CALM
1960, oil on canvas, 73.5 x 91.5 cm
Vancouver Art Gallery
Gift of J. Ron Longstaffe

ST. ELMO'S SHIELD
1968, oil on wood, composition
board, 87 x 87 cm
Vancouver Art Gallery
Gift of Mrs. Jessie Binning

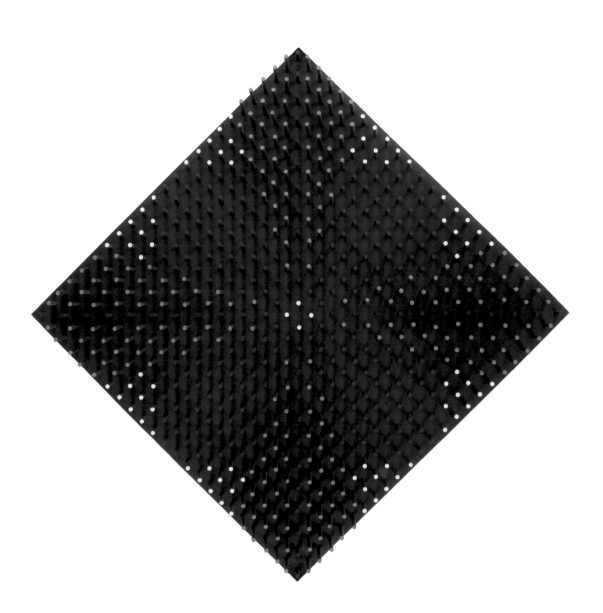

THE SHIELD OF ELECTRA
1968, oil on wood relief, 91 x 91 x 8.9 cm
National Gallery of Canada, Ottawa
Royal Canadian Academy of Arts diploma work
Deposited by the artist, Vancouver, 1968

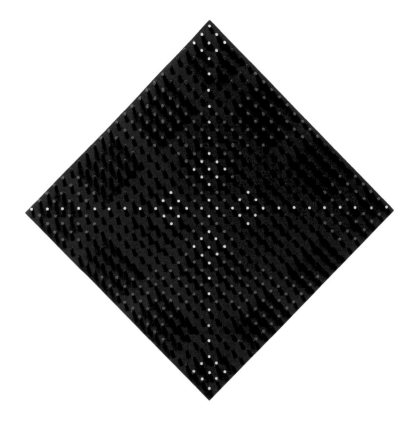

Binning's strong sense of design may also account for an unusual group of works that date from the mid-sixties. These constructions, which include *St. Elmo's Shield*, 1968 (page 150), are more sculptural object than painting and recall the triptychs of the fifties to some degree (certainly this is true in their use of the dowels). Although Binning submitted one of these paintings, *The Shield of Electra* (this page), to the National Gallery of Canada as his diploma piece for full membership in the Royal Canadian Academy of Arts, they are not among his more successful works. The means, the use of colour and the design elements seem at odds with each other.

During the sixties Binning produced very little work; he seems to have been too occupied with his duties at the University of British Columbia and elsewhere.[32] He did produce a small number of works that he called *Motifs*. Of these, perhaps the most successful is *Night Image*, 1966–67 (page 152). While they recall the *Seascapes* of 1960 in colour, the forms are larger and are less overtly elements of landscape. Commenting on these works, Binning felt that "there is a bigness of shape around B.C. that you can't get away from. I find it pretty overwhelming at times. Whether you are looking at the mighty trees, or up into the mountains—or at the expansive space of the sea—there is this tremendous scale. I would imagine that this comes into these works."[33] There is, even, a sense that the forms are almost too big for the canvases. In all of these works (*Summer Sun*, 1965, page 153, is another example), there is a feeling of pushing beyond the confines of the rectangular format.

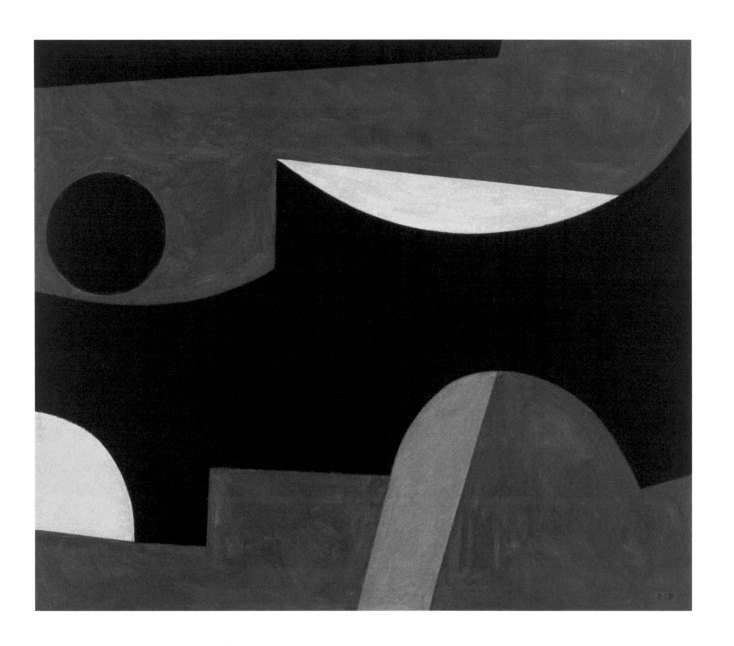

NIGHT IMAGE
1966, oil on canvas, 120 x 137.5 cm
Dalhousie Art Gallery, Halifax

SUMMER SUN
1965, oil on canvas, 137.5 x 119.8 cm
Private collection

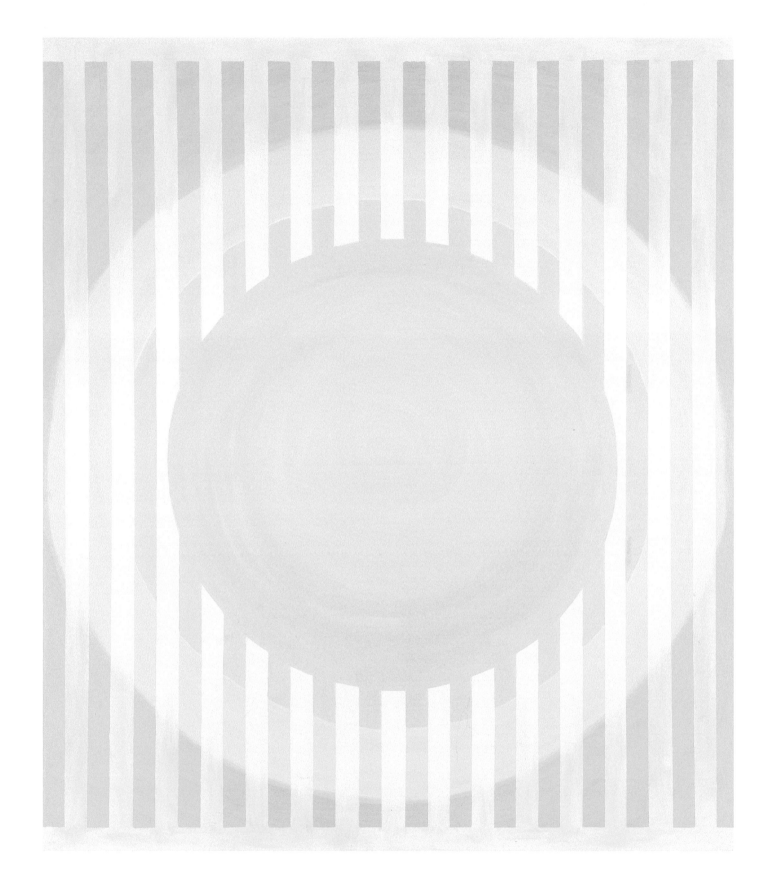

In 1968, Binning resigned as head of the Fine Arts department and shortly afterwards took a sabbatical leave. This allowed him to devote much more of his time to painting, and the period 1969–70 saw a new direction in his art. *Kiss in Nine Pieces,* 1968–69 (page 155), was an important step in determining the nature of his next significant series of paintings. Nine separate square canvases, they are hung as diamonds. Only the largest unit contains all of the colours used—black, white, yellow and two greens. The smaller units echo and enhance the visual statement in the main canvas. Binning's decision to place the darker elements at the right side of the composition means that after our initial left to right reading of the work, the eye returns to the brilliant yellow initial canvas. This conscious choice of colour and the variety of canvas sizes give an almost impulsive rhythm to the whole composition.

In the series *Optional Modules,* 1969–70 (pages 156–57), Binning, while retaining his abiding interest in the "architectural discipline of the canvas," radically shifted his work away from the rectangular format he had always used. Binning felt "that one can work in a more three-dimensional and fluid way than just square or rectangular paintings." He also wanted to allow "the beholder" of the work a way to enter the creative experience. "So I thought that in some modest way I might give him a chance to enter into the thing by creating rectangles and triangles that could be assembled in all sorts of ways to make up a design or painting of all kinds of shapes."[34]

Working with small models, Binning developed a large series of variations for each of the *Optional Modules.* The works range from brilliant studies in vibrant colours to more muted greys, which emerged as winter approached.[35] Binning was not, however, willing to give up complete control of his images and therefore suggested a series of possible arrangements for the elements. Indeed, the exhibition poster for the show of these works at the Bau-Xi Gallery in Vancouver consisted of a series of grey diagrams detailing the variations possible.

Although Binning was criticized for his failure to use more contemporary materials[36] and the manipulating of the canvases can be, to use Binning's word, "cumbersome,"[37] the *Optional Modules* were a highly individual but important contribution to Canadian abstraction of the period. As Doreen Walker has noted, these works are a game and reveal "something of the artist's humour and something of his wit."[38] This body of work as a whole reveals a return to the spirit of exploration so vividly seen in the first important body of paintings from 1948.

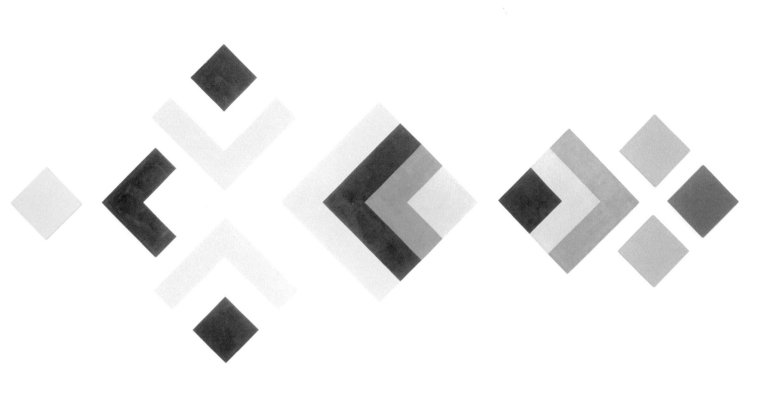

KISS IN NINE PIECES
circa 1968–69, acrylic on canvas, 102 x 102 cm (largest unit),
30.5 x 30.5 (smallest unit), size variable, nine units
Vancouver Art Gallery
Gift of Mrs. Jessie Binning

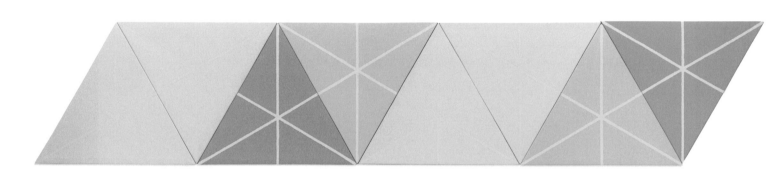

OPTIONAL MODULES IN BLUE AND GREYS
1969–70, acrylic on canvas, 50.7 x 50.7 cm (each unit, eight units)
Vancouver Art Gallery
Gift of Mrs. Jessie Binning

OPTIONAL MODULES
1969–70, acrylic on canvas, 35.5 x 61 cm (each unit, six units)
Vancouver Art Gallery
Gift of Dr. and Mrs. Ben Kanee

UNTITLED
1970, acrylic on canvas, 61 x 61 cm
Vancouver Art Gallery
Gift of Mrs. Jessie Binning

The deterioration of Binning's health prevented him from doing much more painting from 1970 until his death in 1976. In the summer of 1970, however, Binning, while recuperating at home from a serious illness, was asked by his friend Geoffrey Massey to produce a series of screen prints for a hotel project.[39] Binning chose as his subject vine leaves that his wife had in their garden. In conjunction with this project Binning produced a small canvas that can be seen as a coda to his painting career. *Untitled* (page 158) is an abstracted portrait of a single leaf but it is a work of remarkable achievement. Here Binning's sure sense as a colourist, remarkable control of line, and "architectural" sense of the shape of the canvas are all evident. It is a painting that is a product of distillation—a distillation that occurred only after a prolonged contemplation of nature. The quality of Binning's eye, the depth of his powers of observation is something that marks all of his work: drawings, paintings and architecture.

RICHARD E. PRINCE **AFTERWORD: BERT BINNING AT THE UNIVERSITY**
OF BRITISH COLUMBIA

At the northern tip of Point Grey on the campus of the University of British Columbia there sits a cluster of buildings collectively known as the Arts precinct. Sited with adjacent lawns, paths and plazas, they project an elegance and a hopeful generosity in keeping with a view of education that is rigorous yet at the same time nurtures a yearning spirit. These buildings were constructed in the late 1950s and early 1960s, a period of rapid expansion at the university, partly in response to a developing provincial economy but also in anticipation of the arrival of the multitudes of the post-war baby boom. Construction of the Buchanan Building to consolidate the Arts and Humanities began in 1956 and was followed by International House and the Thea Koerner Graduate Centre. These latter two buildings stated an ambitious engagement by the university with the world beyond provincial and national borders.

Envisioned at the centre of this part of the campus was a creative and performing arts core. Now formally named the Norman MacKenzie Centre for Fine Arts, this plaza links the Frederick Lasserre Building for art and architecture, opened in 1962, with the Frederic Wood Theatre and the School of Music. With the completion in 1995 of the Morris and Helen Belkin Gallery, this idealistic and even utopian vision of the place of the humanities and creative and performing arts in university life was settled into its Modernist environs. Each of these buildings, despite their variations in style and detail, reflects the underlying principle of late high Modernism, which asserted that the life of individuals and society will be made better through the integration of good design at all levels of use and the inclusion of visual art as part of our everyday surroundings.

Bert Binning was a significant catalyst in the group of deans and department heads who conceived, promoted and shepherded this ambitious project under the leadership of the president, Norman MacKenzie. I often reflect on the success of their intent as I go

to a class or a meeting in these buildings, which still serve their original functions. The effects of their vision on the academic culture of the university have been profound, lasting and very real.

I first encountered Professor Binning when I was a student in the Department of Fine Arts in the late 1960s and early 1970s. Even in those days of sporadic campus turmoil and wishful student rebellion he was always known as "Professor Binning." Initially he was a distant and exalted figure, as were all professors to beginning undergraduates, but I did get to know him better when I took what was to be the last drawing course he taught. That course had the intimidating title of "Analysis of Style," but Professor Binning with his gently encouraging manner led a drawing class that sparked interest in the translation of the appearance of reality onto a two-dimensional surface.

In keeping with his philosophy of the integration of art and life, and with arms folded comfortably across his suit jacket, Binning brought all of his energy, conviction and compassion to the classroom. Through a series of engaging discussions he probed the nature of drawing and expanded our understanding of the meaning of art. Using slides, he introduced us to a diverse group of artists, taking delight in everything from the fluid line of a Henri Matisse to the anatomical accuracy of a Thomas Eakins. Not everyone who took the class became accomplished at drawing, but what became clear was that learning to draw was not merely a sequence of in-class or out-of-class exercises but was instead part of a process by which to interpret and, hence, to alter the world.

It is always difficult to assess the legacy left by any artist and almost impossible to trace that of the teacher, but in the case of Professor Binning the legacy is visible in his own art and subtly active in his students.

For Binning the artist, there are his paintings and drawings to consider. In particular there is a canvas by Bert Binning now hanging in what was once his office in the Lasserre building. It is a remembrance of his presence and his influence on the campus. This painting with its cream, black and lemon-yellow geometry is a lyrical abstraction exploring the relationship between our lives and the broad scope of art, reassuring us that the art object still matters in an academic world of words.

For Binning the educator, the Arts precinct—largely a result of his vision—almost fifty years later still lends its gracious openness and architectural structures to the belief in an education founded in the arts and humanities. His devotion to art established a department that maintains even now the core of his guiding principles and has mentored thousands of students who have passed through the institution and have been enriched by their contact with art.

Teaching is akin to broadcasting radio signals into space. As signals travel out from the earth, they grow fainter but are, nevertheless, always present to be received by distant planets. Something of the same pertains to Professor Binning's role in that the influence he had upon each student has travelled with them to have its effect on places and people far from the source. And I believe that effect carries his central tenet, which asserts that art is a positive force by which we can first examine and then, indeed, improve our world.

CHRONOLOGY

1909	Born February 10 in Medicine Hat, Alberta
1913	Family moved to Vancouver, B.C.
1927–32	Attended the Vancouver School of Decorative and Applied Arts (renamed the Vancouver School of Art in 1934). Studied under Charles H. Scott, F.H. Varley and J.W.G. Macdonald
1933	Appointed instructor, Vancouver School of Art
1936	Received a Carnegie Scholarship to attend Summer School at the University of Oregon. Studied under Eugen Gustav Steinhof Married Jessie Isobel Wyllie
1938	Travelled to London, England. Attended classes at the Central School of Art (under Bernard Meninsky), at the Westminster School of Art (under Mark Gertler) and at the Ozenfant Academy of Art (under Amédée Ozenfant and Henry Moore)
1939	Prior to the outbreak of World War II, returned to Vancouver via New York, where he briefly attended the Art Students League of New York (under Morris Kantor). Visited the New York World's Fair and the Museum of Modern Art
1940	Designed and built his own house in West Vancouver
1941	Awarded the Beatrice Stone Medal for Drawing at the 10th Annual B.C. Artists' Exhibition, Vancouver Art Gallery
1943	Participated in the formation of the Art in Living Group (with Fred Amess)
1944	Solo exhibition, Vancouver Art Gallery Sold two drawings to the National Gallery of Canada
1946	Solo exhibition, Vancouver Art Gallery, and subsequently at the Art Gallery of Toronto Canadian Graphic Arts, São Paulo, Brazil Arranged the visit of the American architect Richard Neutra to Vancouver (in connection with the Art in Living Group)
1947–48	Took leave of absence from the Vancouver School of Art to spend time painting
1949	Appointed Assistant Professor, School of Architecture, University of British Columbia Design for Living, Vancouver Art Gallery Fifty Years of Canadian Art, Art Gallery of Toronto
1950	Solo exhibition at the UBC Fine Arts Gallery Canadian Painting, National Gallery of Art, Washington, D.C. (organized by the National Gallery of Canada)
1951	São Paulo Bienal Received Carnegie Travel Grant to study art programs at European and North American universities Two-man show (with Stanley Cosgrove), Art Gallery of Toronto

Paintings and Drawings by B.C. Binning, The Little Gallery, Ottawa
Nineteen Western Canadian Painters, Dominion Gallery, Montreal

1952 Wrote *Report of the Committee on Art Education in European and North American Universities,* presented
to the Carnegie Foundation and to Dr. N.A.M. MacKenzie, President, University of British
Columbia
International Exhibition of Contemporary Painting, Carnegie Institute, Pittsburgh, Pennsylvania
Paintings and Drawings from the Collection of J.S. McLean, National Gallery of Canada

1953 São Paulo Bienal
XXVII Venice Biennale

1954 Solo exhibition, Laing Galleries, Toronto

1955 First Biennial Exhibition of Canadian Painting, National Gallery of Canada
Solo exhibition, Watson Art Galleries, Montreal
Appointed Associate Professor and Head, Fine Arts department, University of
British Columbia

1956 B.C. Art To-day, Art Gallery of Greater Victoria

1957 Contemporary Canadian Painters, organized by the National Gallery of Canada for circulation
in Australia
Second Biennial Exhibition of Canadian Art, National Gallery of Canada
Undicesiona Trienale, Milan, Italy
In Venice, Italy, to supervise mosaic work for the mural commissioned by the Imperial Bank of
Canada, Vancouver (now the Canadian Imperial Bank of Commerce), from September to
January 1958

1958 Travelled to Japan on a Canada Council Award for travel and study
Involved in the creation of the Nitobe Memorial Garden at the University of British Columbia
(until its opening in 1964)
Brussels International and Universal Exhibition, Brussels World Fair (Canada Pavilion)
One Hundred Years of B.C. Art, Vancouver Art Gallery
A Canadian Portfolio, Dallas Museum for Contemporary Arts

1959 Contemporary Art in Canada, Wallraf-Richartz Museum, Cologne, Germany

1960 Arte Canadiense, Museo de Arte Moderno, Mexico City

1961 Appointed Professor, Fine Arts department, University of British Columbia
Summer Seascapes, solo exhibition, Vancouver Art Gallery, circulated to Laing Galleries, Toronto

1962 Received the Allied Arts Award from the Royal Architectural Institute of Canada

1963 Received a Canada Council Senior Fellowship
Canada on Canvas, Stratford Shakespearian Festival, Stratford, Ontario

1964 7 Vancouver Painters, organized and circulated by the National Gallery of Canada
 Appointed to the Visual Arts Committee, National Arts Centre, Ottawa (until 1967)

1965 Art and Engineering, Toronto Art Gallery
 86th Annual Exhibition, Royal Canadian Academy of Arts
 The Brock Hall Art Collection, Vancouver Art Gallery
 Appointed to the Advisory Panel for the Arts, Canada Council (until 1967)
 Visited Japan for the second time

1966 Canadian representative at UNESCO conference, Tokyo, Japan; presented a paper titled "East
 and West Influences on Modern Japanese Painting"

1967 Three Hundred Years of Canadian Painting, National Gallery of Canada
 Canadian Painting, 1850–1950, National Gallery of Canada
 Joy and Celebration, Fine Arts Gallery, UBC

1968 Resigned as Head, Fine Arts department, University of British Columbia; continued to teach
 as Professor

1969 The Simon Fraser Centennial Suite, organized and circulated by the National Gallery of Canada

1970 Optional Modules, Bau-Xi Gallery, Vancouver
 Exhibition 4, West Vancouver Visual Arts Society

1971 Officer of the Order of Canada

1973 B.C. Binning: A Retrospective, Fine Arts Gallery, UBC

1974 Retired from the University of British Columbia
 Awarded the degree of D.Litt. *honoris causa,* University of British Columbia

1976 Died March 16, Vancouver

POSTHUMOUS EXHIBITIONS AND AWARDS

1979 Binning: Drawings, Art Gallery of Greater Victoria

1985 B.C. Binning: A Classical Spirit, Art Gallery of Greater Victoria, circulated to the McMichael
 Canadian Art Collection, Winnipeg Art Gallery, Glenbow Museum and Vancouver Art Gallery

1997 Form and Meaning: The Drawings of B.C. Binning, Charles H. Scott Gallery, Emily Carr Institute
 of Art and Design
 Awarded Hon. D.Litt., Emily Carr Institute of Art and Design

2000 Binning residence designated a Heritage House by the Historic Sites and Monuments Board
 of Canada

Chronology prepared by June Binkert

A PASSION FOR THE CONTEMPORARY

1. Binning quoted by Herbert L. McDonald, "B.C.'s B.C. Binning: He's Mining a New Vein of Color," *Vancouver Sun, Weekend Magazine* 11, no. 16 (April 22, 1961), 10.

2. Only a few months after Binning enrolled in Ozenfant's studio the artist left to take up a teaching position in Seattle. Henry Moore then took over the studio. Although Binning's experience with Ozenfant was short it was nevertheless profound. "I learned a lot more than drawing from Ozenfant. [What is in his books] all comes out in his classes—you know that he is thinking about a total kind of environment; art as something quite total." Binning interviewed by Doreen Walker, April 19, 1971 (hereafter Walker).

3. B.C. Binning, "The Artist and the Architect," *Journal, Royal Architectural Institute of Canada* 27, no. 9 (September 1950): 320–21.

4. From "Architecture—Wanting, Needing, But Not Asking," an address to the annual convention of the Ontario Association of Architects (OAA), February 8, 1963.

5. Ibid.

6. Interview with Dorothy Metcalfe, June 10, 1974, transcript in the VAG library (hereafter Metcalfe). "I remember being invited by the Binnings for tea, along with Ron Thom, Jim MacDonald and Colin Hempsal. We took the ferry to the North Shore and hiked up the hill to this special house on Mathers." Note from Gordon Smith, August 2004.

7. "In Binning these polarities are not a contradiction. His playfulness, the pleasure he derives from celebration combine easily with his ability to withdraw into the private world of a search for meaning, order and serenity. The laughing cavalier in him has always been firmly integrated with the disciplined artist and orderly planner." Alvin Balkind in *B.C. Binning: A Retrospective* (Vancouver: UBC Fine Arts Gallery, 1973), 4.

8. From an interview with Alvin Balkind, December 1972, UBC Library, Rare Books and Special Collections.

9. "I was naturally inclined towards Ozenfant … I think it was this classical streak of Ozenfant. He called himself a purist. I wouldn't like to call myself that, but it had something to do with it, a division from cubism in a way." Walker.

10. "In his own house he has painted a mural which fits in architecturally with the house itself, and yet with its serious aesthetic intent, is full of verve, fantasy and fun." John Delisle Parker, "B.C.'s B.C. Binning," *Vancouver Province*, December 30, 1950, 8.

11. "He had more influence [on local architecture] than the professionals … The great thing about him was that he had no compromise at all in matters of taste—it had to be good." Jack Shadbolt quoted in an obituary of Binning in the *Vancouver Province*, March 17, 1976, 7.

12. "[In] my pioneering days back in the early 1930s when I … was prepared to lecture … to anyone on contemporary architecture … during my last school teaching days, that led to the formation of the Art in Living Group. " Binning in a letter to Peter Thornton, January 27, 1954.

13. "Through his leadership in collaboration with … Fred Amess, the Art in Living Group organized two very influential exhibitions which showed the way toward rational design of schools and dwellings emphasizing responsive siting, consideration of sun, light and air and human-scaled functional spaces and equipment." Doris Shadbolt in *B.C. Binning: A Retrospective* (Vancouver: UBC Fine Arts Gallery, 1973), 7.

14. "As I said to Alvin [Balkind], I had this kind of missionary spirit about architecture." Walker. " 'He was really a missionary, I used to say,' recalls Jessie Binning. 'He was a missionary about contemporary architecture and spreading the gospel of art … It was just right for those times …' " Elizabeth Godley, "Binning a Boon to Our Town's Culture," *Vancouver Sun*, November 22, 1986, H3.

15. Binning: "I viewed the University as a pretty brittle and sterile place. I didn't want to have much to do with it. When MacKenzie asked me to come out there and start a department of fine arts it took me a while to decide—to leave the cozy seclusion of the art school … I went out there but they had no place to put me right off so they put me in architecture, because I had been more or less—mostly less—self-taught in architecture … The first thing I saw was an awful lot of students who weren't taking art or architecture or who didn't seem to have much interest in it. I thought it was my responsibility … to get them interested, because I thought it should be part of their education. I don't think in Paris, for example, this would be required." Metcalfe.

16. "Professor Emeritus Stanley Read has added that because Binning was a non-academic in an academic community, he was 'free to cross boundaries.' And cross them he did." Alvin Balkind in *B.C. Binning: A Retrospective* (Vancouver: UBC Fine Arts Gallery, 1973), 6.

17. "To a small boy, he was an imposing person. Big, slow moving, with a deep soft booming voice and a calm almost impassive manner. But he was never in any sense threatening. The gentleness of that extraordinary voice and the soft twinkle of his eyes were never lost on children." Robert K. Macleod recalling his childhood experience as a participant in Binning's Saturday morning experimental art classes at the Vancouver Art Gallery in the 1930s, *Vanguard*, May 1976, 4. "The hearty guffaw and the ironic smile … the quintessential Binning." Alvin Balkind in *B.C. Binning: A Retrospective* (Vancouver: UBC Fine Arts Gallery, 1973), 4.

18. Shortly after Brock Hall opened in 1940, Hunter Lewis, professor of English, suggested that the student council buy paintings for the walls to begin a collection. The first and only purchase was *Abandoned Village*, by E.J. Hughes. In 1955 the student

government set up the Brock Hall Art Committee, and in 1956 J.R. Longstaffe, vice president of the student council, and B.C. Binning induced the council to pass a bylaw making the collection permanent. With proddings from Binning purchases and donations continued. By the late 1960s the collection (forty works) was important enough for works to be lent to major galleries in Canada, Boston and London. In January 1969 the collection was moved to the new Student Union Building (SUB) and renamed the Alma Mater Society Collection. By the late 1970s the lack of student interest moved the Fine Arts department to cease involvement, and in 1982 the collection was stored in a special vault built for it in the SUB. A lack of funding and rising prices slowed the growth of the collection, which is now exhibited in the SUB Gallery only four weeks each year. Information gleaned from catalogue of the Alma Mater Society Art Collection 40th year anniversary publication, 1988.

19. Binning is shocked by a change in the printing format of UBC Reports: "It has degenerated into what appears to be a 'flyer' for a department store." Letter to Ralph Daly, Director of UBC Information Services, October 14, 1964. (From 1952 onwards Binning had badgered the administration to use good graphics.) Re: the "horrible" president's Christmas cards submitted by Gehrke Printing Co., Ltd.—"[They] should be severely slapped for trying to pass out such in the name of Christmas and printing. The craft of printing … is going to get worse and worse unless we … insist on something better." Letter to President MacKenzie, October 22, 1952.

20. "Binning's widow, Jessie, remembers long discussions about their hopes for a brave new world. 'Their boots would be at the door and I would see their legs sticking out in a circle. I fed everybody. We had several of those meetings. It was just so exciting.' " Beverly Cramp, "Supernatural Architecture,"

Vancouver Courier, November 5, 1997, 1–3. Neutra made three such visits to the Binning home, in 1946, 1953 and 1957.

21. "They were so afraid at that time of offending the public … and not make this just a big monster sitting there [which] had to be put there for technical reasons. And so I got Pratt and tried to save the day for them." Walker.

22. "The result is intended to be a visual statement similar to the structural arrangement of a symphony; that is, the main theme at the entrance—the geometric diamond pattern as a statement of the form and plane of the building, the black, grey, blue and green as a statement of the colour or mood of the building. Then, as one walks around and through the building, this theme is played over and over again in many variations. Consequently, this mural cannot be viewed by itself but only as part of a larger and whole scheme." Ron Thom, "Allied Arts Award, 1962: B.C. Binning, Vancouver," Journal, Royal Architectural Institute of Canada 39, no. 4 (April 1962): 47–50.

23. "I was very disappointed in reading in your letter that you had been instructed to have me execute the mural in oil paint … I was from the first of the strongest opinion that the mural should be done in either mosaic or ceramic tile, and indeed my submission was designed in such a way that it could be done in either of these three media. It would seem to me … that the main banking hall, with its elaborate use of materials, requires nothing less than the strong colour and richness of one or the other of these two materials. This mural … planned, by its prominent position, to be a central motif— indeed the centre of interest of the whole banking hall—would become an anti-climax if done in oil paint … I would go so far as to say that I would rather have no mural at all if it is to be executed in oil paint … I want this to be the finest thing I have done [and] want to be able to use a medium in which I can reach this objective." Letter from

Binning to Ron Nairne, McCarter & Nairne Architects, Vancouver, June 25, 1957.

24. "I became obsessed with the idea that visual art was total environment … and I was very keen about contemporary architecture … I felt that it could be enriched with colour and decoration [but] that painting was a little too thin, that it couldn't give the texture and permanency and colour and timelessness that some materials could. Mosaic was one of those materials. I suppose [what] inspired me at that time [was] what the Mexicans were doing. So I was always after the architects to do something like this … I told these hard nosed bankers that they would have to spend some more money, and we'd have to use mosaic. This was after they had accepted my design which they thought [was] going to be done in paint." Metcalfe. "It is … a beautifully designed and bright banking room with the mosaic mural being an inspiring feature." Brochure created to advertise the newly finished Imperial Bank of Canada banking room, circa 1958.

25. "My design includes four colours only [glazed tiles in green, red, grey and grey-black]." Letter from Binning to Mr. J.B. Jakes, J.B. Jakes & Associates, South Edmonton, Alberta, re: ceramic tile mural for the new Edmonton Airport, October 30, 1962. "About the concern expressed by some members of the Committee over the 'sombre forceful choice of colours' … These colours were chosen for several different reasons … First, both the ceiling and floor of this area are particularly light in colour and tone, with the long wall opposite the mural completely glass. Therefore the general effect of the room will be one of lightness and brightness and I felt very strongly that the mural wall should create a firmness to this area in contrast to the almost floating effect of the high-pitched lightness. Further, the design itself was born out of the idea of a strong rectilinear rhythm which would reflect the overall architectural structure of the building as a whole and consequently

the design called for a forceful colour scheme … Dr. Minsos, the architect, is in agreement with me on this matter." Letter from Binning to Mr. G.W. Smith, Director, Construction Branch, Department of Transport, Ottawa, November 2, 1962, re: concern of some members of the Edmonton Air Terminal Fine Art Committee over Binning's colour choices for Exit Concourse Mural.

26. "We are getting nothing but good comment on everything about the building, and this is after having some ten thousand people visit us." Letter to Binning from F.H. Elphike, vice president and general manager of CKWX, on his enthusiasm about Binning's mural, October 9, 1956.

27. Re: the O'Brien mural: "What was left of it is in the house of an old architectural student of mine." Walker. Unfortunately Binning does not give the student's name.

28. The preservation of the CKWX mural was accomplished through the leadership of Shelagh Lindsey, a former adjunct professor in the UBC School of Architecture. She was assisted by the efforts of J. Ron Longstaffe, an art collector long associated with Binning's work at the university, and a host of other volunteers.

29. "The experiences that I happened to have were on the B.C. Coast. I happened to like sailing. I happened to like boats … and I like these little inlets and fjords and bays and coves … I suppose there is something formal about the shapes of ships and their relationships." Walker.

30. Letter from Binning to C.B.A. Engineering Ltd., May 27, 1963.

31. On March 22, 1952, Binning wrote to the editor of the *Vancouver Daily Province* agreeing with Major Matthews (a revered collector of Vancouver archival material) that it might be suitable to erect a sculpture commemorating Lord Stanley in the park named after him "as long it is … not the sort of sentimental rubbish proposed by our well-meaning archivist and recommends the formation of a committee including architects, sculptors and painters to review proposals for public art in the city." (Such a board was not established until 1990.)

An angry response to Binning's letter by a supporter of the Major's campaign concluded: "If a chair of art is ever installed at UBC, let us hope that no so-called 'modernist' will occupy it." Patrick Barr, letter to the editor, *Vancouver Daily Province*, March 31, 1952, 4.

A few days later another irate citizen also chimed in with a letter explaining that "a description of the dedication of the park by Lord Stanley in 1899 reads thus: 'Throwing his arms to the heavens as though embracing within them the whole one thousand acres of primeval forest', he said: 'To the use and enjoyment of people of all colors, creeds and customs for all time, I name thee Stanley Park.'

"One fails to see where the 'sentimental rubbish' which caused B.C. Binning's distress comes in. We would welcome more sentiment in these decadent days of modern monstrosities termed 'art.' " Fanny K. Huntley, letter to the editor, *Vancouver Daily Province*, April 3, 1952, 4

32. From an interview with Kay Alsop, "The Artistic Credo of B.C. Binning," *UBC Alumni Chronicle*, summer 1973.

33. Ibid.

34. Interview with Alvin Balkind, December 1972, op cit.

35. "We feel somewhat isolated in B.C. where we do not have the same opportunity afforded to those in the more populous east to exchange ideas." Letter from Frederick Lasserre, director of the School of Architecture, UBC, to the Awards Committee of the Royal Society of Canada in Ottawa recommending Binning for a fellowship to study in France, March 14, 1955. "It would be a splendid idea if you and Jessie came … to catch up on our culture—you know, the sort of thing you can't get in the West?" Letter to Binning from a friend in Ottawa, October 19, 1947.

36. Alvin Balkind, "On Ferment and Golden Ages," in *Vancouver Forum* 1, edited by Max Wyman (Vancouver: Douglas & McIntyre, 1992), 63–79.

37. "It is astonishing to me, sometimes, especially among the best here in New York, that something completely contemporary in the true sense can come out of my home town." Letter to Binning from Jack Shadbolt in New York, July 4, 1949.

Binning: "When you think of what is happening here in Vancouver now compared with … those early days when Vancouver was simply a little isolated town, disconnected to the rest of Canada …" Metcalfe.

Binning: "There was one little framing shop down on Robson—I think his name was Harry Krump—and he used to keep a few painters hanging around there. The older ones mostly painted water colours. Across the street there was the Vanderpant photographic studio, and dear old Vanderpant who liked music had an electric phonograph. On Saturday nights he used to play the classics, and we used to sit very Bohemian-like in the dark and listen. Those were the big cultural events in those days." Ibid.

Binning: "[re] the Vancouver School of Art where I graduated in 1934—a quiet little provincial art school taught by a staff of teachers who had come over from England and Scotland … We had an art gallery which opened in 1931 which had a collection of paintings nailed to the wall. We heard about people like Picasso and Matisse … as far away people living on another planet almost … I think there was one bookstore in town—one or two that had a sort of standard library … There was a record store that sold the usual classics, but as far as innovative things happening with any fruitfulness or creativeness—it just didn't exist." Ibid.

Binning: "I started in a quiet, simple, humble way. It was the Depression—there wasn't much money around. You couldn't do anything; you couldn't travel. You just

did what you could here … We felt cut off from the rest of Canada. The mountains were really a barrier then. There was absolutely nothing being done in the sense of contemporary [architecture]. Frank Lloyd Wright was known, perhaps because he was closer at hand." Ibid.

38. Three impresarios who struggled to bring well-known performers to Vancouver in the fifties were Ivan Akery and Hugh Pickett, who invited some noted popular stage performers, and George Zukerman, a musician, who enticed various classical music performers to make the trek to the coast.

39. Balkind, "On Ferment," op cit.

40. Letter from Binning to President N.A.M. MacKenzie, March 24, 1961.

41. Jane Howard, "Oracle of the Electric Age," *Life* 60, no. 8 (February 25, 1965): 91–92, 95–96, 99; Alexander Ross, "The High Priest of Pop Culture," *Maclean's* 78 (July 3, 1965), 13, 42–43; Richard Schickel, "Marshall McLuhan: Canada's Intellectual Comet," *Harper's* 231, no. 1386 (November 1965): 62–68.

42. Tom Wolfe, *The Pump House Gang* (New York: Farrar, Straus & Giroux, 1968), 156, 157; Philip Marchand, *Marshall McLuhan* (Toronto: Random House, 1989), 171, 172; Richard Cavell, *McLuhan in Space* (Toronto: University of Toronto Press, 2002), 181.

43. "It's … not the first festival to be invoked in McLuhan's name; that honour is generally given to the University of British Columbia, which hosted a McLuhan inspired 'happening' in the mid-sixties complete with a maze of plastic sheets suspended from the ceiling and overhead light projectors." James Adams, "McLuhanites Gathering to Get Back to the Future," *Globe and Mail,* October 7, 2004, R1.

44. "This mammoth happening … was widely hailed by international critics as the first event of its kind." Murray Farr in *B.C. Binning: A Retrospective* (Vancouver: UBC Fine Arts Gallery, 1973), 8.

45. "This is a performer's festival. We're not so much interested in talking about the con-temporary arts as we are in demonstrating them." Binning quoted by William Littler, *Vancouver Sun,* Leisure section, January 29, 1965, 3.

46. "Temperamentally, organically, and every other way, I disapprove of this whole grandiose scheme." Undated note to Binning from Prof. Cecil Cragg, who insists "it is the critic's job, not artists, to interest the public in art." Cragg, who is here reacting to the idea of the festivals, was in 1964 asked by Binning to act as head of Fine Arts while Binning was recuperating from a heart attack. A review in the February 1964 issue of the *Ubyssey* refers to *Box with the Sounds of Its Own Making:* "That box should be rebuilt and placed in it should be the severed head of the artist. Then it should be dropped in the sea." The critic goes on to deride a student whom he saw listening intently to the sounds: "That girl should be sent after it with 200 pounds of lead weight strapped to her waist." He finishes with the announcement: "Unless the fire-bug sees his duty, the exhibit will last all week." Shancrall, *Ubyssey,* February 6, 1964.

47. "Some of this festival will probably be shocking, but then people were shocked by Michelangelo … I'm not saying that people like Bruce Connor are modern day Michelangelos, but at least they're working in the great tradition of the past." Binning quoted by Michael Valpy, *Vancouver Times,* February 1, 1965.

48. At a meeting of the Fine Arts Committee in 1966, Binning reports that the *Ubyssey* had criticized the festival for catering to only a "small coterie." Warren Tallman indicates "that the *Ubyssey* had given poor coverage to day to day events." Alvin Balkind suggests that the demise of *The Artisan* (a student publication devoted to the arts) had made a difference. Helen Sonthoff is of the opinion the '66 festival was "not as exciting" as previous ones. Art Perry observes that the audiences were "passive," lacking the kind of involvement generated by "The Medium Is the Message" production of the previous year. Minutes of the meeting of the Fine Arts Committee, April 27, 1966.

49. Scott Lawrence writing in the *Ubyssey* refers to the festival in terms of its "potential for furthering the philosophy of revolution … Why wasn't there a massive rock dance or a trips festival?" Page Friday, *Ubyssey,* February 10, 1967.

50. Stan Persky, an English teacher and leader of the anti-establishment students who later matured as a noted literary critic and academic, claims his students found the '67 festival "incomprehensible." Mrs. Goodwin counters that "many of the 'way out' people we [invited] in the past had become more comprehensible and famous later on." Binning suggests that the need for the festival to "consider a total re-organization, with a general shake-up and a fresh concept." Persky suggests "bagging" the Buchanan Quadrangle with big events such as rock 'n' roll bands. An equal misunderstanding of Binning's intentions is voiced by Herb Gilbert, who suggests that the festival should bring in the sciences, e.g., physics, the new Planetarium, etc. Minutes of the meeting of the Fine Arts Committee, March 29, 1967.

51. Murray Farr in *B.C. Binning: A Retrospective* (Vancouver: UBC Fine Arts Gallery, 1973), 8.

52. George Woodcock in *B.C. Binning: A Classical Spirit,* edited by Nicholas Tuele (Victoria: Art Gallery of Greater Victoria, 1986).

53. Binning: "[After spending] five or six months on a Carnegie Grant and wandering all over Europe and North America to find out how other people were doing this I came back wanting a fine arts centre. Now we have it except the one thing, ironically, that we haven't got is a new art gallery." Walker. "They gave me a retrospective exhibition in that very same damned gallery that I'd been fighting for more than 20 years to have replaced." Binning quoted by Kay Alsop, "The Artistic Credo of B.C. Binning," *UBC Alumni Chronicle,* summer 1973, 18–23. "I saw President Kenny at the University the other day—where he has two of Bert's paintings hanging in his

office—and expressed to him the hope that one day UBC would build a new fine arts gallery and name it after Bert. I think that would be a most fitting tribute to him and I remain optimistic that some day it will happen." J. Ron Longstaffe in *Vanguard,* May 1976, 4.

54. "The man responsible for the inception and repeated successes of the Festival was B.C. Binning … This period which we remember with such nostalgia we could quite justifiably refer to as the Binning Era." Alvin Balkind in *B.C. Binning: A Retrospective* (Vancouver: UBC Fine Arts Gallery, 1973), 4.

THE HOUSE

1. Adam Gopnik, "Love's Progress," *The New Yorker* 64, no. 6 (March 28, 1988): 87.
2. The plaque in front of the Binning House states: "BINNING RESIDENCE–Daring and innovative, this house captures the spirit of early Modern architecture in Canada. Conceived by renowned painter Bertram Charles Binning in 1941, it responded to the social and economic conditions of the time by using local materials and efficient construction methods to create an affordable home. The design is based on contemporary lifestyle patterns, incorporating abstract murals and the surrounding landscape. Harmonizing art and architecture, form and function, the Binning residence inspired many architects across Canada over the following decades. Historic Sites and Monuments Board of Canada, 2000."
3. Peter Thornton's 1938 West Vancouver house is arguably the first incontrovertibly Modern house on the West Coast.
4. What reads as a "curve" in the wall was generated by the supporting beam accidentally bending during construction, likely because the foundation of the adjacent rooms, built at a higher grade, was not perfectly aligned with the direction of the original corridor wall.
5. Phyllis Lambert, written communication, April 4, 2005.

6. To cite two examples: in the studio clerestory, the height of the glass panes begins at 18 inches at the south end nearest the door and rises to 24.5 inches at the north end. In the living room, the angle where the glass-door wall meets the stone wall is 78 degrees rather than the standard 90 degrees.
7. Binning to Jessie Binning, June 18, 1936, collection of Jessie Binning.
8. Peter Oberlander, personal communication, December 2, 2004.
9. Quoted in Malcolm Reading and Peter Coe, *Lubetkin and Tecton: An Architectural Study* (London: Triangle Architectural Publishing, 1992), 135.
10. Berthold Lubetkin, "Two Bungalows at Whipsnade," *Architectural Review* 80, no. 12 (1936): 60.
11. Amédée Ozenfant and Le Corbusier, cited in Susan L. Ball, *Ozenfant and Purism: The Evolution of a Style, 1915–1930* (Ann Arbor: UMI Research Press, 1981), 36.
12. Jessie Binning to her mother, June 4, 1939, transcribed by Adrian Archambault from the personal collection of Jessie Binning.
13. *Art in Our Time* (New York: Museum of Modern Art, 1939), 291.
14. Jessie Binning, personal communication, April 12, 2002.
15. Geoffrey Massey, personal communication, July 13, 2005.
16. The proper specifications for stair detailing are outlined in Binning's copy of *Architectural Graphic Standards*, which he curiously chose not to follow in this instance. Most likely he did not wish the stair to extend into the gallery space and thus mar its sweeping openness—another case of the Artist trumping the Architect.
17. Massey, personal communication.
18. *Art in Our Time* (New York: Museum of Modern Art, 1939), 289.
19. B.C. Binning, "Allied Fields: The Need for Understanding and Means of Implementation," *Journal, Royal Architectural Institute of Canada,* 37, no. 7 (July 1960): 300–301.
20. Massey, personal communication.

21. John Allan, *Berthold Lubetkin: Architecture and the Tradition of Progress* (London: RIBA Publications, 1982), 182.
22. Jessie Binning, personal communication, West Vancouver, April 2002.
23. The tilting of the roofline is generally believed to have been a practical gesture to allow an internal drainage system and thus avoid ugly drainpipes. The house has nonetheless experienced leakage problems in the past; a sketch of the house made by Binning in a note for his brother-in-law suggests that it did at one point require an outdoor drainage system.
24. One example: the renderings of the Binning House in the exhibition West Coast Residential at the Charles H. Scott Gallery, Vancouver, 2003.
25. According to Russell Hollingsworth, cited by Geoffrey Massey, personal communication, July 13, 2005. The scored concrete allowed Binning to avoid using factory tiles or specifying custom tiles, and has a remarkable stonelike appearance.
26. Jessie Binning, personal communication, April 12, 2002; the accidental bending was likely due to the adjacent studio foundation being constructed at a higher grade (Massey, personal communication).
27. Charles H. Scott, "Coast to Coast in Art: West Coast, Vancouver: Drawings by B.C. Binning," *Canadian Art* 1, no. 4 (April–May 1944): 169–70.
28. B.C. Binning, interview with Doreen Walker, June 13, 1972, transcript from original tape recording, in UBC Fine Arts and VAG libraries.
29. Interview with Doreen Walker, April 19, 1971, University of British Columbia, Vancouver.
30. See Susan Bronson, "Binning Residence, West Vancouver," *Architecture in Canada* 27, no. 4 (summer 2002): 51–64.
31. District of West Vancouver Notice of Assessment, West Vancouver, 1942; backed up by original receipts found in the Binning House; personal collection of Jessie Binning.
32. For cost comparison see *Plan to Build 1,000*

Low Cost Homes (Vancouver: Quality Homes Corp. and Vancouver Titles Ltd., 1942, City of Vancouver Archives), 7.

33. B.C. Binning, "Colour in Architecture," *Canadian Art* 11, no. 4 (summer 1954): 141.

34. B.C. Binning, "The Artist and the Architect," *Journal, Royal Architectural Institute of Canada* 27, no. 9 (September 1950): 320.

35. Quoted in Douglas Shadbolt, *Ron Thom: The Shaping of an Architect* (Vancouver: Douglas & McIntyre, 1995), 10.

36. See Arthur Erickson's introduction, page xi, for an account of his meeting with Neutra at the Binning House.

37. B.C. Binning, cited in Scott Watson, "B.C. Binning: Modernism in a Classical Calm," *Vanguard* 15, no. 3 (summer 1986): 24.

38. Christopher Macdonald, written communication, January 21, 2005. "However the splayed geometric order was drawn into the deliberations of the house's design, its consequence is to extend and give nuance to the conventional expectations of 'canonic' modernism," notes Macdonald, current director of the UBC School of Architecture. "The house becomes a kind of cipher for how the often-coarse polemics of modern architectural rhetoric may be rendered familiar, poignant and local."

39. Sigfried Giedion, *Space, Time and Architecture: The Growth of A New Tradition* (Cambridge: Harvard University Press, 1941), 20.

40. B.C. Binning, "The Artist and the Architect," *Journal, Royal Architectural Institute of Canada* 27, no. 9 (September 1950): 320.

BINNING AS A DRAFTSMAN

This essay, in a slightly different form, was originally published in *Form + Meaning: The Drawings of B.C. Binning*, published by the Charles H. Scott Gallery in 1997. I am grateful to the gallery director, Greg Bellerby, for permission to reprint it here. The epigraph is from B.C. Binning, "The Teaching of Drawing," *Canadian Art* 5, no. 1 (autumn 1947): 21. Although this article is revealing of several of Binning's attitudes to drawing, it is interesting to note that it appears just as Binning ceased to make drawing his principal artistic activity.

1. This drawing was likely done at the summer camp of the school on Savary Island. Mortimer-Lamb often visited the camp in the early thirties.

2. *The Paintbox* was the publication of the student body of the Vancouver School of Decorative and Applied Arts. It seems to have functioned as a sort of annual.

3. The paucity of work from this period may be explained by a letter Binning wrote to his sister Margaret, postmarked April 14, 1939, collection of Jessie Binning. Contemplating his eventual return to Vancouver, Binning asked that she "burn all the drawings" in storage in Vancouver.

4. Binning, "The Teaching of Drawing," 21.

5. He graduated from the school in 1932, having taken off the year 1928–29.

6. In 1933, after a disagreement about reduced salaries due to school board cutbacks and hours of work, Varley and Macdonald left the school to set up the B.C. College of Arts. The VSA therefore had to quickly recruit replacement staff to join Scott and Grace Melvin as teachers. Fred Amess, another recent VSA graduate, was hired along with Binning. Although there was a crisis at the Vancouver School of Art, the decision to hire Binning and Amess was a brilliant one. Both went on to distinguish themselves as educators. Binning founded the Fine Arts department at the University of British Columbia and Amess succeeded Scott as principal of the Vancouver School of Art.

7. Binning to Mrs. A.F. Binning, postmarked August 11, 1938, collection of Jessie Binning.

8. Binning to Mrs. A.F. Binning, October 23, 1938, collection of Jessie Binning.

9. "Mr. Meninsky in particular (whose word is respected) has said he is elated at the promise he sees in Bert's work." Jessie Binning to Margaret Binning, October 29, 1938, collection of Jessie Binning.

10. Binning to Mrs. A.F. Binning, February 24, 1939, collection of Jessie Binning.

11. I am grateful to Adrian Archambault, who pointed out this parallel.

12. Collection of Vancouver Art Gallery.

13. Interview with Doreen Walker, 1973, audiotape in a private collection, and in a letter to his mother, March 15, 1939, collection of Jessie Binning. *Guernica* was exhibited with sixty-seven preparatory drawings at the New Burlington Galleries in October 1938. During this period there were also shows of modern French painting at the Whitechapel Gallery and several commercial galleries and a major show of French nineteenth- and twentieth-century drawings at the Matthiesen Gallery.

14. Binning to Mrs. A.F. Binning, January 21, 1939, collection of Jessie Binning.

15. Ibid.

16. Binning to Mrs. A.F. Binning, February 10, 1939, collection of Jessie Binning.

17. Binning to Margaret Binning, February 16, 1939, collection of Jessie Binning.

18. Walker interview, op cit.

19. *Art Students League Calendar*, 1959–60, unpaginated.

20. Binning to Mrs. A.F. Binning, May 29, 1939, collection of Jessie Binning.

21. Binning as quoted in Browni Wingate, "Artist Binning Depicts B.C. in One-Man Show at Gallery," *Vancouver News-Herald*, February 21, 1946, 8 (hereafter Wingate 2).

22. In the Vancouver School of Art Graduates Association First Annual Exhibition, Vancouver Art Gallery, 1933.

23. Interestingly enough, although *The Art Gallery Bulletin* (vol. 9, no. 3, November 1941) records that Binning won the medal for a drawing entitled *Young Man at a Table*, there is no record in the catalogue for the Tenth B.C. Artists' Exhibition of Binning exhibiting that year. He exhibited a painting, *Reclining Figure*, and a drawing, *Girl Thinking*, in the 1941 B.C. Society of Fine Arts exhibition.

24. Max Maynard, "Medal Awards," *The Art Gallery Bulletin* 9, no. 3 (November 1941), unpaginated. Maynard is not identified as the author in this *Bulletin* but in an article on Binning published, on the occasion of his one-person show, in the *Bulletin* 11, no. 7 (March 1944).
25. His work entered the collection of the Vancouver Art Gallery in 1944, the National Gallery of Canada in 1945 and the Art Gallery of Ontario in 1946. Binning had a one-person show of drawings at the Art Gallery of Toronto (now the Art Gallery of Ontario) in 1946.
26. Mildred Valley Thornton, "Drawings of Distinction on Exhibition," *Vancouver News-Herald,* March 7, 1944, 17; Palette (John Delisle Parker), "One-Man Show of Drawings Wins Acclaim for Binning," *Vancouver Province,* March 4, 1944, 20; and Browni Wingate, "Creative Vancouver Artist Holds First One-Man Show at Gallery," *Vancouver News-Herald,* March 4, 1944, 7 (hereafter Wingate 1) all reviewed the show favourably.
27. C.H.S. (Charles H. Scott), "Coast to Coast in Art: West Coast, Vancouver: Drawings by B.C. Binning," *Canadian Art* 1, no. 4 (April–May 1944): 169–70; Doris Shadbolt, "The Drawings of B.C. Binning," *Canadian Art* 3, no. 3 (March–April 1946): 94–96.
28. Palette, op cit.
29. Ibid.
30. Thornton, op cit.
31. Wingate 1.
32. Thornton, op cit.
33. Scott, op cit.
34. Ibid.
35. Wingate 1.
36. Doris Shadbolt, "The Drawings of B.C. Binning," 96.
37. Ibid.
38. Ibid.
39. Palette (John Delisle Parker), "Boat Life on North Shore Theme of Gallery Display," *Vancouver Province,* February 21, 1946, 6. Browni Wingate also reviewed the show, op cit.
40. Interview with Doreen Walker, June 13, 1972, transcript from original tape recording, in UBC Fine Arts and VAG libraries.
41. Interview with Doreen Walker, October 10, 1973, audiotape in a private collection.
42. There is a small group of plant drawings from 1969–70.
43. Binning as quoted in Wingate 1.

BINNING AS A PAINTER

1. Vancouver Art Gallery, Sixth B.C. Artists Exhibition.
2. Interview with Dorothy Metcalfe, June 10, 1974, transcript in the VAG library.
3. Ibid.
4. Ibid.
5. Binning to Mrs. A.F. Binning, postmarked August 11, 1938, collection of Jessie Binning.
6. Binning to Mrs. A.F. Binning, October 12, 1938, collection of Jessie Binning.
7. Jessie Binning to Margaret Binning, December 14, 1938, collection of Jessie Binning.
8. Binning to Mrs. A.F. Binning, January 21, 1939, collection of Jessie Binning.
9. Binning to Mrs. A.F. Binning, February 10, 1939, collection of Jessie Binning.
10. Binning to Mrs. A.F. Binning, March 15, 1939, collection of Jessie Binning.
11. Binning to Mrs. A.F. Binning, March 31, 1939, collection of Jessie Binning.
12. Binning to Mrs. A.F. Binning, May 29, 1939, collection of Jessie Binning.
13. Ibid.
14. Binning to Mrs. A.F. Binning, July 3, 1939, collection of Jessie Binning.
15. Donald W. Buchanan, "Exponent of a New Architecture in Paint," *Canadian Art* 6, no. 4 (summer 1949): 149.
16. Ibid., 149–50.
17. Interview with Doreen Walker, June 13, 1972, transcript from original tape recording, in UBC Fine Arts and VAG libraries.
18. Buchanan, op. cit., 150.
19. Quoted by Buchanan, 150.
20. Interview with Doreen Walker and Grace Melvin, October 10, 1973, typescript.
21. Walker interview, op cit.
22. Ibid.
23. Quoted by Buchanan, 150.
24. Walker interview, op cit.
25. Ibid.
26. Interestingly, Binning indicated that *Theme Painting* could be hung either horizontally or vertically. This would confirm that his primary interest was in the play of colour and shape.
27. Ibid.
28. Binning was fascinated by early Sienese paintings, which with their elaborate frames and small painted surfaces were "as much objects as paintings." Quoted in *B.C. Binning: A Retrospective* (Vancouver: UBC Fine Arts Gallery, 1973), 13.
29. These works were also shown at the Laing Galleries in Toronto.
30. Artist's statement written for the Laing Galleries show, typescript.
31. Doreen Walker quotes Binning as saying that he had "unconsciously borrowed from Rothko" the techniques of scumbling and glazing, but I would argue that it is also the form of the work that is borrowed from Rothko, *B.C. Binning: A Retrospective*, 15.
32. Nicholas Tuele has recorded some of his activities. See *B.C. Binning: A Classical Spirit* (Victoria: Art Gallery of Greater Victoria, 1986).
33. Quoted by Doreen Walker in "The Rich Architectonics of Binning," *Vie des Arts* 18, no. 72 (automne 1973): 97.
34. Walker interview, op cit.
35. See Walker, "The Rich Architectonics," 97.
36. See Joan Lowndes, "Bert Binning's Exhibition in Vancouver," *Vie des Arts* 15, no. 60 (automne 1970): 50.
37. Walker interview, op cit.
38. *B.C. Binning: A Retrospective,* 15.
39. Personal communication, December 27, 2004.
40. Quoted in Buchanan, op cit., 150.
41. Walker interview, op cit.

SELECTED BIBLIOGRAPHY

WRITINGS BY B.C. BINNING

Binning, B.C. "Allied Fields: The Need for Understanding and Means of Implementation." *Journal, Royal Architectural Institute of Canada* 37, no. 7 (July 1960): 300–301.

———. "The Artist and the Architect." *Journal, Royal Architectural Institute of Canada* 27, no. 9 (September 1950): 320–21.

———. "Colour in Architecture." *Canadian Art* 11, no. 4 (summer 1954): 140–41.

———. "Interview between B.C. Binning and Doreen Walker." June 13, 1972. Transcript from original tape recording. UBC Fine Arts and VAG libraries.

———. "Mosaics: Vancouver to Venice and Return." *Canadian Art* 15, no. 4 (November 1958): 252–57.

———. Chairman of Committee to Investigate Art Education in North America and Europe. *Report of the Committee on Art Education in European and North American Universities.* Based on a survey, summer 1951. Typescript.

———. "The Teaching of Drawing." *Canadian Art* 5, no. 1 (autumn 1947): 20–23.

———. "To See and Understand through Art." *UBC Alumni Chronicle* 19, no. 4 (winter 1965).

———. "Up to Public to Study Art in Abstract, Painter Claims." *Vancouver Sun,* May 21, 1960, 2.

———. "Video Taped Interview with B.C. Binning and Dorothy Metcalfe." Vancouver Art Gallery, June 10, 1974. Typescript.

SELECTED BOOKS

Ainslie, Patricia. *Images of the Land: Canadian Block Prints, 1919–1945.* Calgary: Glenbow Museum, 1984.

B.C. Binning: A Retrospective. Introduction by Doreen Walker. Vancouver: UBC Fine Arts Gallery, 1973.

Buchanan, Donald W. *The Growth of Canadian Painting.* London: Collins, 1950.

Burnett, David, and Marilyn Schiff. *Contemporary Canadian Art.* Edmonton: Hurtig Publishers, 1983.

Contemporary Canadian Artists. Toronto: Gale Canada, 1997.

Duval, Paul. *Canadian Drawings and Prints.* Toronto: Burns & MacEachern, 1952.

———. *Four Decades: The Canadian Group of Painters and Their Contemporaries, 1930–1970.* Toronto: Clarke, Irwin & Co., 1972.

Elder, Alan, and Ian M. Thom, eds. *A Modern Life: Art and Design in British Columbia, 1945–1960.* Vancouver: Arsenal Pulp Press and Vancouver Art Gallery, 2004.

Harper, J. Russell. *Painting in Canada: A History.* 2nd ed. Toronto: University of Toronto Press, 1977.

Hubbard, R.H. *The Development of Canadian Art.* Ottawa: National Gallery of Canada, 1963.

Hubbard, R.H., and J.R. Ostiguy. *Three Hundred Years of Canadian Art.* Ottawa: National Gallery of Canada, 1967.

Kilbourn, Elizabeth, and Frank Newfeld, eds. *Great Canadian Painting: A Century of Art.* Toronto: Canadian Centennial Publishing Co., 1966.

McInnes, Graham C. *Canadian Art.* Ottawa: Macmillan, 1950.

Morris, Jerrold. *100 Years of Canadian Drawings.* Toronto: Methuen Publishers, 1980.

Ostiguy, Jean-René. *Un siecle de peinture canadienne, 1870–1970.* Quebec: Les Presses de l'Université Laval, 1971.

Reid, Dennis. *A Concise History of Canadian Painting.* Toronto: Oxford University Press, 1973.

Ross, Malcolm. *The Arts in Canada: A Stock-Taking at Mid-century.* Toronto: Macmillan, 1958.

Shadbolt, Doris. "The Vancouver Scene." In *Canadian Art Today,* edited by William Townsend, 61–70. London: Studio International, 1970.

Thom, Ian M., ed. *Art BC: Masterworks from British Columbia.* Vancouver: Douglas & McIntyre and Vancouver Art Gallery, 2000.

———. *Form + Meaning: The Drawings of B.C. Binning.* Vancouver: Charles H. Scott Gallery, 1997.

Tippett, Maria, and Douglas Cole. *From Desolation to Splendour: Changing Perceptions of the British Columbia Landscape.* Toronto: Clarke, Irwin, 1977.

Tuele, Nicholas, ed. *B.C. Binning: A Classical Spirit.* Victoria: Art Gallery of Greater Victoria, 1986.

Vancouver: Art and Artists, 1931–1983. Vancouver: Vancouver Art Gallery, 1983.

Visions: Contemporary Art in Canada. Vancouver: Douglas & McIntyre, 1983.

Winnipeg West: Painting and Sculpture in Western Canada, 1945–1970. Edmonton: The Gallery, 1983.

SELECTED PERIODICAL AND NEWSPAPER ARTICLES

Anonymous. "Allied Arts Medal Awarded to Binning." *Journal of Commerce,* June 2, 1962.

———. "Artist Binning Receives Major Appointment." *Listowel Banner,* May 29, 1958.

———. "Artist/Educator Leaves Legacy for Vancouver." *Performance,* April 1976, 10.

———. "Artists Join UBC Faculty." *Vancouver Province,* November 10, 1949.

———. "At the Dominion Gallery." *Montreal Standard,* May 5, 1951.

———. "At U.B.C.—Fine Arts Head Quits." *Vancouver Sun,* February 24, 1968.

———. "B.C. Binning." *Ottawa Citizen,* August 10, 1957.

———. "B.C. Binning (1909–1976)." *Le Soleil du Colombie,* Mai 14, 1976, 7.

———. "B.C. Binning: Artist Influenced B.C. Architects." *Globe and Mail,* March 18, 1978.

———. "B.C. Binning Drawings and Water Colours, January 11–February 3." *Update* 1, no. 1 (January/February, 1980).

———. "B.C. Binning Drawings Exhibition, October 24–December 9." *Art Victoria* 5, no. 3 (October 1979): 7.

———. "B.C. Binning Mural Goes to UBC." *Vancouver Courier,* April 2, 1989, 7.

———. "Bertram C. Binning Influential Painter." *Toronto Star,* March 18, 1976.

———. "Binning Art Saved." *Vancouver Province*, April 5, 1989.

———. "Binning Gets Major Award." *UBC Reports*, May/June 1962.

———. "Binning Mosaics." *Canadian Art* 15, no. 4 (November 1958): 252–57.

———. "Binning Opens Talks." *New Westminster Columbian*, January 13, 1972.

———. "Binning Paintings at Dominion Gallery." *Montreal Gazette*, May 5, 1951.

———. "Binning Shows Work in Watson Galleries." *Montreal Gazette*, October 22, 1955.

———. "Bold Lines for a Bold Medium" (mural for O'Brien Advertising Agency). *Vancouver Province*, March 12, 1955.

———. "Canada at the Eleventh Triennial, Milan." *Canadian Art* 15 (January 1958): 65.

———. "Canadian Art—World War II." *Arts West* 5, no. 1 (January/February 1980): 28–31.

———. "Citations to Chancellor Awarding Honorary Degree to B.C. Binning." *UBC Reports*, May 21, 1974.

———. "Coast to Coast in Art: West Coast, Vancouver: Drawings by B.C. Binning." *Canadian Art* 1 (April/May 1944): 169–70.

———. "Definite Humour Illuminates Art Display by B.C. Binning." *Ottawa Journal*, May 22, 1951.

———. "Exhibition Notes: B.C. Binning." *Vancouver Art Gallery Bulletin* 28, no. 7 (March 1961).

———. "Founder of U.B.C. Department, Painter B.C. Binning Dies." *Vancouver Sun*, March 17, 1976.

———. "Local Artist Joins Faculty." *Journal, Royal Architectural Institute of Canada* 27, no. 4 (April 1950).

———. "Medal Awards." *Vancouver Art Gallery Bulletin* 9, no. 3 (November 1941).

———. "Mosaique de 500 pieds carres realise pour un Banque de L'Ouest." *Montreal la Presse*, mai 21, 1958.

———. "Must Focus Energies onto Community Level: View of B.C. Binning at Meeting of Canadian Artists." *Montreal Gazette*, April 15, 1946.

———. "Nature Colours in B.C. Electric Building." *Vancouver Sun*, March 29, 1957.

———. "New Office's Mural in Striking Effect." *Vancouver Province*, August 25, 1954.

———. "New Trends in Banks, Cafes, Hotels." *Vancouver Province*, March 1955.

———. "Noted Artist Charles Binning Dies." *Globe and Mail*, March 18, 1976.

———. "Noted Artist to Lecture in Kingston." *Whig Standard*, October 5, 1959.

———. "Notes on March Exhibitions." *Vancouver Art Gallery Bulletin* 9, no. 1 (March 1944).

———. "Un peintre canadien qui sait se renouvier." *Montreal Perspectives*, April 22, 1961.

———. "A Pioneer Spirit" (architecture of Bertram C. Binning). *Globe and Mail*, February 1, 1992, C6.

———. "Prominent Painter B.C. Binning Dies." *Vancouver Province*, March 17, 1976.

———. "The Realm of Art Logic Supreme for Binning." *Vancouver Province*, March 28, 1961.

———. "Six to Receive Honorary Degrees." *UBC Reports*, April 4, 1974.

———. "Three Canadian Painters." *Vogue*, April 15, 1955, 108–9.

———. "Two Hundred Thousand Piece Mosaic Depicts Resources Industry." *Windsor Daily Star*, May 7, 1958.

———. "Vancouver Artist B.C. Binning Is Among Group Awarded $4500 Canada Council Art Fellowships." *Vancouver Province*, March 16, 1963.

———. "What B.C. Means to Nine of Its Best Artists." *Maclean's* 71, no. 10 (May 10, 1958): 27–33.

———. "You Win Some You Lose Some." *Western Living* 31, no. 8 (October 2001).

Allow, Dorothy. "Navigation Signals." *The Christian Science Monitor*, April 28, 1956.

Alsop, Kay. "The Artistic Credo of B.C. Binning." *UBC Alumni Chronicle*, summer 1973, 18–23.

Archambault, Adrian. "Binning: Artist with Street Sense." *Vancouver Sun*, January 29, 1994, D5.

Baldwin, Martin. "Art as a Household Word." *Canadian Homes and Gardens*, November 1947.

"B.C. Binning (1909–1976)." *Vanguard*, May 1976, 3–4.

Boddy, Trevor. "Celebrating Modern: West Vancouver Renowned for Architectural Style." *North Shore News*, May 10, 2000, 22–23.

Buchanan, Donald W. "Canadian Painting 1947–1948." *Canadian Art* 6, no. 1 (January 1949): 10–15.

———. "Exponent of a New Architecture in Paint." *Canadian Art* 6, no. 4 (summer 1949): 148–50.

Christensen, Layne. "West Van's Special House." *North Shore News*, September 22, 1998, 3.

Clark, Michael. "Vancouver Gets Major Drawing Show: Binning Exhibit Succeeds Matisse and Gericault." *Emily Carr Institute of Art and Design. Visions in the Making* 4, no. 1 (October 1997): 4.

Cramp, Beverly. "Supernatural Architecture." *Vancouver Courier*, November 5, 1997, 1–3.

Crawford, Lenore. "First for Canada in Vancouver Glass Mosaic." *London Free Press*, September 13, 1958.

———. "Happy Art Trademark of Binning." *London Free Press*, January 22, 1949.

Downey, Don. "Architect Displayed Love of Tall Timbers." *Globe and Mail*, November 2, 1986.

Doyon, Charles. "Les arts la peinture du Cote du Pacifique." *Montreal le Haut-Parleur*, May 12, 1951.

Duke, David Gordon. "Vancouver's Modernism Considered." *Vancouver Sun*, May 29, 2004, D7.

Duval, Paul. "Graphic Arts Reveal Interesting Riches." *Saturday Night* 61, no. 10 (June 8, 1946): 4.

Flaman, Bertrand. "The Airport as City Square." *BlackFlash* (Canada) 20, no. 3 (2003): 4–11.

Foster, Dorothy. "The Binning House." *North Shore News*, December 18, 1992, 20.

Fotheringham, Allan. "A Retrospective Showing." *Vancouver Sun*, March 17, 1976.

Freedman, Adele. "A Dreamer Who Walked the High Wire." *Globe and Mail*, November 3, 1985.

———. "A Pioneer Spirit." *Globe and Mail*, February 1, 1992, C2.

Godfrey, Stephen. "Art that a City Looks Up To: B.C. Binning Left His Mark on Vancouver in Many Ways." *Globe and Mail*, January 14, 1986, A12.

Godley, Elizabeth. "Art Lovers Wanted to Save Mosaic Mural." *Vancouver Sun*, March 8, 1989.

———. "Binning: A Part of Our History." *Vancouver Sun*, November 1, 1986.

———. "Binning a Boon to Our Town's Culture." *Vancouver Sun*, November 22, 1986, H3.

———. "Quirky Selection but None the Less Pleasing." *Vancouver Sun*, January 3, 1987.

Grayson, Mary. "Lighthearted Not Light Weight." *Edmonton Journal*, January 21, 1980.

Holmes, Willard. "A Retrospective Look at UBC's Binning Era." *Vancouver Province*, March 26, 1973.

Hubbard, R.H. "A Climate for the Arts." *Canadian Art* 12, no. 3 (spring 1955): 99–105, 139.

———. "Show Window of the Arts—XXVII Venice Biennale." *Canadian Art* 12, no. 1 (October 1954): 18–19.

Jarvis, Alan. "Canadian Paintings." *Star Weekly Magazine*, February 1, 1958.

Kahane, Anne. "Art and Architecture in Western Canada." *Canadian Art* 4, no. 2 (winter 1957): 79.

Kelly, Ronald. "Architectural Witticisms." *P.M. Magazine* 1, no. 2 (December 1950–January 1951): 29–34.

Knox, Paul. "Fine Arts Head Quits to Do Creative Work." *The Ubyssey*, February 27, 1968.

Laurence, Robin. "Show Flashes Back to B.C.'s Modernists Heyday: Visual Arts: A Modern Life." *Georgia Straight*, May 7, 2004.

Lindsey, Shelagh. "Binning Mural Safely Relocated." *Community Arts Council*, April 4, 1989.

Lowndes, Joan. "B.C. Binning at the Vancouver Art Gallery." *Canadian Art* 18, no. 4 (July–August 1961): 268–69.

———. "B.C. Binning in Joyful Retrospective." *Vancouver Sun*, March 23, 1973.

———. "Bert Binning's Exhibition in Vancouver." *Vie des Arts* 15, no. 60 (automne 1970): 50.

———. "Binning Art Smash Hit at UBC." *Vancouver Sun*, March 23, 1973.

———. "Binning Exhibits Work." *Vancouver Sun*, March 13, 1973.

———. "Three Hours Later Really Just in Time." *Vancouver Sun*, March 13, 1973.

MacDonald, C.G. "Binning Work Seen as Unimaginative." *Montreal Herald*, May 2, 1951.

McDonald, Herbert L. "B.C's B.C. Binning: He's Mining a New Vein of Color." *Vancouver Sun, Weekend Magazine* 11, no. 16 (April 22, 1961): 10–13.

Mackie, John. "Influential in Modern Architecture: Binning House Now a Historic Site." *Vancouver Sun*, May 26, 2001.

McMordie, Michael J. "Modern Architecture in Vancouver." *Canadian Architecture* 29, no. 3 (March 1984): 22–27.

Malkin, P. "Gordon Smith" (interview). *Vanguard* 5, no. 3 (April 1976): 3–4.

Millard, Peter. "Four Score and Plenty." *Border Crossings* 17, no. 3 (July 1998): 64–65.

Morris, J.A. "Artists and Industry." *Community Arts Council* 7, no. 2 (November 1984).

Murray, James. "The Role of the Architect." *Canadian Art* 19, no. 3 (May–June 1962): 194–97.

Palette [John Delisle Parker]. "B.C. Binning to Make Overseas Art Survey." *Vancouver Province*, April 14, 1951.

———. "Binning's New Mural Striking." *Vancouver Province*, September 29, 1956.

———. "Boat Life on North Shore Theme of Gallery Display." *Vancouver Province*, February 21, 1946, 6.

———. "City Artist Wins High Praise in East." *Vancouver Province*, December 31, 1954.

———. "One-Man Show of Drawings Wins Acclaim for Binning." *Vancouver Province*, March 4, 1944, 20.

———. "Tour Provides Impetus for Art in Rural Areas." *Vancouver Province*, December 31, 1946.

———. "U.B.C. Professor Creative Artist." *Vancouver Province*, March 17, 1950.

Paradis, Andrée. "Une gallerie d'art, au Pavillon." *Vie des Arts*, no. 11 (été 1958): 22–31.

———. "Une pensée pour B.C. Binning." *Vie des Arts* (été 1973): 79.

Parker, John Delisle. "B.C.'s B.C. Binning." *Vancouver Province*, December 30, 1950.

Perlin, Rae. "Western Artists Varied." *St. John's Evening Telegram*, October 28, 1966.

Roussan, Jacques de. "Art in British Columbia." *Vie des Arts*, no. 44 (automne 1966): 101.

Scott, Michael. "Out of This Century." *Vancouver Sun*, February 4–March 22, 2000.

Sexsmith, Dennis. "The Unknown B.C. Binning." *Vie des Arts* 32, no. 127 (June 1987): 32–35, 78–79.

Shadbolt, Doris. "The Drawings of B.C. Binning." *Canadian Art* 3, no. 3 (March–April 1946): 94–96.

Stott. "My Jiggs Eye View of Culture." *Victoria Times*, March 25, 1960.

Thom, Ian M. "B.C. Binning." Vancouver Art Gallery, 1994. Pamphlet.

Thom, Ron. "Allied Arts Award, 1962: B.C. Binning, Vancouver." *Journal, Royal Architectural Institute of Canada* 39, no. 4 (April 1962): 47–50.

Thornton, Mildred Valley. "Drawings of Distinction on Exhibition." *Vancouver Sun*, March 3, 1944.

Turner, Evan H. "Art at the Airports." *Canadian Art* 21, no. 3 (May–June 1964): 128–43.

Varley, Peter. "Christmas Greetings from Seven Canadian Artists." *Canadian Homes and Gardens* (Montreal), December 1955.

Walker, Doreen. "The Rich Architectonics of Binning." *Vie des Arts* 18, no. 72 (automne 1973): 96–97.

Ward, Robin. "Melding the Past with the Future." *Vancouver Sun*, June 18, 1990, B6.

———. "Yesterday's Visions Ignored by Builders of Today." *Vancouver Sun*, December 3, 1997, C8.

Warrington, Graham. [B.C. Electric Building

mosaic photograph]. *Vancouver Sun, Weekend Magazine* 9, no. 4, 1963.

Watson, Scott. "B.C. Binning: Modernism in a Classical Calm." *Vanguard* 15, no. 3 (summer 1986): 23–27.

———. "B.C. Binning: A Retrospective," October 31, 1986–January 4, 1987. Pamphlet.

Weder, Adele. "A Loving Link to a Modernist Past." *Globe and Mail,* November 22, 1997, CII.

Weiselburger, Carl. "B.C. Binning Master of Ships." *Ottawa Citizen,* May 22, 1951.

———. "Japanese Love Their Gardens Like Americans Love Their Cadillacs." *Ottawa Citizen,* October 8, 1959.

———. "Ships in Classical Calm." *Ottawa Citizen,* May 18, 1951.

———. "This Business of Serious Joy: B.C. Binning, Master of Ships." *Ottawa Journal,* May 22, 1951.

Williams, R., and G. Swinton. "The Great Winnipeg Controversy." *Canadian Art* 13, no. 2 (winter 1956): 244–49.

Wingate, Browni. "Creative Vancouver Artist Holds First One-Man Show at Gallery." *Vancouver News-Herald,* March 4, 1944, 7.

Wood, Daniel. "Design of the Times." *Western Living,* June 1958, 22–26.

Woodcock, George. "The Business of Serious Joy: B.C. Binning 1909–1976." *Artscanada* 33, no. 1 (April–May 1976): 85–86.

Woodworth, John. "The B.C. Binning House: Time Confirms Its Principles." *Western Homes and Living,* October–November 1950, 15–18.

Wylie, Liz. "West of Winnipeg: A Tale of Six Cities." *Vanguard* 12, no. 10 (December 1983/January 1984): 15–18.

Yamanaka, Kaori. "Leisure and Pleasure as Modernist Utopian Ideal: B.C. Binning's Drawings in the Mid-1940s." *Collapse,* no. 5 (July 2000): 144–76.

Bibliography prepared by Melva J. Dwyer, former head librarian, Fine Arts Library, University of British Columbia. The author acknowledges the assistance of the librarians and staff of the following libraries: Emily Carr Institute of Art and Design, Vancouver Art Gallery and UBC Fine Arts department. To Doreen Walker and Nicholas Tuele, special thanks for their work in earlier publications.

JUNE BINKERT worked for B.C. Binning in the UBC School of Architecture from 1953 to 1954. In 1955, she became Department Secretary for the Fine Arts department and worked closely there with Binning until his death in 1976.

ARTHUR ERICKSON is an internationally acclaimed architect. He received the Gold Medal from both the Architectural Institute of Canada and the Académie française d'architecture in 1984, and in 1986 received the Gold Medal from the American Institute of Architecture. He is now an Honorary Fellow, Royal Institute of British Architects and an Honorary Master, Frank Lloyd Wright Foundation and School. He was a lifelong friend of B.C. Binning.

RICHARD E. PRINCE graduated in 1971 with a B.A. in art history from the University of British Columbia. He is now an artist and a professor in the Department of Art History, Visual Art and Theory at UBC.

ABRAHAM J. ROGATNICK began a friendship with B.C. Binning in the mid-fifties and became a colleague of Binning's in 1959 when he was appointed professor in the School of Architecture at UBC. He worked closely with Binning, participating in and contributing to the Festivals of the Contemporary Arts as well as working with Binning on plans to complete the MacKenzie Fine Arts Complex.

SIMON SCOTT is a Vancouver architectural photographer and graphic designer who studied architecture and graphic design in England before emigrating to Canada. He has worked with numerous architectural firms and developers, including many years with Arthur Erickson. His work has appeared in books, magazines and exhibitions worldwide. He created the award-winning book *The Architecture of Arthur Erickson*, won a Lieutenant Governor's Award for his photographic and advocacy work on the restoration of Erickson's Filberg House, and in 2004 designed the City of Vancouver street banners that graphically depicted several Erickson buildings.

IAN M. THOM, a graduate of the University of British Columbia, is Senior Curator—Historical at the Vancouver Art Gallery. The editor or author of several books and catalogues, he has published widely on British Columbia art history, including studies of E.J. Hughes, Gordon Smith, Robert Davidson, Emily Carr, Jack Shadbolt, B.C. Binning and Takao Tanabe. He has organized numerous exhibitions, including two of Binning's drawings and watercolours.

ADELE WEDER is an architectural writer and cultural journalist based in Vancouver and Haida Gwaii. A former editor of *Insite* magazine, she writes for design journals across North America and is a contributing editor of *Azure*. She recently completed a master's in architectural studies at the University of British Columbia with a thesis on the Binning House.

INDEX

Page numbers in *italic* refer to illustrations.

Allan, John, 59
Amess, Fred, 11, 67
Andrew, Geoff, 39
Arp, Jean, 51
Atwood, Margaret, 34

Balkind, Alvin, 40
Baxter, Iain, 35
B.C. Electric Building, 20
B.C. Electric (Dal Grauer) Substation, 19, 21, 67
BCB by BCB, 95, 111
Binning, Mrs. A.F. (mother), 7
Binning, Bertram Charles
 awards, 39–40, 91
 death, 159
 early years, 2–3, 4, 5, 6, 7, 82, 84, 120
 exhibitions, 91–92, 94, 96, 98, 106, 143
 later years, 24, 26, 40, 112, 125, 151, 159
 marriage, 6
 murals, 6, 18, 21, 23, 24, 54, 132, 134, 143
 and public art, 14, 18, 27, 33, 37–38
 as teacher, 12, 67, 82, 161, 162
 travels in Europe, 6, 8–9, 21, 23, 48–50, 82,
 84, 87, 118, 120
 travels to Japan, 28, 29, 143
 travels in United States, 48, 51, 82, 87, 89,
 120
 at Vancouver School of Art, 6, 67, 82, 118,
 125
 working methods, 98, 100, 103
 as yachtsman, 24, 26, 60, 63
Binning, Cecil, 3
Binning, Jessie (Wyllie), 6, 7, 11, 13, 15, 18, 29, 32,
 42, 43, 60, 65, 118, 124
Binning family, 5
Birdcage, 64, 92, 112
Black Island, 146
Bland, John, 49
Blaser, Robin, 34
Boat, 106

Boback, Bruno and Molly, 11
Brackman, Robert, 120
Brakhage, Stan, 36
Braque, Georges, 51
Buchanan, Donald, 126

Campbell, Joseph, 36
Cariboo, 121
Cavell, Richard, 33–34
Cézanne, Paul, 30, 51
Coates, Wells, 49
Connor, Bruce, 36
Cotton, Peter, 11
Creely, Robert, 34

Dal Grauer Substation, 19, 21, 67
Davick, L.E., 4
Diller, Burgoyne, 136
Doodle (image-eye-heart-hand-canvas), 12
Duncan, Robert, 34

Eakins, Thomas, 161
Erdman, Jean, 36

Farr, Murray, 38
Female Figure, 90, 111, 123
Fisher, Orville, 11
Fisherman's Shack, 118
Five dinghies, moored sailboat, tree, 88, 111
Flotilla in Primary Colours, 136, 137
Forest, 97, 112
Fuller, Buckminster, 51

Garden potting shed, 101, 111
Gardiner Thornton and Gathé Associates, 39
Garnier, Tony, 2
Gertler, Mark, 48, 84, 118, 123
Giedion, Sigfried, 50, 68
Goldschmidt, Nicholas (Nicky), 32
Goodwin, Helen, 35, 36
Gopnik, Adam, 42
Grauer, Albert Edward "Dal," 18

Grauer, Sherrard, 35
Greene brothers, 15–16
Gropius, Walter, 51, 52, 59

Halprin, Ann, 36
Harris, Bess, 10, 11
Harris, Lawren, 10, 11, 139
Harrison House, 59–60
Hine, Daryl, 34
Hollingsworth, Fred, 11

Imperial Bank of Commerce, 21, 22, 23, 144–45

Jarvis, Don, 32
Jessie at Tea Table, 64, 65

Kael, Pauline, 36
Kantor, Morris, 89, 120, 123
Kato, Shuichi, 28
Keays House, 59–60
Kiss in Nine Pieces, 154, 155
Koerner, Iby, 32
Koerner, John, 11
Koerner, Otto, 32

Lambert, Phyllis, 45
Lasserre, Fred, 11, 12, 16, 32, 49, 67
Le Corbusier, 2, 9–10, 16, 51, 59
Lescaze, William, 51
Lubetkin, Berthold, 49, 50, 51, 52, 53, 54, 59

Macdonald, Jock, 82
McDonald, Belinda, 32
MacKenzie, Norman A.M., 14, 30, 160
McLuhan, Marshall, 33–34, 36
Man Seated by Bureau, 104
Maquette for Head, 1937 (Henri Moore), 49
Maquette for the Imperial Bank Mural, 144–45
Marchand, Philip, 33
Mariner's Triptych: For Night Navigation, 140
Massey, Geoffrey, 159
Matisse, Henri, 89, 111, 125, 146, 161

Matthews, J.S., 27
Maybeck, Bernard and Annie, 15
Maynard, Max, 91
Mendelsohn, Erich, 16
Meninsky, Bernard, 48, 82, 84, 118, 123
Merrick, Paul, 24
Mondrian, Piet, 51, 136
Moore, Henry, 6, 48–49, 50, 51, 59, 84, 87, 120
Mori, Kanosuke, 30
Morris, William, 2
Mortimer-Lamb, H., 82
Motifs, 151

Neutra, Richard, 16, 18, 48, 51, 52, 59, 67
Nicholson, Ben, 91
Night Harbour, 131, 140
Night Image, 151, 152
Nude, 93
Nude Figure, 122, 123

Oberlander, Peter, 49
O'Brien Advertising Centre, 19, 135
Olmsted, Frederick Law, 4
Optional Modules, 1969–70, 154, 157
Optional Modules in Blue and Greys, 156
Ozenfant, Amédée, 6, 10, 48, 50, 51, 82, 84, 87, 120

Paintbox, The, 82
Parker, John Delisle ("Palette"), 92
Picasso, Pablo, 51, 84, 89, 91, 120, 123
Plants, powerpoles, two houses, 100, 112
Porter, John, 11
Port Mann Bridge, 24, 25
Portrait of H. Mortimer-Lamb, 82
Portrait of Jessie, 124, 125
Pratt, Ned, 11, 18, 59
Preparation for Tea at Rockcliffe, 110
Purple Calm, 148, 149

Reflected Ship, 128, 130
Reid, Irene Hoffar, 123, 125

Related Colour Forms, 139
Roberts, Gilbert Owens, 118
Roberts, William, 118
Rothko, Mark, 148
Rowboat #2, 96, 112

St. Elmo's Shield, 150, 151
Sakamoto, Kojo, 28, 29
Scott, Charles H., 7, 64, 82, 91, 94, 112, 123
Self Portrait in Ship's Cabin, 112, 114–15, 116
Shadbolt, Doris, 91, 94, 98
Shadbolt, Jack, 11, 23, 82, 112, 118
Shield of Electra, The, 151
Ships and Tower, 126, 128, 129
Ships in Classical Calm, 126, 127
Ships of the Line Sailing in Review, 136–37
Sketch for Jessie and Bert (Picnic), 105, 111
Smith, Gordon, 11
Spence-Sales, Harold, 49
Squally Weather, 132, 133, 136
Steinhof, Eugen, 46, 82
Stern, Gerd, 34
Still-life, 83, 87
Study for 555, 64, 65
Sullivan, Louis, 2
Summer Sun, 151, 153
Sunday Morning, 107, 112
Sunset Sea, 146, 147

Table & Still-Life, 89, 111
Tanabe, Muneo, 30
Tanabe, Takao, 34
Tecton Group, 49
Tessai, 30, 31
Theme Painting, 136, 138
Thom, Ron, 67
Thomas, Lionel, 11
Thornton, Mildred Valley, 92, 94
Thornton, Peter, 11, 49
Three Ships and Reflections, 131, 132
Todd, Frederick, 4
209 Plaza Hotel, 1 Degree Below Zero, Kamloops, 113

Untitled, circa 1939, 119
Untitled, 1941, 64, 86, 106, 111
Untitled, circa 1955, 140, 141, 142
Untitled, 1970, 158, 159
Untitled (Farm in the Cariboo), 85, 106, 111
Untitled (O'Brien Advertising Mural), 135

van der Rohe, Mies, 9–10, 16, 51, 52
van Doesberg, Theo, 136
Varley, Frederick, 82, 118

Walker, Doreen, 154
West Bay, 108–9, 112
Weston, W.P., 82
White Horse, The, 84, 121, 123
White Shadow, 146, 148
Wilson Grooming His Dog, 99
Wingate, Browni, 94
Wolfe, Tom, 33
Woodcock, George, 38
Wright, Mr. and Mrs. Bagley, 36
Wright, Frank Lloyd, 2, 16, 51, 52, 59
Wyllie, Jessie. See Binning, Jessie (Wyllie)

Young Painter, 102

Toy tugboat. Binning made
a few such boats for the children
of friends in the 1950s.